Gustave Courbet

GUSTAVE COURBET

PAINTER IN PROTEST

by Georges Boudaille

New York Graphic Society Ltd.

Greenwich, Connecticut

Translated from the French
by Michael Bullock

Standard Book Number 8212-0343-6
Library of Congress Catalog Card Number 73-86264

© *1969 in Italy by Alfieri & Lacroix Editore, Milan*

Printed in Italy

Contents

List
of Illustrations

Self-Portrait, 1846
(Musée de Besançon)

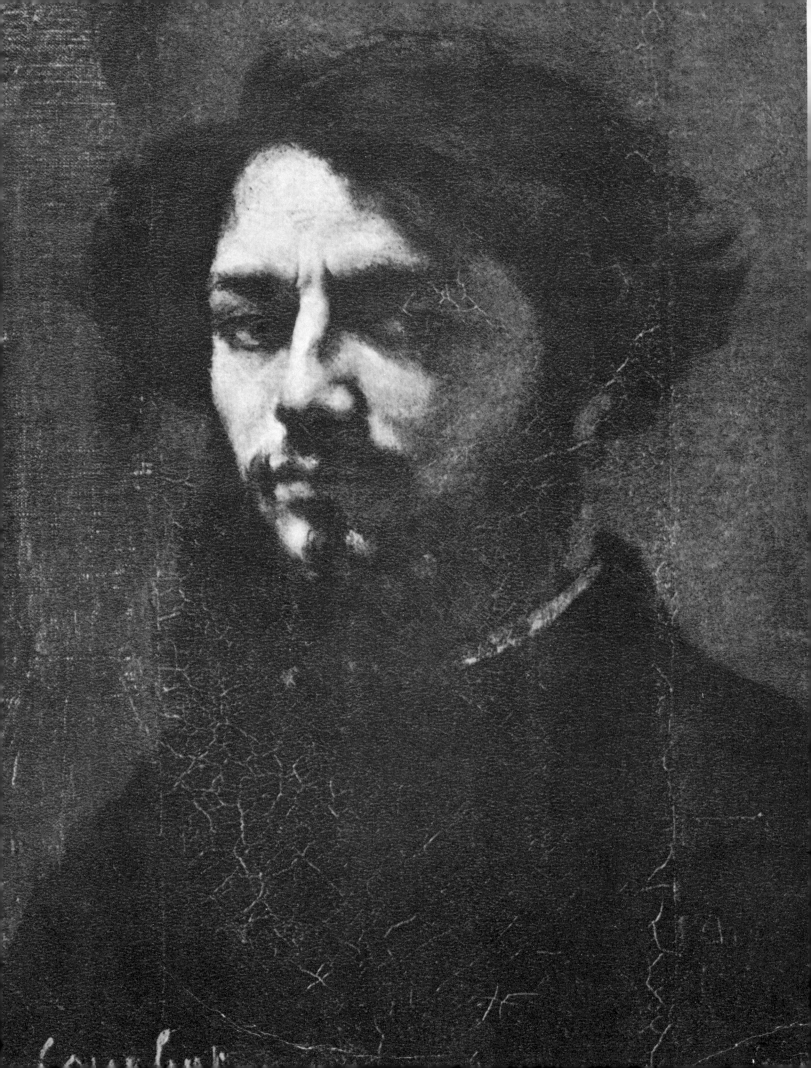

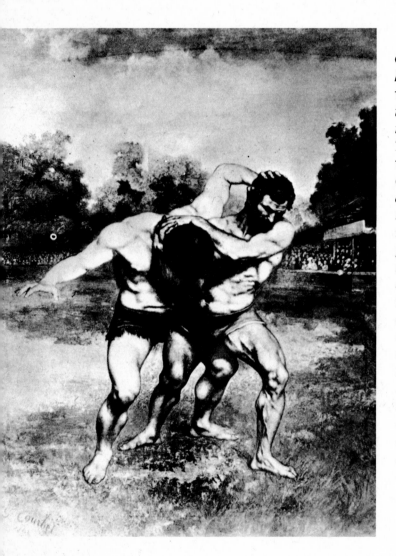

A new "Courbet"? I should prefer to say a true Courbet, freed from the dross of the myth: a more human Courbet, closer to ourselves, a Courbet whom we can follow from day to day, right up to his death, in an uninterrupted colloquy that is neither magnified nor diminished by the testimony of his contemporaries. The author has gathered together letters, thoughts, writings, and anecdotes of the "citizen-painter" of Ornans; he has reconstructed the history of the period and of bourgeois society from the last years of the reign of Louis-Philippe to the revolution of 1848, to the agonized events leading to the coup d'état and the proclamation of the Napoleonic Empire; then he records the ephemeral military successes, the extravagances of social life, the frustrations of foreign policy, the birth and progressive development of an anti-monarchist and Socialist opposition, and finally the outbreak of the Franco-Prussian War and the inglorious downfall of the Empire. Thirty years of French history terminating in the civil war between the Commune and Thiers' Versaillais, and the victory of reaction.

Courbet took part directly or indirectly in this chain of events; in the end in a climate of tragedy amidst the conflagrations and massacres of May 1871, he was actually implicated, as a protagonist, in the overturning of the Vendôme Column.

The figure of Courbet, closely linked though it is with the events of the Second Empire and the birth of the Third Republic, has acquired an unexpected topicality during the present turbulent years of protest, a new vitality due to the prophetic nature of many of his pronouncements. Moreover, a reading of Courbet's works provides many surprises when the paintings are seen against the background of the present.

Some years ago we were reproached for alluding to the pictorial quality of Courbet's work when studied for its real values, independent of his theoretical statements, even those derived from Proudhon; yet we were far from wishing to limit the significance and polemical contribution of the latter. All the same, after a century, Courbet's quarrel with Classical and

Romantic art in the name of Realism has come to seem less valid as a rigid classification, and his ideas on the subject serve less to cast light on these theoretical categories than to illumine the psychology and moral outlook of the artist.

Who, in fact, was Courbet?

Boudaille tells us — without giving in to the temptation to paint an idealized portrait and while remaining faithful to the evidence, which he carefully interprets. Courbet the man aroused intense passions by his attitudes and gestures, by his anarchic and rebellious behavior, which seems often to have been an unconscious reaction against the yielding of his sensibility, against hidden weaknesses and uncontrolled spontaneity. There was in him an innate ruggedness, a frank vigor deriving from his peasant origins in keeping with the very landscape of the Franche-Comté, wild and rocky as it is. A great hunter, given to exceptional feats of eating and drinking, fond of sitting up all night engaged in interminable discussions, a lover of his native soil like the provincials of the good old days, Courbet integrated his painting into his love of the land, which went well with his sanguine temperament and from which he 'drew his inspiration or, better, his visual imagination.

At this point the testimony of Odilon Redon, included in what seems to us a statement of fundamental importance written in 1882, confirms in the most opportune manner the most generally acceptable interpretation of Courbet's art. He writes: "It is difficult to judge one's contemporaries; perhaps it is impossible to understand them. One lives in an artistic atmosphere through which it is difficult to see clearly what is happening in other areas. Posterity, after all, is nothing but the sum of the judgments formulated during the passage of time by isolated and disinterested individuals who make comparisons and announce the truth to others, beyond all envy, free from passion, and distrusting the ideas of the moment.

"It is thus that we are able today to look, without making too many mistakes, at the work of the great Realist who was simply a great painter."

Seen in the perspective of time, the label "Realist" has lost the virulence it possessed in 1848. To us, Courbet does not seem very different from his contemporaries, who did not understand him, just as they did not understand Daumier, Ingres, Delacroix, and even the good Corot. Basically, the people who had voted for Napoleon III shared the opinion of the Emperor, who struck the picture Les Baigneuses with his whip. (Too buxom, perhaps, for the languid taste of His Majesty.) The people's taste had got no further than David (the David of Marat, or of Napoleon I?).

But let us come to Redon's judgment free from "too many mistakes."

"Courbet developed vigorously within a unique field of activity. He was a sensitive, delicate spectator of things, a joyful and amused student of the fairy-like changes in outdoor light. For him, unquestionably, the art of painting was an enjoyment; and as he never painted except with love and for pleasure, he was always impeccable. Not a square inch of canvas, not an accent, that was anything but the exuberant ardor of color itself, that is to say, of the eternal play of light upon light, with an exact feeling for all the interrelationships."

Courbet learned his craft all on his own, perfecting the use of the palette knife, which replaced the brush for drawing and constructing forms with solid layers of paint on the canvas.

He was a romantic Narcissus. He looked at himself in the mirror; perhaps he admired himself in the Assyrian face reflected in the limpid waters of streams; he saw himself as pale and gloomy, a happy lover or one plunged in the shadow of death, and always, in the air of his unspoiled native region — among valleys, forests, monumental cliffs, mysterious and dark springs — as plunged in a nature and a life that had remained simple and unchanged for centuries. And everywhere he went — hunting in German forests or walking along the seashore — he carried with him memories of the first encounters of his youth, of marvellous visual discoveries:

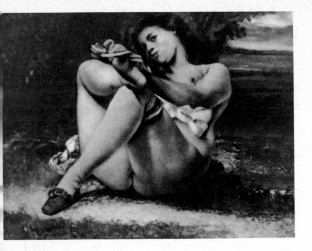

The Woman with the White Stockings,
1861-62
(Barnes Foundation, Merion, Pennsylvania)

trees, skies, waters, flowers, animals, mountains, unending visions of the reality that he had felt and had translated into painting with the loving enthusiasm which Redon rightly sees in his work.

Baudelaire attributed to him a "fanaticism" for "external, positive, immediate nature"; but in order to discover it and thereby reveal himself a great painter, Courbet did not have to wait for the utterances of Proudhon. The painter in Courbet was born long before his summary and confused Realist "credo." And with time his "fanaticism" became consolidated, passing from the domain of art to the more appropriate area of action, especially during the period of the Paris Commune.

Théophile Gautier condemned Courbet the painter. Alexandre Dumas fils and Barbey d'Aurevilly demolished Courbet the "Communard," the man who had planned to bring down the Vendôme Column, but who had saved from destruction the masterpieces of the Louvre and even the works of art in Thiers' house.

In its last chapters, Boudaille's story assumes the dramatic rhythm of Courbet's adventurous life, intensely relived through the written and illustrated documents of the time. It is therefore unnecessary to mention here the persecution suffered by Courbet, his arrest and imprisonment in the prison of Sainte-Pélagie, and the troubles which beset him until his death in exile at La Tour de Peilz on December 31, 1877.

Today Courbet's protests and rebellions against academic teaching, his proposals for the abolition of the academies, and his polemics against the organization of the art world are sympathetically received in a climate of protest against all manifestations of intellectual life organized according to the spirit of the fin-de-siècle *salons, against all outworn and decrepit educational and cultural structures.*

And outside all myths and legends the interpretations of Courbet's true personality by two artists, Redon and De Chirico, become more up-to-date than ever. Two painters, not two historians, have contributed to the formation of an objective judgment, freed

from polemical debris marked with the sign of Realism. Thus a Courbet seen in a modern way in the subtle pages of Boudaille can be full of interest for today's readers; he can live again in their minds with the fidelity to his true being that was too often denied him by his contemporaries.

February 1969

Giuseppe Marchiori

3

Chapter 1

AN ORIGINAL FAMILY
A PRECOCIOUS OPPOSITION

Born at Ornans (Doubs) on 10 June 1819, began his studies at the seminary of his home town and completed them at the Collège royal, Besançon. He then spent a year with a teacher of mathematics, M. Delly, who, unknown to his family, encouraged his vocation for painting. His father intended him for the Bar.

Gustave Courbet, 1866.

(Autobiographical note, now in the Bibilothèque Nationale, Paris, intended for the Panthéon des Illustrations françaises au XIXème siècle.)

Jean Désiré Gustave Courbet, born at Ornans near Besançon in the department of Doubs on 10 June 1819: this name, this place, this date, become highly significant in retrospect.

Does this mean that this man was born under particularly favorable stars? He was to live in a period of great upheavals and extraordinary, unforeseeable developments. He was destined to take part in them, to contribute to them to the extent of sacrificing his reputation, his fortune, his health, and his life for them.

Little or nothing, however, seemed to be carrying him toward such a destiny.

Gustave Courbet was born at the moment when the Napoleonic epic was drawing to a close, when the sounds of the great dream of 1789 seemed to be deadened by the padded hangings of the restored monarchy. Following the Congress of Aix-la-Chapelle, which took place the previous year, the Allies had evacuated France. But the echoes of the French Revolution spread far in space and time, and henceforth all the peoples of Europe, including those of Austria and Greece, demanded independence and freedom. France itself, which seemed to have been rendered sluggish by the prosperity it had apparently recovered, was to experience numerous upheavals, and the child born at Ornans in 1819, Gustave Courbet, was to become the artist most troublesome for the society of his epoch and was to be associated with every revolt. His work came to be regarded as the symbol of all social demands, all protests.

The century in which Gustave Courbet would live, as Louis Aragon wrote at the beginning of his essay on the painter, was to see "the awakening of a giant such as is not found in fairy tales, who opened his eyes, raised his head and propped himself up on his elbow. He knew neither his strength nor the effects of his movements, and he was amused by tearing off the cobwebs which had bound him in his sleep and by the whole Lilliput of people and ideas that tumbled from his powerful shoulders in this first moment.

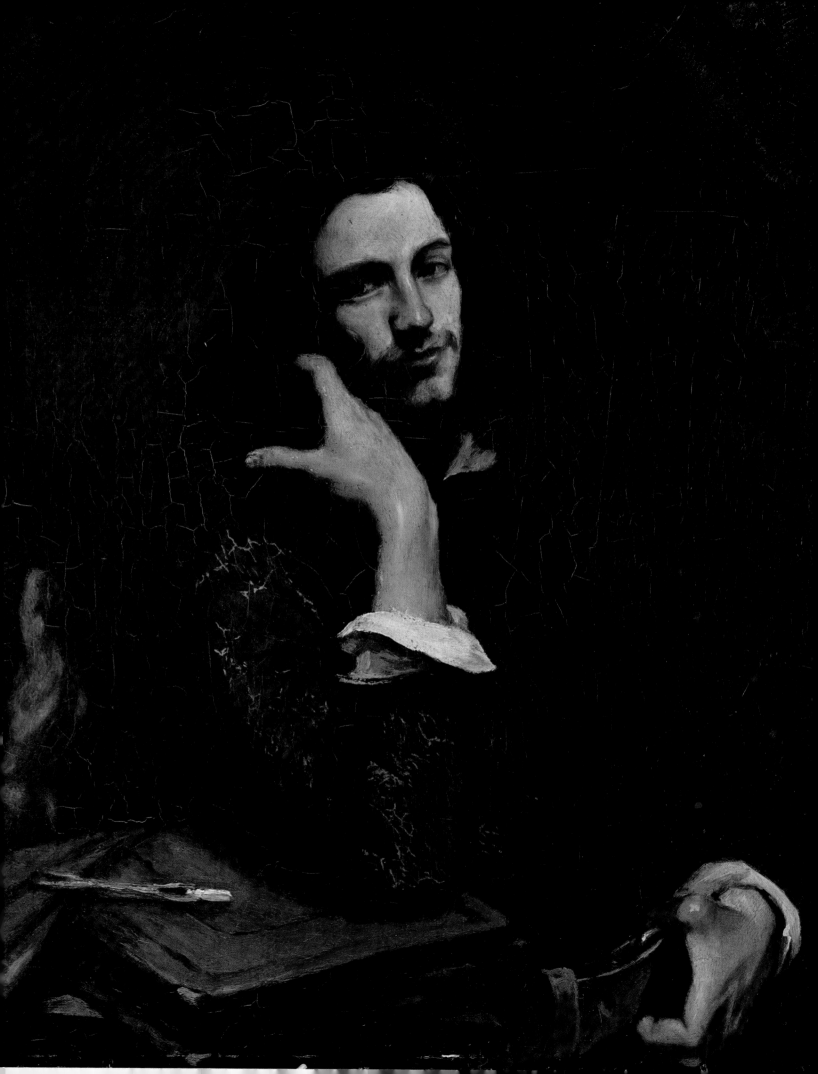

Man with a Leather Belt, ca. 1840
(National Gallery, London)

Valley of the Loue, drawing, ca. 1840
(Musée du Louvre, Paris, Moreau-Nélaton
Bequest)

But he did not yet know how to shake himself free from all these vermin, nor that they were going to come back more numerous than before, nor that they would quickly learn a thousand ways of paralyzing giants... That century, in France, the giant Proletariat stirred... and the nations on all sides heard him."

Courbet was one of those who heard the sighs, the groans, then the roars, of this giant, and he re-echoed the sounds in canvases which today are famous: *The Stone Breakers; The Atelier; Bonjour, Monsieur Courbet; The Corn Sifters.* His contemporaries even saw a criticism of their society in his choice of models for portraits and in his way of painting the nude. For to every genre he brought something new through his temperament, his personality, his style.

Courbet's century was to witness at one and the same time a decay of French architecture and a soaring to new heights of French painting as a vehicle of individual expression; and the effect of this soaring was increased tenfold through the fact that painting lost its national character and came to participate — already — in a kind of internationalization that abolished frontiers. Courbet, among the first, traveled widely and enjoyed in Belgium and Germany a welcome denied him in France. These esthetic characteristics of the nineteenth century, which Elie Faure was the first to disentangle from the multiplicity of movements and schools, are in line with the specific contribution of Gustave Courbet.

To say that 1819 was the year in which Géricault painted *The Raft of the Medusa* and Ingres *Roger Rescuing Angelica,* in which Schubert composed *The Trout,* and in which Lamartine and Shelley wrote their most beautiful Romantic poems, will establish the artistic context of the painter's birth. But these facts and these works had no influence on the newborn child of a young family of Franc-Comtois winegrowers. To say that Courbet was exactly contemporary with George Eliot, Walt Whitman, and Offenbach is no more revealing. It seems more significant that Karl Marx was born the previous year, Friedrich Engels the following year, and Flaubert, Baudelaire, and Dostoyevsky in 1821.

More significant still was the family environment and the geographic and ethnic framework within which the future champion of Realism grew up. Besançon, former capital of the Franche-Comté and chief town of the department of Doubs, is situated in the heart of a region of vineyards and forests, at once verdant and wild. The area has long-standing traditions of liberty, not unconnected with the proximity of the Helvetic Confederation. Remote from Paris though they were, its inhabitants were not isolated; in thought, and thanks to the *gazettes,* they participated in all the events in the capital, and they were scarcely conscious of the distance that separated them. The countryside was rich in splendid archeological sites and steeped in a dramatic atmosphere in which the young man was to experience his first romantic emotions and was to be inspired to paint his most beautiful landscapes. But life there was hard, and at the beginning of the nineteenth century the peasants led an arduous, austere existence. True poverty was rare, but work on a farm left little time for leisure.

Gustave Courbet's parents were young. Three years before Gustave's birth, Régis had married Sylvie Oudot; he was eighteen; she was twenty-two. Neither of them was a true peasant: they lived from their estates, and they kept a close watch on the agricultural work in order to derive the maximum profit from it. In fact, this duty fell to the mother, a practical, positive, harsh woman whose tireless activity and supervision made up for her husband's shortcomings. Régis was the son of the magistrate of a neighboring village, Amancey. He was a dreamer, an inventor with a passion for novelties, even the most chimerical. One day he designed a harrow based on novel principles, and its ravages on the local farm land kept many around Ornans provided with gossip for a long time to come. It was doubtless from him that Courbet inherited his tendency to megalomania and Utopian dreams. From

Man with a Leather Belt, ca. 1844
(Musée du Louvre, Paris)

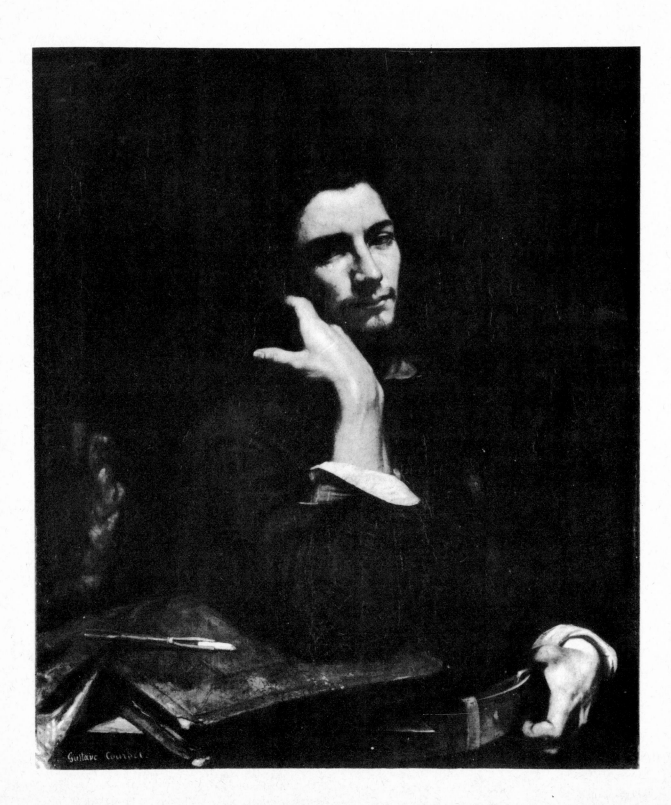

his mother he derived sound common sense and a taste for material and concrete realities; in a word, the practical efficiency which his father totally lacked. Above all he learned by precept and example from his maternal grandfather, Jean-Antoine Oudot, who never forgot that he had been twenty-two in 1789 and a member of a Jacobin club in 1793, and he ardently desired to pass on to his grandson his Voltairian, revolutionary, and anti-clerical ideas. It was he who read the boy pages and pages of the old *Almanach républicain*. Courbet seems later to have adopted its motto: "Shout loud and march straight."

Gustave was to have four sisters, all of whose portraits he painted with the exception of Clarisse, who died in childhood. The painter's first biographers, who had an opportunity of getting to know the "Demoiselles Courbet," have left very definite descriptions which, if they do not precisely capture their characters, do provide a picture of the family atmosphere. Zélie traditionally appears as "romantic and sickly"; she played the guitar. Zoé was "sentimental and imaginative"; her marriage to an academic painter named Reverdy, winner of the Prix de Rome, brought about a break with the Courbet family; she died insane. Juliette was always "active and pious"; she remained faithful to the memory of her brother throughout her life, except during the two months of madness that preceded her death.

Apart from the family home at Ornans, Courbet's father possessed lands scattered through the three neighboring communes of Flagey, Silley, and Chantrans. Harmony cannot always have reigned in the family, for it often happened that when the father arrived at Ornans, the mother and children moved out to Flagey, and vice versa.

In 1831 Gustave was sent to the little seminary at Ornans, a religious establishment which also prepared pupils for lay careers. Even at this stage the young Courbet showed little aptitude for study and proved to be a mediocre pupil in every subject except drawing.

It is true that he was lucky enough to have as his teacher "le Père Baud," a former disciple of Baron Gros and, it seems, a good pedagogue. His methods were revolutionary. He actually had the idea of taking his pupils out on fine days to draw from nature. This was a very audacious step at that time. Up until the period of Romanticism the landscape did not exist in its own right; it was merely the setting for mythological or other compositions. Ancient ruins alone were considered worthy of the painter's attention. A rather naïve canvas by le Père Baud shows his pupils, among them Courbet, drawing the source of the Loue, and Georges Riat saw many such drawings in the possession of Juliette Courbet.

I do not want to romanticize or exaggerate the traditional opposition of middle-class families to an artistic career, but it is possible that Régis Courbet looked unfavorably upon his son's enthusiasm for drawing and upon le Père Baud's hold over him. He wished his son to attend the national institute of mathematics and engineering, the Ecole Polytechnique in Paris. Perhaps he secretly hoped to find in him a helper in his various inventions, or simply to realize in his progeny a personal ambition of his own.

In October 1837 Gustave found himself a boarding student in the philosophy class at the Collège royal, Besançon. At sixteen he suffered from this violent change and revealed his vigorous and intransigent character. "This," he wrote thirty years later, "was the program which we rebels drew up between us:

"1. Not to go to confession. 2. To make classes impossible. 3. To do drawing and music. 4. To write verses, novels and love letters to the girls of the Sacré-Coeur. 5. To organize gymnastics and midnight battles. 6. To play tricks on the monitor."

The letters he wrote to his family are nothing but a series of recriminations and demands. He complains about everything: they have to get up at five o'clock, the beds are hard, he is cold, the kitchen is filthy. The young student indulges in constant blackmail of

Self-Portrait and Croquis, ca. 1840
(Musée du Louvre, Paris, Moreau-Nélaton
Bequest)

Man Reading and Port de Nahir at Ornans,
ca. 1840
(Musée du Louvre, Paris, Moreau-Nélaton
Bequest)

Portrait of Juliette Courbet, 1844
(Musée du Petit-Palais, Paris)

his parents. At one moment he tries to gain their sympathy by claiming to be ill; at another he threatens in order to make them give in. "Perhaps you imagine that I wrote what I have just written for fun. Not at all, for I have just sold my college coat for 33 francs in accordance with an estimate from the tailor, who told me it cost 35... Since in everything and everywhere I must always be an exception to the general rule, I am leaving to fulfill my destiny."

At Easter 1838 his father finally weakened and Gustave was given permission to take a room in town, in the rue du Rondot Saint-Quentin, which later became the Grand-rue.

Chance came to the aid of his vocation. In the same house there lived a painter by the name of Jourdain and two pupils from the Ecole des Beaux-Arts: Baille, who became a religious painter, and the landlord's son, Arthaud. Gustave neglected courses and private lessons in philosophy and mathematics to follow his friends into Flajoulot's studio at the Ecole des Beaux-Arts. A former pupil of David, the master was popular with his students. His motto was: "Drawing first." Under him Courbet learned what academic perfection was. But when someone is living in the house in which Victor Hugo was born, when he is nineteen and *Ruy Blas* is being performed in Paris, how could he fail to lend an ear to the battle of Romanticism? An *Odalisque* seems to be directly inspired by a poem of Victor Hugo.

A childhood friend, Max Buchon, a fellow student at the little seminary in Ornans, was now living with the Jesuits in Fribourg and was about to publish his first poetic essays. He asked Courbet to illustrate his booklet. At this point Gustave discovered lithography and, in addition to a few vignettes in a definitely Romantic style, executed several prints representing landscapes to which he was to return later: *The Bridge of Nahin, La Roche du Mont, The Valley of la Loue, The Islands of Mongesoye, The Approach to Ornans.* He sent a number of proofs to his parents, requesting

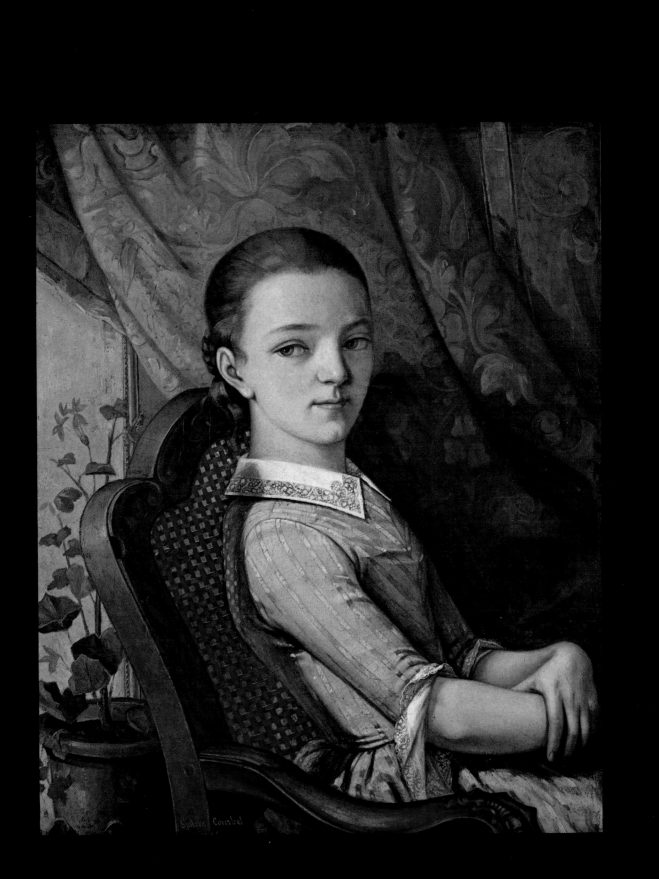

that they distribute them to acquaintances with a note:
"I have recently taken up a form of drawing which
would suit me perfectly if my financial resources enabled
me to do it fairly often. This is lithography." The
letter ends with a demand for money, because printing
is expensive!

Courbet's vocation seemed irrevocable. He drew a
great deal and painted a few rather studious canvases,
among them *Arcade* and a composition in a romantic
vein, *Les moines de la Chaise Dieu.*

In December 1837 he wrote to his parents sentences
that sound prophetic. "I must tell you that I have
taken a decision and that I need only another two
months in the position in which I now am to put it
into execution. Everyone has proved so stubbornly
opinionated where I am concerned, and this has utterly
disgusted me. People have tried to force me, and in
all my life I have never done anything in response to
force — that's not my character."

We can understand that his father, Régis Courbet,
distrusted the resolution of an eighteen-year-old boy,
but Gustave already possessed in embryo that intran-
sigent character which was to be the source of his
strength and his misfortunes. The student at the Collège
royal in Besançon was a "protester" before the term
came into fashion. It was a role he was to maintain
until his last breath.

In 1840, having completely neglected his studies,
Gustave did not even take his examination. He returned
to Ornans and spent his vacation roaming the country-
side, drawing and sharing again the life of the peasants.
He used all his powers of persuasion to obtain both
permission and money from his father to leave for
Paris. Concession followed concession, and he was
allowed to forego Polytechnic training on the condition
that he study law. In any case, he had just become
twenty-one.

Yet Courbet did not break his ties with his native
soil. Not only did he return frequently, but he drew
his inspiration from it. The winegrowers, the hunters
and the fishermen were his friends. He painted them,
but he also painted the game and the fish, the Jura
roebuck and the trout.

His native countryside also provided him with friend-
ships as numerous as they were precious: the regionalist
poet of the Franche-Comté, Max Buchon, and the Fou-
rierist philosopher Victor Considérant, both of whom
were from Salins, and the journalist Proudhon, who
was from Besançon, not to mention the publicist Francis
Wey and many others who were to play a part in his life.

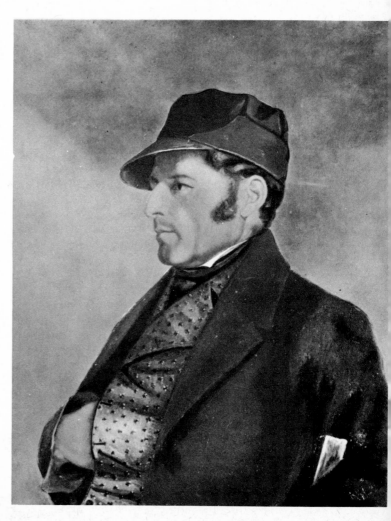

IN PARIS
THE FORMATIVE YEARS
ASSAULT ON THE SALONS

After arriving in Paris he was very disillusioned to see the pictures of the French school, and told his companions that if this was painting he would never be a painter. He looked at all the painting to be seen in Paris and sorted out his ideas. He began serious and systematic study, devoting his attention to each school in turn. His nature, which appeared very strange and original to his companions, led the latter to follow him everywhere and repeat his sayings. He had a picturesque way of speaking and made very skillful use of the little knowledge he possessed. He was nicknamed Courbet the Preacher. His companions craftily took him to the Musée du Luxembourg to make him talk. They placed him in front of the Delacroixs and asked him what he thought of them. His audacious reply is quoted. "I could paint pictures like that tomorrow if I dared to." As for M. Ingres, he did not understand his work at all to begin with, but later he realized that all these painters were significant and that they were all searching for a means to establish art in France. Seeing all these efforts, he said to himself: "The only thing to do is to go off like a bomb across all the subdivisions."
Gustave Courbet, Ibid.

It is easy enough to reconstruct the first years of Gustave Courbet's life in Paris. As we shall see, they were not noticeably different from those of any young man from a middle-class provincial family, divided between the need for independence and a deep emotional attachment to his family, his region, his home.

In this state of exaltation and emotional crisis, Courbet paid little attention to political events. Indeed he was so indifferent to them that his first years in Paris left him with the impression that it was a happy period — as it was for him — and he retained a certain feeling of affection for the reign of Louis-Philippe, son of Philippe-Egalité, duc d'Orléans, who voted in the National Convention for the death of Louis XVI. Like Louis-Philippe, Courbet, the grandson of Jean-Antoine Oudot, seems to have forgotten at times the example of his Jacobin ancestor. After the July Revolution of 1830 Louis-Philippe's first ministers several times had to use force to establish order and keep themselves in power. They confronted the insurrections of 1834, which captured Lyons, those of Louis Bonaparte in 1836 and 1840, and above all the movement led by Barbès and Blanqui in 1839.

In order to survive, the constitutional monarchy moved from the liberalism of Thiers to the conservatism of Guizot, a change that was given concrete form in 1841. French foreign policy led to a greater rigidity of those in power, but the young Courbet paid no heed to these events. He was entirely preoccupied by his personal problems.

The death of his teacher Flajoulot was the decisive event that precipitated Courbet's departure from Ornans, after a summer visit to Paris where he had stayed with his friend Charles Nodler, then librarian at the Bibliothèque de l'Arsenal. With no one to help him at Ornans, he needed Paris, the Louvre, the advice he never took and the connections he abused.

It is hard to imagine a family of small landowners allowing their son to leave for Paris without someone to keep an eye on him. The friend *in loco parentis*

was Julien Oudot, a cousin from Ornans, a professor at the Ecole de Droit, who had Gustave enroll at the school. The latter soon made it clear, however, that law was only to be a temporary alibi.

After a brief stay in the rue Pierre-Sarrazin, Gustave rented a modest room, or rather a garret, at 28 rue de Buci. He attended the Académie du Père Suisse (a former model of Jacques-Louis David) at the corner of the boulevard du Palais and the quai des Orfèvres — a free school where the students drew the nude from life but where there was no teacher to correct them. It was the same at the studio of Père Lapin (whose real name was Desprez), which Courbet also frequented because it was cheap (6 francs a month) and because it was situated at Saint-Germain des Prés, close to the rue de Buci. The young painter attracted attention by the large scale of his drawings, in which he represented only parts of the body.

Courbet also put in an appearance at the studio of Baron de Steuben, where he cultivated an air of polite interest in the hope of being invited to the Salon. It was another teacher, Hesse, who arranged for him to be admitted. But Courbet always denied owing anything whatever to these two masters. He mentions Hesse's name in connection with the catalog of the 1844 Salon, but this is merely a formal expression of gratitude.

The young painter was not isolated. He met a friend from Besançon, Hervé Baille, a student at the Ecole des Beaux-Arts who was already exhibiting at the Salon. At the Académie Suisse he made the acquaintance of a populist painter, Bonvin, who was also an official at the nearby Préfecture, and then of Alexandre Schanne, the "Schaunard" of Henri Murger's *La vie de Bohème,* and of Tattet, a friend of Alfred de Musset, who introduced him to the forest of Fontainebleau. Soon he was receiving commissions for portraits, which made some improvement in his precarious financial position.

Yet Gustave Courbet soon found himself in financial difficulties. To begin with, his parents helped him,

notably through the intermediary of Messieurs Panier, merchants in the Marais quarter. Georges Riat discovered a letter to Régis Courbet, dated 1842, saying: "We shall always be pleased to remit to your son the sums he requires, but we shall always call upon you to reimburse us for these sums at a date of one month or one month and a half." It is impossible to tell when this assistance came to an end. Although inadequate, it probably continued until 1844 at least — otherwise why should Gustave have felt called upon to justify himself by letter to his parents? Cousin Julien Oudot believed it his "duty" to inform the Courbets that their son had abandoned law to devote himself entirely to painting; moreover he reproached him for trying to make his way on his own instead of working in the studio of a recognized master.

Régis thought that his son was living a gay life in Paris on his money, whereas Gustave, who was big and strong, felt very unhappy at being able to eat only one meal a day. He is wasting away, he is working very hard, he says; and he presents his life in a romantic light that may not be altogether contrary to the facts.

"If you think I am having fun, you are very much mistaken. For more than a month I have really not had a quarter of an hour to myself. This is how it goes. I have models who cost me a great deal of money and from whom I work from the moment I can see clearly in the morning until five in the evening, when I have my dinner. In the evening I have to procure the things I need for my work and run after models from one end of Paris to the other, then go and see people who may be useful to me and then go to parties, which are indispensable if I am not to be taken for a boor." (February 2, 1844)

He finishes another letter with the words: "and many other people are agreed in predicting that if I go on working like this I shall ruin my health."

At this time his painting tends in the same dramatic direction, and his first period bears the imprint of the Romantic era that saw his birth. One of his first self-

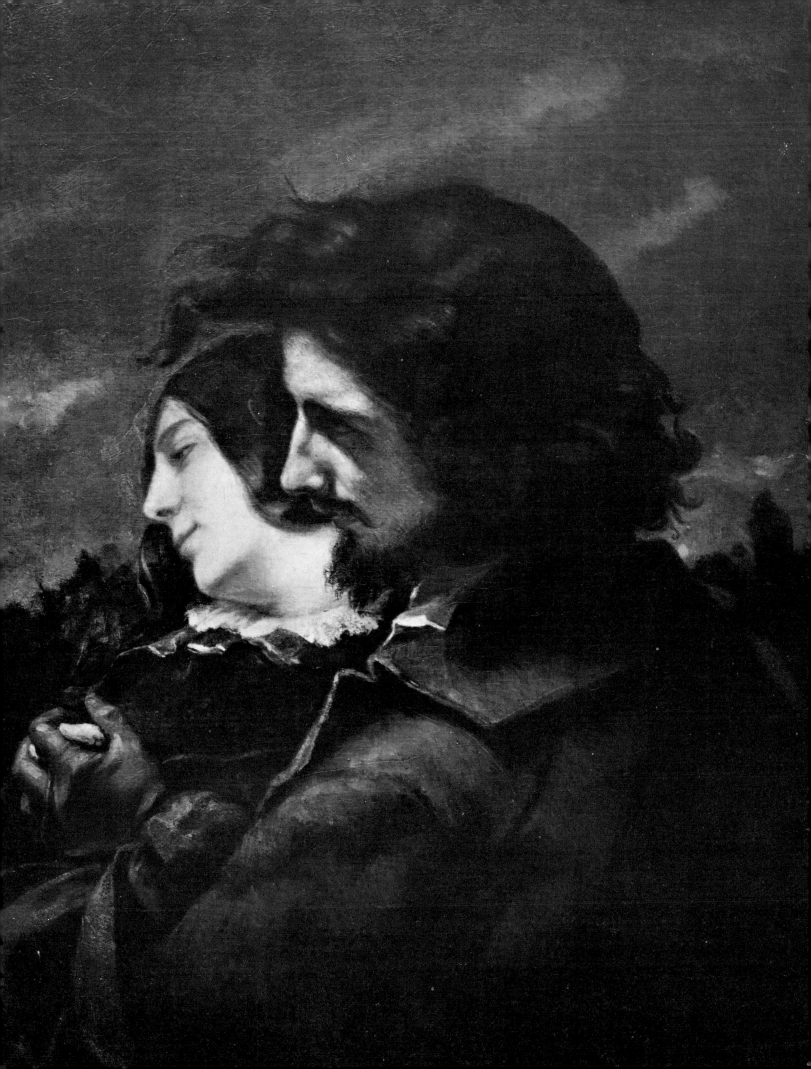

portraits, *Le Désespéré* (*The Man in Despair*) (1841), shows him wide-eyed, gazing fixedly at the spectator, with long hair, a wide moustache, and the beginnings of a beard. The light-colored, loose shirt wide open at the neck declares the artist. The whole work betrays a high degree of self-satisfaction.

The first self-portraits are entirely in keeping with the recollections of eyewitnesses such as Burty. "He was slender, tall, supple, with long black hair and a silky black beard. He was invariably escorted by friends, as the Italian masters are said to have been when they left their studios. His long, languorous eyes, his straight nose, his low, proudly modeled forehead, his protruding lips — with a hint of mockery at the corners, as his eyes had too — and his smooth, bulging cheeks, gave him the closest possible resemblance to those profiles of Assyrian kings that terminate the bodies of bulls. His drawling and melodious accent... added a peasant charm to his speech, which could be very caressing or very subtle."

On January 8, 1843 young Courbet (he was twenty-three), tired of living and painting in a tiny, inadequately lighted garret on the fourth floor of the rue de Buci, moved to 89 rue de la Harpe and a more spacious accommodation that was to serve as a studio. "It was the former chapel of the Collège de Narbonne, which was arranged as a studio for M. Gati de Gramont, a well-known painter; at the present time it serves as a music room for M. Habeneck, conductor at the Opéra." (December 24, 1842) The young painter furnished the place meagerly and asked for the aid of his family in doing so. It seems that henceforth Courbet was not merely settled in Paris, but felt himself at home there.

He had spent the previous summer at Ornans as he did every year. While there he painted not only portraits of his sisters, Zoé and Juliette, but also the *Self-Portrait with the Black Dog* at the entrance to the cave at Plaisir-Fontaine. He regained contact with the family circle and returned to Paris with an increased

determination to make a name for himself and to live by his painting. This was to be a period of intense work. He gradually shook off the influences he had assimilated and at the same time freed himself from his shyness and from scholastic bonds. The years 1842-49 were decisive in his development.

Courbet rejected all his contemporaries: none of them was worthy to show him the way. In fact he never understood them. We have heard his reaction to Delacroix — [better than David, but] "I could paint like that tomorrow if I dared to" — and it was in front of *Les Massacres de Scio* — hardly one of Delacroix's weakest pictures — that he expressed himself so scathingly. He showed an equal lack of understanding for Ingres and for Manet. But this did not prevent him from making numerous copies, notably of Delacroix's *Dante and Virgil* and of a *Horse's Head* by Géricault.

In the Louvre his choices were spontaneous, intransigent and final. He was immediately attracted by the Spaniards (whom he described as realists), Velázquez, Zurbarán, Ribera, and by the Dutch — Rembrandt, but also the genre painters such as van Ostade — and we can see why. He was indulgent toward the Germans, especially Holbein. And for the Italians, so highly thought of at the time, he had only contempt and insulting phrases. He made an exception of the Venetians, as may be seen from the subtitle of the self-portrait *Man with a Leather Belt:* "A Study after the Venetians."

In fact up to 1848 we can see distant reminiscences of the Spaniards and Dutch in his work. But Courbet never studied the Old Masters closely enough to be deeply influenced by them. What he retained from his visits to the Louvre was a spirit, a manner of seeing, rather than specific techniques. After having made the rounds of the schools which attracted him, without going into them deeply, he found a style that was original because it was natural; it consisted of painting modern, popular subjects in a manner that was inspired

The Wounded Man, 1844
(Musée du Louvre, Paris)

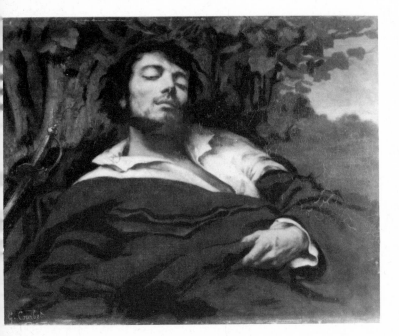

by the masterpieces of the past without imitating them. Courbet was never sufficiently industrious nor sufficiently docile to submit to any esthetic discipline other than his own. One is inclined to agree with his own words many years later, in spite of their boastfulness (cf. p. 62). "I wanted to extract from the entire body of traditional knowledge the reasoned and independent sense of my own individuality." And rather than the (always relative) modernity of his subjects, it was precisely this sense of his own individuality that made Courbet one of the first authentically modern painters.

For the next several years the events Courbet lived through are secondary to the works that came from his hand. When he arrived in Paris the painter already possessed the essentials of his craft: he had learned to draw accurately from the instruction of his teacher Flajoulot, who had transmitted to him the lesson learned from David. But as soon as he looked closely at some of David's large paintings, he repudiated this teaching. At Besançon he was admired for his gifts as a colorist, but the sight of Delacroix must have been for him a harsh lesson in modesty, whatever his public judgments on that artist may have been. The gifted young provincial, adulated by his family, measured what he lacked to become the painter he dreamed of being. However, he never displayed the slightest trace of humility, but rather the reverse. Already he laid down the law, contradicted, asserted himself.

Yet there was nothing to justify this self-confidence. What we know of his work at that time is on the level of good studio work, such as the two studies of female nudes executed at Besançon, the few rather somber landscapes, which may have suffered under the hand of time, and the portraits of friends, quite incisive but labored.

In Paris, carried away by his ambition, he did not hesitate to paint certain large and pretentious canvases that have unfortunately disappeared, such as *A Monk in a Cloister, Walpurgis Night,* a romantic and alle-

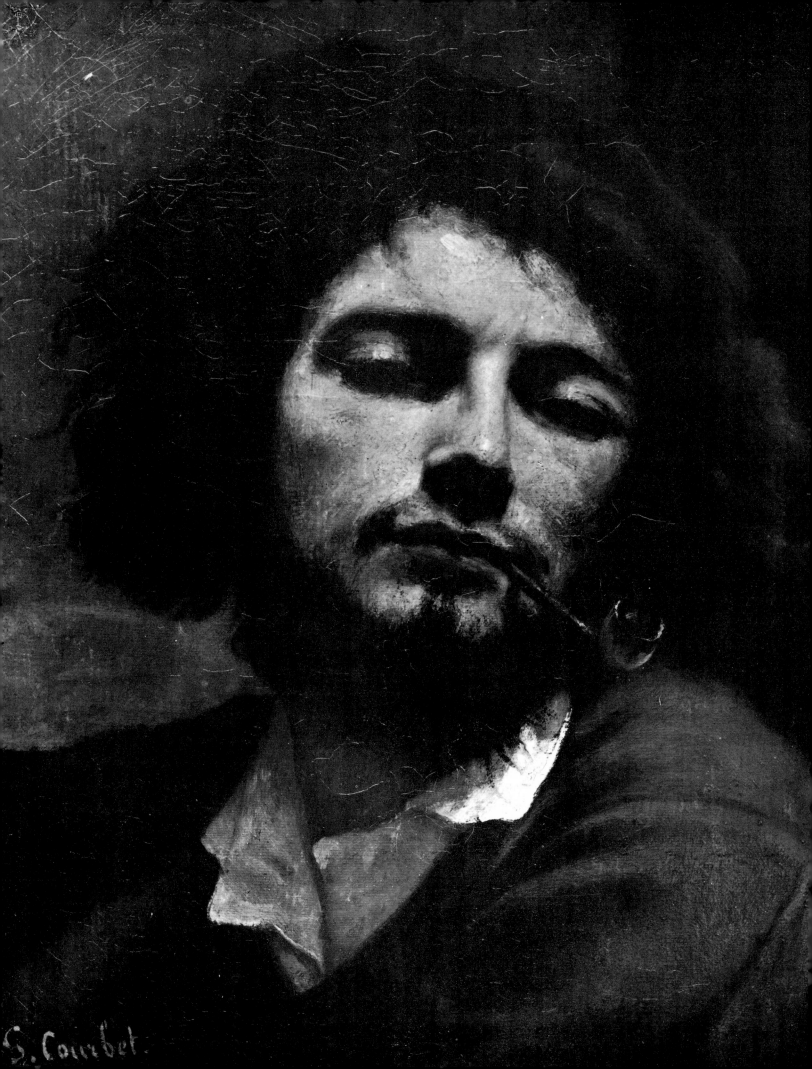

G. Courbet.

gorical Faust satire over which he later painted his *Wrestlers,* and *The Man Delivered from Love by Death.* The sole extant witness to this period is *Lot and His Daughters,* which Théophile Silvestre was to describe as "a work repellent for the obscenity of the idea and a pretentious and vapid execution," a very severe judgment. In fact it is very difficult to recognize this work from the descriptions of Courbet's earliest biographers. It was they who must have had a perverse imagination in order to see in it so many invitations to vice. All we can see today is a scene in the post-David style showing Lot getting dreamily and sadly drunk in the presence of two buxom but not very provocative females. And since Courbet did not arouse much liking for himself, outside a small number of faithful friends, we cannot help wondering whether the libidinous descriptions of this picture made by so many critics were not inspired by the deliberate wish to harm him and perhaps to attract the attention of the censor to him.

We will pass quickly over the portraits of his sisters painted at Ornans during the summer of 1842 and halt at a first series of self-portraits that led to his being described as a "peasant Narcissus." In fact Gustave Courbet, like Rembrandt, like Gauguin, like Cézanne, frequently painted portraits of himself reflected in a mirror. His hagiographers see in this frequency only the consequence of the lack of a model and a concern for economy. His detractors see in it an illustration of his vanity and unspeakable conceit. They imagine him skillfully combing and arranging his hair, smoothing his beard, carefully working out the most favorable lighting. Nevertheless this taste for self-portraiture is not without significance: it illustrates Courbet's need to affirm himself in his work, as he did in words every time he had an opportunity, and this need betrays not merely his concern for the opinion of his contemporaries, but also a deep-seated anguish, perhaps a diffidence coupled with pride.

After *Le Désespéré,* a romantic, exaggerated, theatrical work if ever there was one, *Courbet au chien noir* (*Self-Portrait with the Black Dog*), while equally romantic, already gives evidence of a new spirit. The face emerges from the shadow of the hat in a chiaroscuro that hints at Courbet's discovery of Rembrandt. The silhouette formed by the man and the dog takes on a sculptural relief. Finally, it is worthwhile drawing attention to the part played by the landscape, which is far more than a background. This is not simply a self-portrait but a portrait of a man in one of his favorite haunts within a setting of vegetation and rocks, which was to be the theme for an important series of canvases and which completes the psychological atmosphere of the portrait. The expression of affected self-satisfaction — perhaps tinged with irony — visible at the corners of the lips and in the movement of the pupils may be explained in many ways. Courbet was very proud of the black spaniel, "pure bred," he used to say, which was a gift and which he took with him on his vacations at Ornans; but above all, the satisfaction is probably the result of being back home. After a hard season in Paris where he was struggling to make a name for himself, he was again in his native countryside, and, as was always to be the case, fussed-over and surrounded by admiration. He recovered not merely his strength but also his self-confidence. Few works painted at twenty-three show so much intensity.

Other self-portraits followed: *The Wounded Man, Man with a Leather Belt, Man in a Helmet, Lovers in the Country,* all dating from 1844, and still others — famous self-portraits such as *The Cellist, Man with a Pipe, Man with a Striped Collar, The Atelier,* and the self-portrait now in the Pontarlier Museum. Whatever the setting of these autobiographical fragments, the care which Courbet lavished on the reproduction of his features guarantees their veracity. It was not without reason that he called himself a "realist," and an analysis of the folds, the furrows, the pouts, enables us to follow stage by stage how he stood up to the

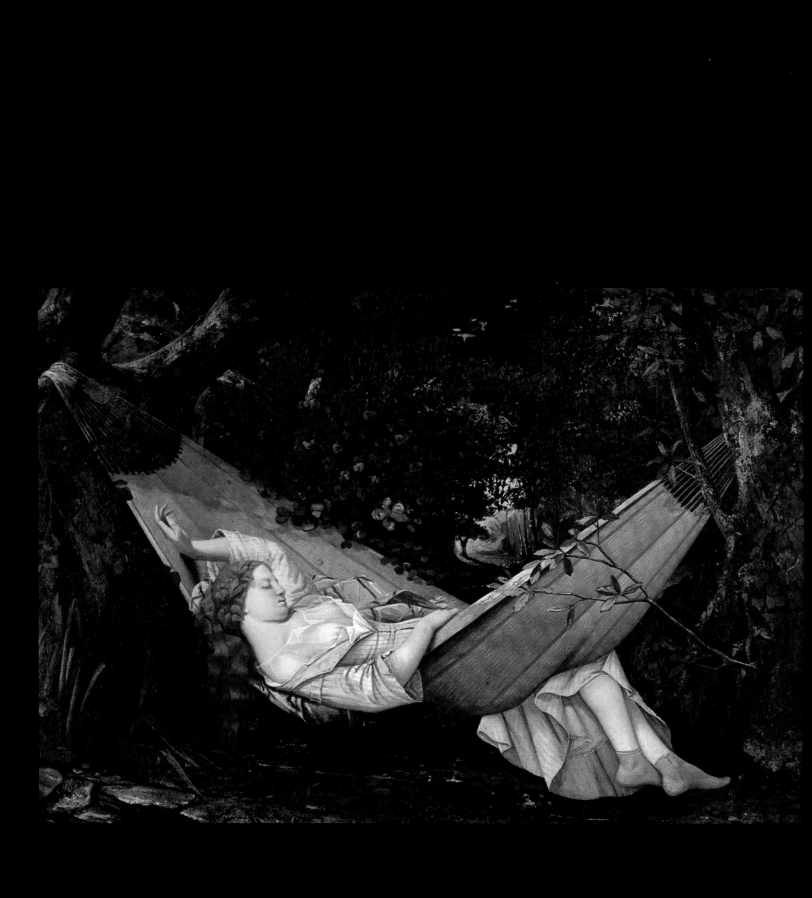

The Hammock, 1844
(Collection Oskar Reinhardt, Winterthur)

Self-Portrait, 1846 (detail; cf. page xi)
(Musée de Besançon)

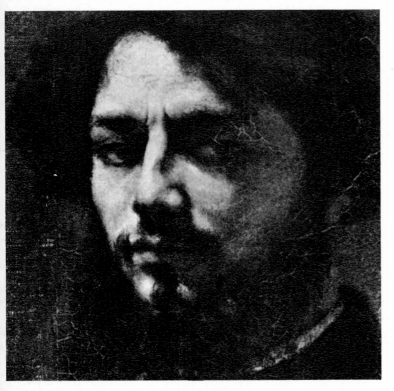

trials he underwent, how he faced both failure and success.

The year 1844 clearly marks a growing self-awareness. We can see this from Courbet's need to scrutinize his face in order to assert himself, and also to question himself, to know who he is, what he can do, what he will do. For, although until then he had done nothing but paint, he had never had an opportunity to show his work in public. It was important for him to exhibit in order to obtain official confirmation of his status as a painter, to prove that he was right to persevere in his vocation, to justify himself in the eyes of his parents so that he could continue to enjoy their assistance.

From 1844 to 1848 Courbet's life was concentrated on the difficult task of getting into the Salon. It is impossible to imagine today the importance which the Salon then had in France. It was the one and only opportunity for an artist to exhibit in public. At that time there were neither galleries nor art dealers in their present form, but naturally art lovers visited artists in their studios and bought from them directly.

The Salon's prestige was heightened by the fact that it was held in the Louvre under the highest official patronage, that of the King himself, and because the selection — and, alas, this was a difficult obstacle to overcome — was the privilege of the very conservative Académie des Beaux-Arts. Outside the Salon there was no salvation, that is to say no contact with the art-loving public, no official commissions; in short, it was impossible for an artist to live by his art. Therefore we can understand Courbet's stubborn desire to penetrate this citadel, either through patronage or by exhibiting an old work already out of date in his own eyes. Knowing his pride, we can understand what a humiliation it was for him to have to submit the works of which he was proudest to the hasty and biased judgment of elderly academicians whom he despised.

But this narrow door must open for him the way to fame and fortune. Hence we can understand his

21

joy when in 1844 his *Self-Portrait with the Black Dog* was accepted. "I have at last been accepted for the Exhibition [March 1844]," he wrote, "which gives me the greatest pleasure. It is not the picture which I most wanted to be accepted; but that doesn't matter; it is all I ask for, since the picture they rejected wasn't finished. I didn't have time because I started too late. They have done me the honor of giving me a very fine position in the Exhibition."

The following year, 1845, Courbet was ready. In the summer, at Ornans, he painted the portrait of his grandfather, Jean-Antoine Oudot, and a large composition, *St. Nicholas Reviving the Children,* for the Eglise des Saules. This is the only religious painting by Courbet extant, and if we are to believe the testimony of his sister Juliette, he produced only two. He sent five pictures to the Salon. "The first is a young girl's dream [this no doubt was the *Lovers in the Country, or The Sentiment of Youth,* in which he painted himself with his model and current mistress, known to some as Justine and to others as Joséphine]; the second is a guitarrero; the third represents draughts players [disappeared, so far as is known]; the fourth is a life-size portrait of a man [?]; and the fifth a portrait of Juliette, which I have entitled as a joke *La Baronne de M****. The frames cost me a lot of money, but that can't be helped." Of all these pictures the jury accepted only the dull and romantic *Guitarrero,* a self-portrait of the painter disguised as a troubadour, his cape thrown over his shoulder, in high red boots, seated on a rock plucking the strings of a guitar, wearing a nostalgic expression — just the kind of thing to illustrate the literature of Louis-Philippe's reign. A potential buyer appeared, then recoiled from the price asked: 500 francs.

Of the eight works submitted for the Salon of 1846 the jury of the Institute accepted only one, *Portrait of M. M***,* which Courbet called a self-portrait but which no one has been able to identify with certainty.

In 1847 his three submissions were rejected. From the catalog of his retrospective exhibition in 1867 we can see that these were the portrait of his friend Urbain Cuenot, the *Man with a Pipe* and *The Cellist.*

Faced with what he considered an affront, Courbet became furious and inveighed against the Salon and its jury of *"institutards."* Nevertheless he had attained his first objective; he had made his name slightly known, sold some landscapes and obtained commissions for a few portraits. But his financial position was still critical and he remained dissatisfied. He felt that in order to really make his mark he had to appear in the Salon with a large composition. He mentioned this often in his correspondence and even more often in conversation.

His relations with clients were a source of great indignation. His impetuous and anti-bourgeois temperament was already bursting out. As he wrote the following year: "There is nothing in the world harder than to practice art, especially when no one understands it. Women want portraits in which they have no wrinkles; men want to be dressed in their Sunday best; there is no way of getting out of it. Rather than earn money with such things it would be better to be a wheelwright; at least one would not have to renounce one's ideas."

But the clients' demands were not the only thing; there was also their habit of haggling about the price. He was promised two hundred francs and then offered one hundred. A letter on the subject of price to Alfred Tattet, de Musset's friend who had just retired to Fontainebleau, not only tells us something about Courbet but also shows us that the position of the young artist has scarcely changed in a century. "For the kind of portrait which you also want, M. Grongin pays me 800; he is giving me 400 silver francs plus a magnificent gun... I have just painted the portrait of M. Saurier, a lawyer of Bourges — he paid me 1,000. I shall paint the portrait you want for 500 or 600. I am leaving this evening for the Isle-Adam to hunt."[1]

[1] Quoted by Charles Léger in *Courbet et son temps,* p. 21.

How much truth was there in all this? Did Courbet really have as many commissions as he claims and at the prices he quotes? Whatever the result of this transaction, he accepted because he needed money and was still living rather monastically.

His correspondence with Tattet reveals another interesting fact in referring to a landscape representing the Vallée de Franchard. Courbet went there to visit his patron at Fontainebleau. At this date, therefore, if he had happened to take a detour, he could have made contact with Théodore Rousseau, Charles Daubigny and the painters of the Barbizon school, whom he got to know later and whose style has analogies with his own.

Another mystery, chronological this time, is the date of a marvelous picture, pure Courbet ahead of time, *The Hammock* (in the Oskar Reinhardt Collection). All the experts have dated it 1844, but it is so mature as to suggest that it was contemporary with *Les Demoiselles des bords de la Seine.* In any case, after the painter's death, a certain Pastor Dulon found at Courbet's last home, La Tour de Peilz, seven youthful works, including a study for *The Hammock,* more romantic, less realist, but bolder, and apparently dating from 1839. Courbet, it seems, like several exceptional artists, was in possession of certain of his major themes since his youth. No doubt he did not develop them at once because he thought they would not gain him the success which he desired at that time and which he so urgently needed in order to continue his work.

His wish to see and to know got the better of his desire to exhibit at the Salon a vast canvas comparable to such monumental works of Delacroix's as *The Capture of Constantinople by the Crusaders.* For about this time Courbet had had a visit from a Dutch connoisseur of his hown age. H. J. Van Wisselingh,[2] half art dealer, half collector, bought two pictures, commissioned his portrait, and invited him to Holland. Courbet left to see the Rembrandts.

"I am already enchanted by everything I have seen in Holland, and it is really indispensable for an artist. A journey like this teaches you more than three years of work. At The Hague, which is a charming town, I saw the most beautiful collections. It is the King's place of residence. I don't know yet when I shall leave, because I could very well do a portrait here. I am assured that if I stayed two or three months, long enough to become known, I should earn money. My kind of painting appeals to them."

After The Hague, Courbet visited Amsterdam and the Rijksmuseum, where he went into ecstasies in front of *The Night Watch* and Frans Hals' portraits. Moreover, it was at Van Wisselingh's that the painter Hendrik Willem Mesdag discovered Courbet, several of whose works are still displayed in the Mesdag Museum in The Hague.

Courbet brought back from this trip an increased admiration for Flemish and Dutch painting. It was not until the beginning of September that he returned for his annual rest at Ornans.

[2] The same individual is called Visluiyt by Georges Riat, but we must trust Charles Léger, who found Wisselingh's portrait in his sister's house in Holland.

Self-Portrait with the Black Dog, 1842
(Musée du Petit-Palais, Paris)

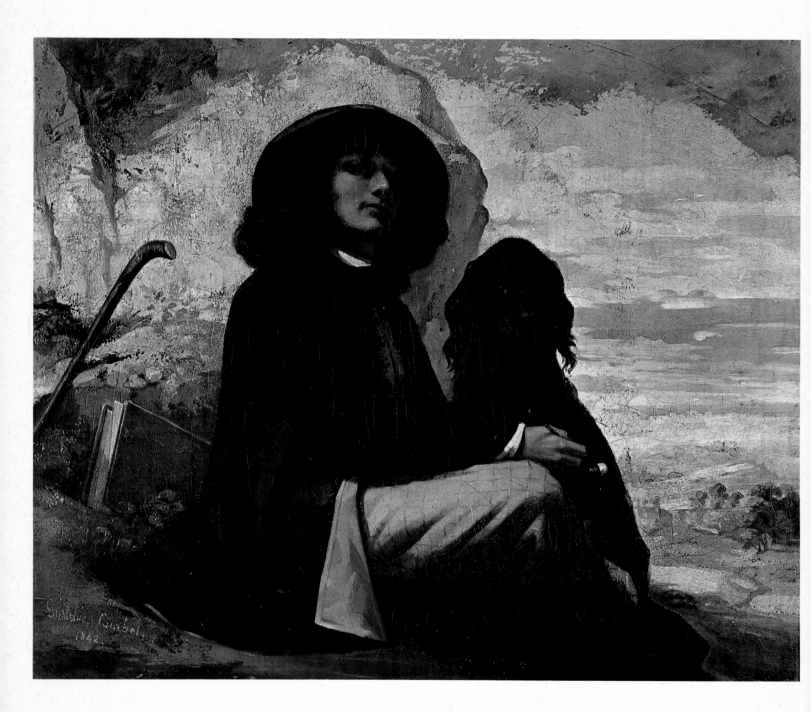

Chapter 3

BAUDELAIRE
AND THE REVOLUTION OF 1848

This man, totally independent, coming from the mountains of the Doubs and the Jura, a Republican by birth through his maternal grandfather, continued the revolutionary idea received from his father, a sentimental liberal of the 1830 type, and his mother, a Rationalist and Catholic Republican. He forgot the ideas and teachings of his youth to follow, in 1840, the Socialists of all sects. On his arrival in Paris he was a Fourierist. He followed the pupils of Cobet and Pierre Leroux. At the same time as his painting, he continued his philosophical studies. He studied the French and German philosophers and for ten years, until 1848, took an active part in the Revolution along with the editors of La Réforme *and* Le National. *Then his pacifist ideas revolted at the reactionary acts of the 1830 liberals, the Jacobins and the restorers of history devoid of genius.*
Gustave Courbet, Ibid.

The Brasserie Andler, 28 rue Hautefeuille, in the Latin Quarter was run by Alsatians and frequented by Bavarians, but also by artists and writers. Courbet came to live at number 32 in the same street. Even when he had been in the rue de la Harpe, the Brasserie had been only a few steps from his door; the Boulevard Saint-Michel, which now separates the two streets, was not to be constructed until 1855. At that time its predecessor, called the Boulevard Sébastopol rive-gauche, ran only as far as the rue de Médicis. As for the Boulevard Saint-Germain, this was not cut until 1866, on the initiative of Baron Haussmann, not only to assist the traffic but also to enable the troops to maneuver more easily in case of insurrection.

At the Brasserie Andler, Courbet used to meet artists and writers — Corot, Decamps, Daumier, Nanteuil, Chenavard, Barye, Jules Vallès, Théophile Silvestre, Castagnary, and his old friend, the poet Max Buchon.

Meetings of artists and exchanges of views provide food for gossip but also give rise to important decisions. A group that included Delacroix, Théodore Rousseau and Decamps met at the studio of the sculptor Barye to plan the creation of an independent Salon as a protest against the attitude of the official Salon. But this was in 1847. The events of 1848 caused this project to be forgotten.

Was it at the Brasserie Andler that Courbet first met Baudelaire? Relations between the champion of Realism and the poet of the *Paradis artificiels* remain obscure. No one knows how they met nor how they came to be friends. For there was a friendship between them for a time. Was Courbet attracted by the critic who had not mentioned his submissions to the Salon of 1845 and of 1846? Was Baudelaire capable of feeling something for this robust, coarse painter with such a strange accent and peasant manners? Or did he simply take advantage of the disinterested hospitality offered to him by Courbet? No one will ever know; Baudelaire never let people know what he thought of them.

France in 1848, in one of its typical convulsions, swept away the monarchy of Louis-Philippe and installed

its Second Republic. Courbet, thanks to Max Buchon, had already been won over to the ideas of Victor Considérant (the social reformer and follower of Charles Fourier), and of Pierre-Joseph Proudhon, but paradoxically, he adopted an attitude of prudent restraint. Baudelaire, however, whose written and confirmed opinions had always been asocial — not to say antisocial — took what we today would call a radical position. This writer, whose views would nowadays make him an odious reactionary, became editor in chief of a revolutionary news-sheet, *Le Salut public.* True, this lasted for only two issues — the short time it took for the revolutionaries to be dispossessed by the new government.

In *L'Exemple de Courbet,* one of the too rare recent works on the painter that is neither a systematic apology nor a rapid survey of his work, Louis Aragon has taken the trouble to show Baudelaire's true ideas as they emerge from his various writings, and it will not be without value to recall the most striking points.

In *Mon coeur mis à nu:*

"My intoxication in 1848.

What was the nature of this intoxication? A taste for vengeance. A natural pleasure in destruction. A literary intoxication: the memory of things I had read...

The horrors of June. Madness of the people and madness of the bourgeoisie. A natural love of crime...

1848 was amusing only because everyone built Utopias like castles in the air.

1848 was charming only through its very excess of the ridiculous.

Robespierre is estimable only because he coined a few fine phrases...

There is no rational and secure government except aristocracy. Monarchy and republic based on democracy are equally absurd and weak."

In his *Salon de 1846* Baudelaire went further still:

"Have you ever felt the same joy as myself upon seeing a guardian of the public repose — a constable, the true army — beating a Republican with the butt of his musket? And have you, like me, said in your heart: Hit him, hit him harder, go on hitting him, policeman of my heart?"

This is the poet to whom Courbet was to extend hospitality. Baudelaire wrote little or nothing about this friend during Courbet's years of poverty. In his account of the Universal Exhibition of 1855 he devoted a few lines to him — in the chapter on Ingres! In his *Salon de 1859,* without ever mentioning his name, Baudelaire expounded at length against Realism and all Courbet's ideas.

In his *Souvenirs intimes,* Gros-Kost recalls the relationship between the two men. But Gros-Kost's memoirs were not written until 1880, thirty-two years after the facts which they recount, and they are marred by a regrettable confusion of dates. Gros-Kost is amused by Courbet's sayings, which clearly demonstrate the antinomy of ideas and temperament between the poet and the painter. Gros-Kost quotes Courbet:

"To write verses is dishonest. To talk differently from everyone else is to pose as an aristocrat.

In one corner there was a pile of rags. We put two sheets over it: the bed was improvised. Henceforth the poet had a home...

While one painted, the other rhymed."

Courbet reproached Baudelaire for his misuse of drugs, but it seems that he was quite willing to note down the words that the poet uttered in his sleep or his delirium. He seized the opportunity to paint the famous portrait which he used in his large composition, *The Atelier,* in 1855. Neither of them was very satisfied with it. "It's impossible to catch him," complained Courbet. "He is different at every moment."

It seems that neither the revolt of February nor the bloody days of June distracted Courbet from his work. At twenty-nine he was totally absorbed by the work to be done and the position to be conquered: in a word, by success. While Baudelaire was marching through the streets shouting — for reasons more personal than political — "Death to General Aupick!" (Aupick was his mother's second husband), Courbet was painting. He did not attempt to give the young Republic a new face, like his friend from the Brasserie Andler, Honoré

26

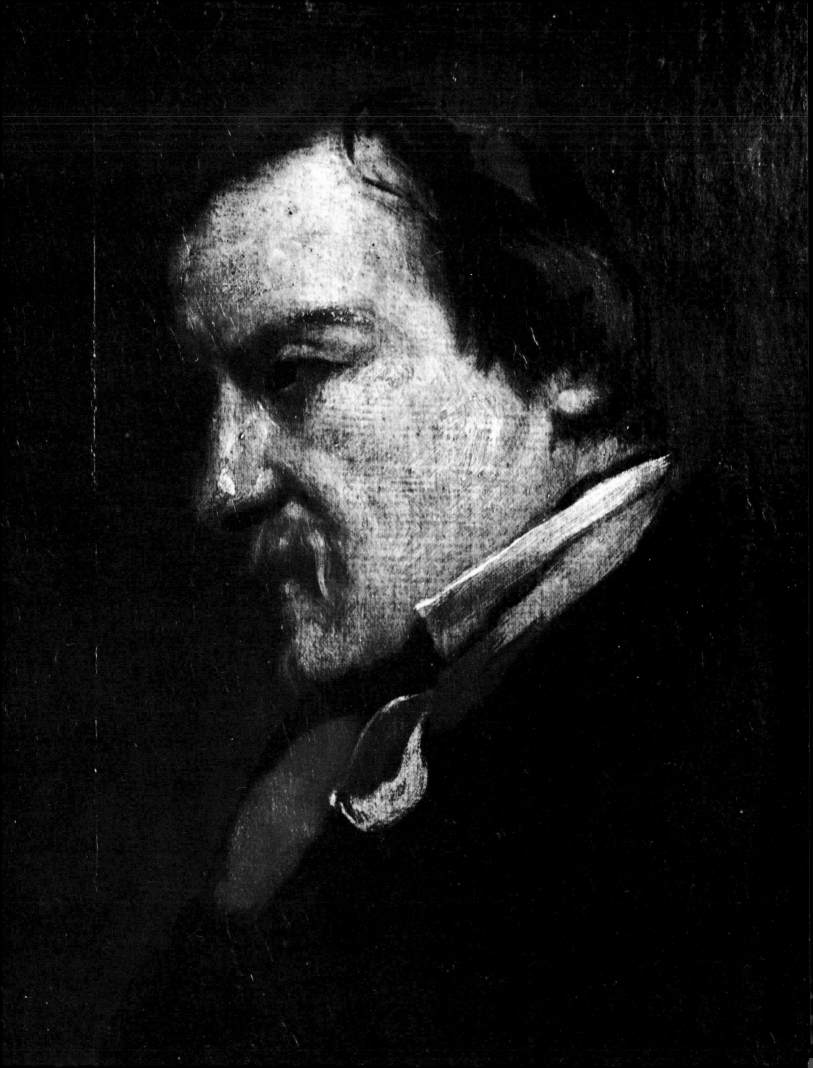

Daumier. Courbet wrote of him: "Daumier saluted the first year of the new era with a painting."

The government had decreed a public competition at the Ecole des Beaux-Arts for a figure symbolic of the Republic. But what an exhibition resulted! There were pink, green, yellow Republics; Republics surrounded by the attributes of 1789: broken chains, the egalitarian triangle, fasces, tables of the law; Republics in silk dresses, in housecoats, in the uniform of the National Guard. The artists naïvely believed that the word "competition" sufficed for everything, creating talent, inspiring enthusiasm. As soon as the announcement appeared in the *Moniteur* decreeing that a symbolic figure would be chosen from among the entries, the painters set to work.

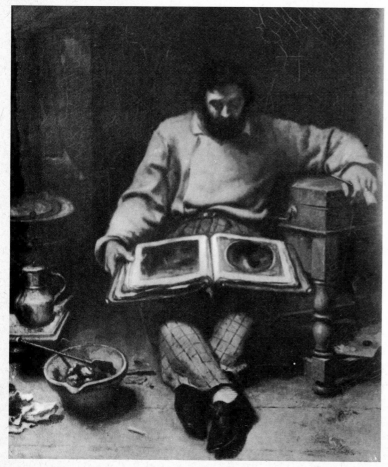

"Come on, undo your dress," they said to the first girl to come along, "brandish a pike, push the red bonnet over one ear."

In the midst of this ludicrous competition, who could notice Daumier's simple, serious canvas? A seated woman carries two babies hanging at her breasts. At her feet other children are reading. The picture bears the motto: *La République nourrit ses enfants et les instruit (The Republic feeds its children and teaches them —* Champfleury).

Courbet wrote to his parents: "I did not enter the competition for the picture of the Republic destined to replace the portrait of Louis-Philippe, but to make up for it I shall take part in the competition for musicians to compose a popular song." (April 17, 1848) For some time Courbet had been in the habit of singing the songs of his region, altering the words and transforming the tunes to express his own feelings. With his thunderous voice he enjoyed a great success among his friends and, thanks to a vast repertoire of folk songs, he attracted attention in the brasseries. From this to believing that he possessed talent as a composer was only a short step, which his blind self-confidence allowed him to take — until the day when this claim led to a lasting quarrel with Hector Berlioz.

Courbet did not remain untouched by events. After the intervention of General Cavaignac's troops ended the insurrection of June 1848, he said: "It was the most heart-rending spectacle imaginable. I don't think anything like it has ever happened in France, not even the Massacre of St. Bartholomew."

Thus Courbet had been present, had seen, but he had not intervened. He explains why: "I do not fight for two reasons. First, because I have no faith in war with the gun and the cannon and because this is not in keeping with my principles. For two years I have been fighting the war of intelligence. I should not be consistent with myself if I acted otherwise. The second reason is that I have no weapons and cannot be tempted."

Courbet's only concrete participation in events was his design for the frontispiece for the second issue of

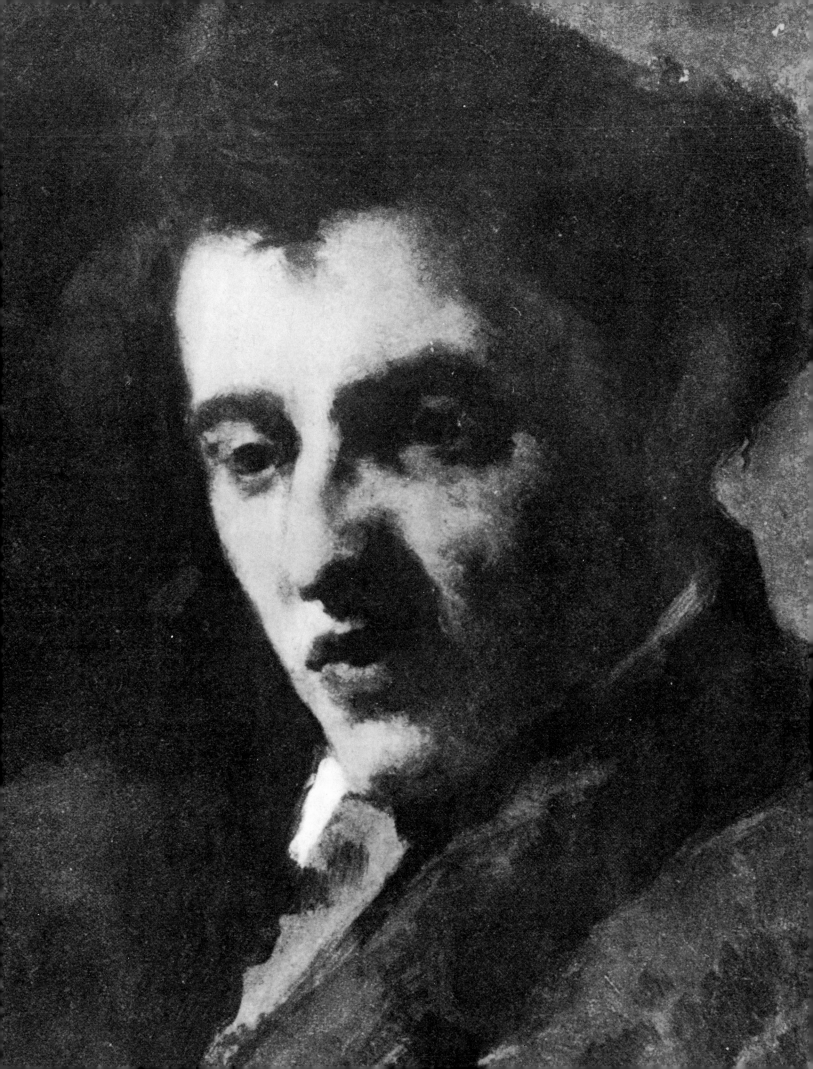

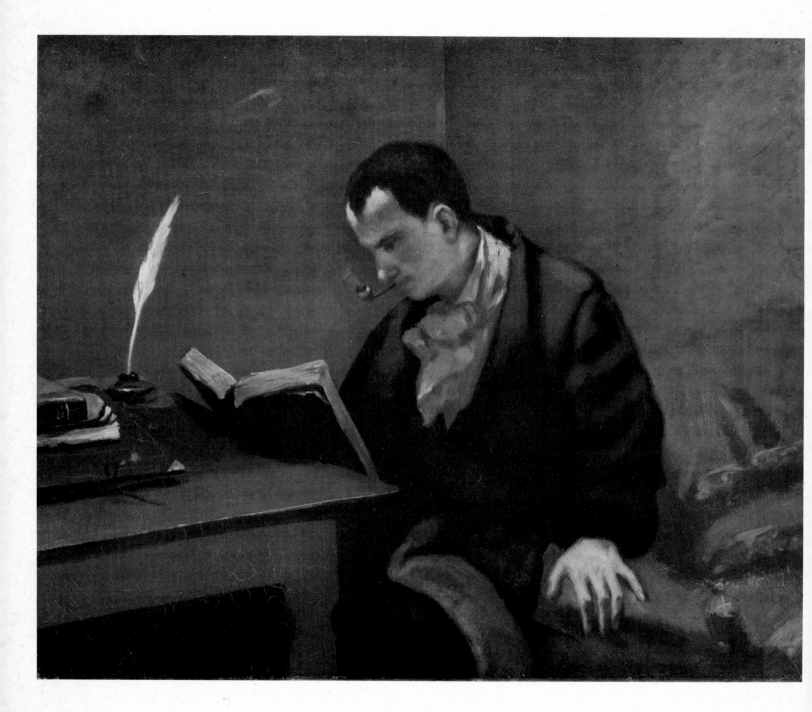

Salut Public, the revolutionary news-sheet put out by Baudelaire. The print executed by the engraver Fauchery is an interpretation if not a falsification of Courbet's design. Behind the central figure — an insurgent brandishing a gun and a flag — the crowd which Courbet's design merely indicated as a mass takes on an individualized aspect; and, above all, the flag is decorated with an inscription that does not bespeak Courbet: *"Voix de Dieu, voix du peuple"* *(Voice of God, voice of the people)*. For if his socialism is a form of sentimental idealism, neither God nor religion ever had any place in his ideas. He occasionally painted priests (see his *Return from the Conference*), but it was in response to a genuine anticlericalism inherited from his Jacobin grandfather and never abandoned.

From these heroic years Courbet retained friendships that were precious to him for the support and ideas they brought him. Through his former fellow student from the seminary, Max Buchon, he was in touch with philosophers, theoreticians, and agitators: Marc Trapoux, who was to become a character in *La Vie Bohème* and whom Courbet painted leafing through ... of prints; Jean Journet, a pharmacist from ... former Carbonaro, whom Courbet portrayed ... *Setting Out to Conquer Harmony*) and wi... ...d in a psychiatric institution for distribu... ...he Opéra; and finally Proudhon, the author of works, among others in 1840 *What is Pr...* ...r: it is theft) and a *Philosophy of Poverty*, w... ...n by the name of Karl Marx reduced to its tru... ...s by publishing in French in Paris in 1847y entitled *The Poverty of Philosophy*.

Here we touch upon the weaknesses of Courbet's ideas. If he had read Marx he would have realized that Proudhon, by entrenching himself behind his position as a man of science, failed to master the capital-labor or bourgeois-proletarian conflict, that he could not avoid this conflict because he wished to reconcile the unreconcilable and could not make up his mind to sacrifice one side or the other. It was probably Proudhon's influence that led Courbet to condemn the workers' coalitions and the recourse to violence, and to adopt the attitude of withdrawal from active participation in the events of 1848.

Jules Husson, the young writer called "Champfleury," two years Courbet's elder, supported him by his writings and his friendship. Champfleury introduced him to Francis Wey, a publicist from the Franche-Comté, who in his turn was to aid Courbet. Francis Wey is the father in the serial novel *Les Enfants du Marquis de Ganges* that appeared in *La Presse* during 1838.

The Salon of 1848 assumed a special character. Without a jury, it finally opened its doors to all the victims of the members of the Institut. It was an "open" salon. Courbet sent in everything he wanted: his self-portrait as a cellist, the *Young Woman Sleeping,* three landscapes, four drawings, and the *Portrait of Urbain Cuenot*. But open exhibitions are not always better than others. To make room for the work of all the exhibitors the pictures were hung right up to the ceiling. Courbet complained that his were horribly badly placed. His canvases passed almost unnoticed and he sold nothing!

This meant that the arrival of Francis Wey was particularly providential. In the rue de Seine, Champfleury spoke to Wey of "an immensely gifted young painter who deserves a visit. He is still absolutely unknown and like you a native of the Franche-Comté." He added that this artist had taught himself all he knew and that he had no support and no contacts.

"When we reached our destination," writes Wey, "a tall young man with pride in his eyes, but very thin, pale, yellow, bony, ungainly [Courbet was like this in those days], left his work to meet us and greeted me with a nod without uttering a word." Wey saw the canvas on which Courbet was working and was astounded:

" 'With such a rare and marvelous talent, how is it that you are not yet famous? No one has ever painted like that.' 'You're right,' he replied with a strong Franche-Comté accent, 'I paint like the Good Lord.' "

Wey adds: "This young man appeared to me very strange; at times he seemed to be in revolt against the majority of theories and imbued with a voluntary ignorance that was intended to create an effect. In what studio had he studied? 'In none,' he said. 'I know what I want and I look for it. I am too independent to have submitted to masters like a slave! We shall have to put a stop to all that!' "

Without intending to change the course of art history, Wey played a modest but effective part in Courbet's career. In the summer of 1849 he invited Courbet to his property in Louveciennes, where the artist painted some landscapes of Marly and Bougival; Wey bought a few canvases from him, commissioned a portrait of his wife and then of himself. Finally, it was through him that Courbet got to know Berlioz, persuaded him to sit for a portrait and would have sold it to him if the conversation had not wandered to music. The musician was so amazed by the painter's remarks that he decided he was mad and refused ever to see him again.

By one of those effects of temporal compression which memory alone permits, Francis Wey juxtaposes the reflections of Delacroix and Ingres confronted by *After Dinner at Ornans*. Delacroix: "Have you ever seen anything like it, anything so strong that is not derived from anyone? This man is an innovator, a revolutionary even. He has emerged all of a sudden without any precedent. He is quite unknown." Ingres: "How nature ruins her own finest creations! She has bestowed upon this young man the rarest gfts. Born with qualities that others so rarely acquire, he has them fully-fledged at his first brushstroke. With a kind of bravado he employs masterly workmanship on the most difficult points — the rest, that which constitutes art, is absolutely lacking. He has given nothing of himself and he has received so much. What values lost! What gifts sacrificed! It is both astonishing and heart-breaking. Nothing in the way of composition, nothing in the way of drawing. Exaggeration, almost a parody! That lad is an eye; he sees — with a perception quite peculiar to himself, in a harmony whose

tonality is a convention — realities so homogeneous among themselves that he improvises a reality more energetic in appearance than the truth; what he offers of artistry is of absolutely no value. This revolutionary will be a dangerous example!"

The contrast between the opinions of Delacroix and Ingres before Courbet's first important work reveals the painter's position at the outset of his career and indicates the enemies who await him. Delacroix defended him because Courbet, in his very realism, continues the revolution begun by the Romantics. Ingres, as a defender of Classicism, scents the foe, the artist who is going to try to transform painting and who will succeed.

From 1849 on, in fact, Courbet produced a continuous series of large compositions that make up a major part of his total *oeuvre*. Public events seem to pale into insignificance before the colossal labor of the painter from Ornans. The moment has finally come when the young bourgeois from Ornans, who arrived in Paris filled with ambition, becomes the frenziedly hard-working painter who realizes that it is through painting alone that he will make his mark.

Chapter 4

THE LARGE COMPOSITIONS
AND LIFE AT ORNANS
1849-53

In 1848 he had eleven pictures in the Exposition libre; *in 1849 the Republicans gave him a medal to protect him from rejections and from the simple-minded governors of art in France. In 1851 he exhibited* The Burial at Ornans, The Stone Breakers, The Peasants of Flagey, *and the portrait,* The Man with a Pipe, *which was a resounding statement of his revolutionary principles regarding a purely human painting.*
Gustave Courbet, Ibid.

In the winter of 1849-50 Gustave Courbet entered an intensely productive period, and until 1866 his painting developed with a vigor and logic rare in the history of art. We might say until 1870; but though he continued to paint a considerable number of canvases during the last years of the Second Empire, large compositions became the exception. This enormous capacity for work continued to the end of his life. After the events of 1871 he still produced a great deal, but there had been a deep psychological rupture; there is still an abundance of excellent paintings, but there are no longer ambitious works comparable to those which marked the years 1850-66, nor any of those bold and sometimes disconcerting compositions which made him the great Realist of the nineteenth century.

Courbet's work can be divided into periods only very arbitrarily and by imposing upon it esthetic preconceptions; in fact, his style evolved progressively. Nevertheless — in spite of the criticism such a division inevitably arouses — we are constrained to adopt it for two reasons: because it is the only way of drawing attention to the diversity of a body of work so exceptionally homogeneous, and because it is the only possible line of approach to rational analysis.

It might seem more judicious to divide this monumental and complex *oeuvre* into subjects rather than periods. But, alas, Courbet proves just as resistant to this kind of classification today as he did in 1866. He is a painter who dealt with all subjects, not successively, but throughout all the periods of his life.

The *self-portraits* are spread over forty years of painting and mark out stages of psychological as well as esthetic interest.

In those same years Courbet was a *portraitist* with extremely rapid reflexes which enabled him to capture the features of all his subjects.

Throughout his career he was a passionate painter of *landscapes* and *seascapes,* poetic in his realism, who found subject matter in every place he visited: in the gentle greenery and harsh rocks of his native countryside as in the waves of Palavas and Deauville-Trouville, in the panoramas of Saintonge, on the banks of the

The Young Ladies from the Village, 1851
(Temple Newsam House, Leeds)

Seine around Louveciennes, and on the shores of Lake Léman (Lake Geneva), his home in exile in his last years.

Courbet was extremely fond of firm, fresh flesh. His "great" *nudes* fall chiefly between 1860 and 1866, but he painted them at all periods, starting with the study for *The Hammock,* which is probably earlier than 1840, and, most important, the *Baigneuses* in the Montpellier Museum, which goes back to the beginning of 1853.

The *hunt scenes,* which are not merely studies of undergrowth but compositions in which the animals take prominence even when man is present, also cover a long period whose high points lie between 1855 and 1868. But their origins go back not only to his friendships with the hunters of his own region, but also to his trip to Germany — not the trip to Munich in 1851 but the one in 1852 to Frankfurt where he received a warm welcome and where he returned during the winter of 1858-59. With this hunting sequence Courbet embarked on a genre that was rarely practiced in France. Perhaps he would never have ventured into it without the encouragement he received beyond the Rhine.

Each of these subjects, which constitute the various facets of his work, will be dealt with according to the date that marks its peak. The final chapters will be devoted to his actual role, and to the role attributed to him, during the Commune (which never prevented him from painting), and to his last days in exile at La Tour de Peilz on the banks of Lake Léman, and to his numerous late works, the majority of which have remained in Swiss collections.

We shall now touch upon an essential aspect of Courbet's work and life, the series of large compositions which made him "the Champion of Realism" on the occasion of the Universal Exhibition of 1855. This

The Spinner Asleep, 1853
(Musée Fabre, Montpellier)

Self-Portrait, drawing, 1852
(British Museum, London)

Sleeping Woman, ca. 1853
(Private Collection)
(page 37)

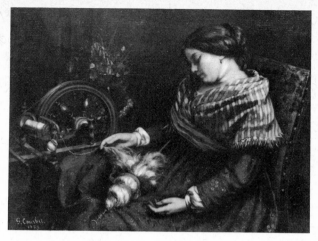

series also brought him the friendship of Alfred Bruyas, who took Courbet for a beneficent sunlight cure in his own region — Montpellier and the shores of the Mediterranean — from which the artist returned with increased self-confidence, ready to conquer Paris and the world.

Courbet's first painting which did not merely provoke reactions based on the critics' opinions, but also reached a new and wider public, was *After Dinner at Ornans*, which he exhibited at the Salon of 1849 and which gained him a second gold medal.

Conditions had changed. In 1848 the Salon *libre* was a forum open to everyone, and its egalitarianism and disorder did not serve the interests of painting. Courbet himself complained about it. In 1849 the Director of the Beaux-Arts, Charles Blanc, obtained the minister Léon Faucher's agreement to carry out a reorganization which was to prove ephemeral but which, for the time being, filled certain gaps and corrected numerous injustices. The selection committee was formed of artists elected by the exhibitors. The jury charged with deciding awards was less democratic; it was composed half of elected artists and half of persons designated by the Government.

Among the exhibitors whose names have come down to us are Delacroix, with *Les Femmes d'Alger* and other works, Corot, Millet, and Constant Troyon. Ingres is said to have refused to exhibit, as did Amaury-Duval, Ary Scheffer and Eugène Isabey. For the first time the Salon was held in the Tuileries. The pictures were hung on wooden and canvas panels set up in front of the national collections. The lighting was unreliable and, in any case, inadequate.

Together with Théodore Rousseau, Courbet won a second gold medal, and *After Dinner at Ornans* was bought for fifteen hundred francs by the State for the Musée du Luxembourg, then sent to the Musée de Lille (where it remains). Courbet was pleased, although he would have preferred to have his work remain in Paris. His entries also included *The Courbet Sisters at Flagey, Wine-Harvest at Ornans, The Valley of the Loue, View of the Château de Saint-Denis*, the

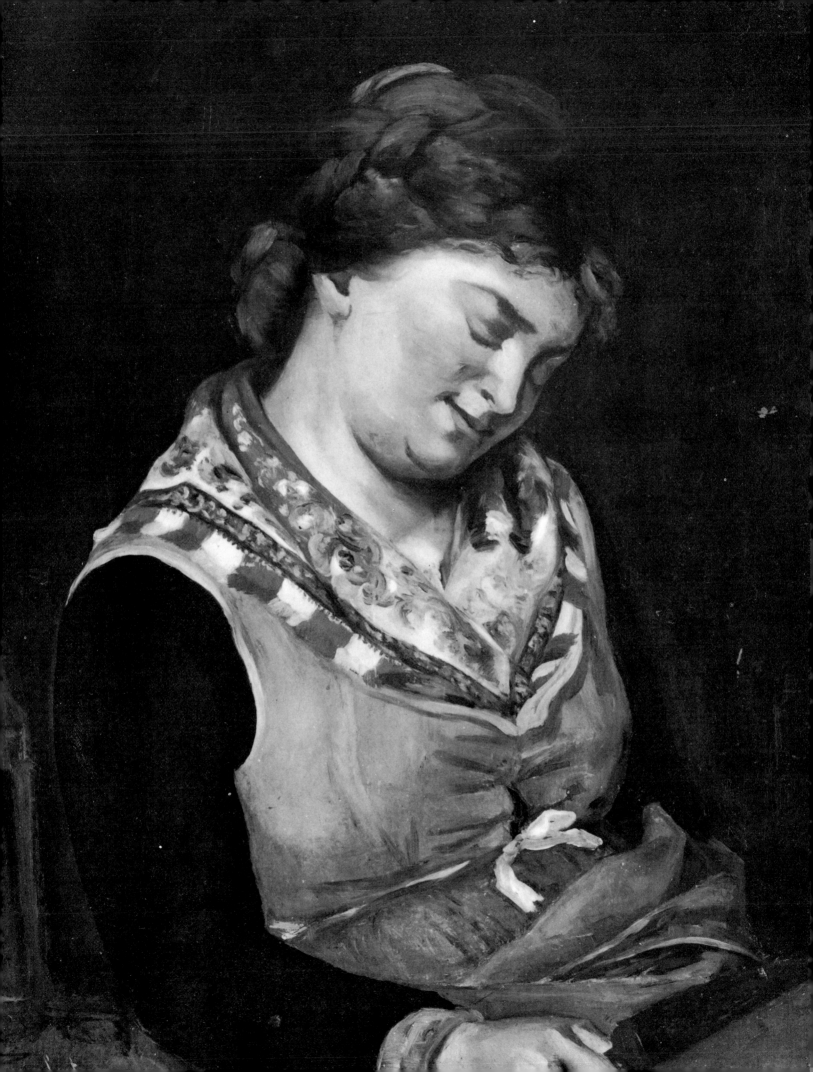

After Dinner at Ornans, 1849
(Musée de Lille)

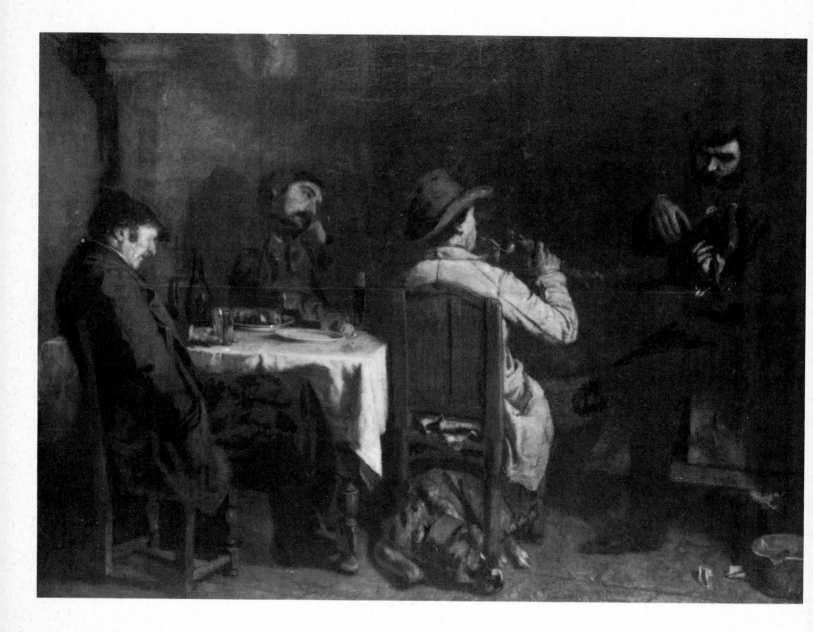

portrait of *Trapadoux Examining a Book of Prints*, and *The Man with a Leather Belt*, subtitled "A Study after the Venetians" and one of the finest of his youthful self-portraits.

Treated in the same style as *The Man with a Leather Belt, After Dinner at Ornans* marks a decisive stage in the affirmation of Courbet's personality, not only by its subject, but also by the particular outlook expressed in the composition; not only by the provocation constituted in the portrayal of peasants in the mid-nineteenth century — even under the ephemeral Second Republic — but also by the natural manner in which Courbet treated them. Here he joined the tradition of the Le Nain brothers, the Germans Holbein and Dürer, and their fifteenth — and sixteenth — century precursors. Yet he softened the shocking effect which such a scene might have had on his contemporaries — who admired mythological and historical compositions or the worldly portraits of Monsieur Ingres (whose portrait of the Baroness James de Rothschild is of the same period, 1848!) — by treating colors and lights in a manner which today we should describe as "museum tones." This chiaroscuro has become even darker with time, doubtless as a result of the mediocre materials Courbet used during those years of economy.

What, then, is this *After Dinner at Ornans* which marks the birth of the "champion of pictorial realism"? The painter's first biographers, Georges Riat, Charles Léger and, before them, the faithful Castagnary, have described the content of the picture. Four people are gathered around the table in the rustic kitchen of the house at Ornans: the father Régis Courbet is dozing on the left; Gustave himself is dreaming, his head resting on his hand; a friend, Adolphe Marlet, seen from the rear, is lighting his pipe with a brand while another friend, Promayet, is playing the violin. This painting of Courbet's life at Ornans is an excellent rustic genre scene distantly related to the Dutch masters. The drowsiness and indifference of the diners after a

good meal copiously washed down, compared with the self-absorption and industry of the musician, is not without unintentional humor.

The dimensions of the picture (76 by 100 inches) make it impressive. The figures are practically life-size. This is not chance but a resolution in which Courbet persisted, as though he were jealous of *The Night Watch* and wished to compete with Rembrandt.

A canvas of the same year, at once a figure composition and a landscape, had already shown his desire to break out of traditionally defined academic categories. The *Wine-Harvest at Ornans* presents not merely a magnificent tree and the magnificent panorama beneath the Roche du Mont, but also an episode in the work of the Jura winegrowers. The almost central composition has a natural simplicity: the light and its play are rendered with a great concern for relief; matter is rich and solid; the overall composition, supported by a distant view of rocky cliffs, has an unusually realistic depth free from trickery or *trompe-l'oeil*. Was the painter aware, at this date, of the competition of photography? By 1840 Daguerre was producing numerous daguerreotypes. But Courbet knew that the painter could always create something better, because more alive, and he proved it. Nevertheless, like Manet, who made a photograph of Bruyas before painting his portrait, Courbet was interested in photography and sometimes used it as a source of imagery for his drawings and paintings.

After Dinner at Ornans and the *Wine-Harvest* assume their full importance when we look back on the path that Courbet had traveled since his beginnings in 1839. Trained in the discipline of classical drawing (as we have seen, le Père Baud was a pupil of Baron Gros, and Flajoulot of David), his first gesture of independence was to abandon drawing and follow the example, not in the color but in the effects of light and shade, of the Dutch masters whom he admired.

From this point of view the whole series of youthful self-portraits from the *Self-Portrait with the Black Dog*

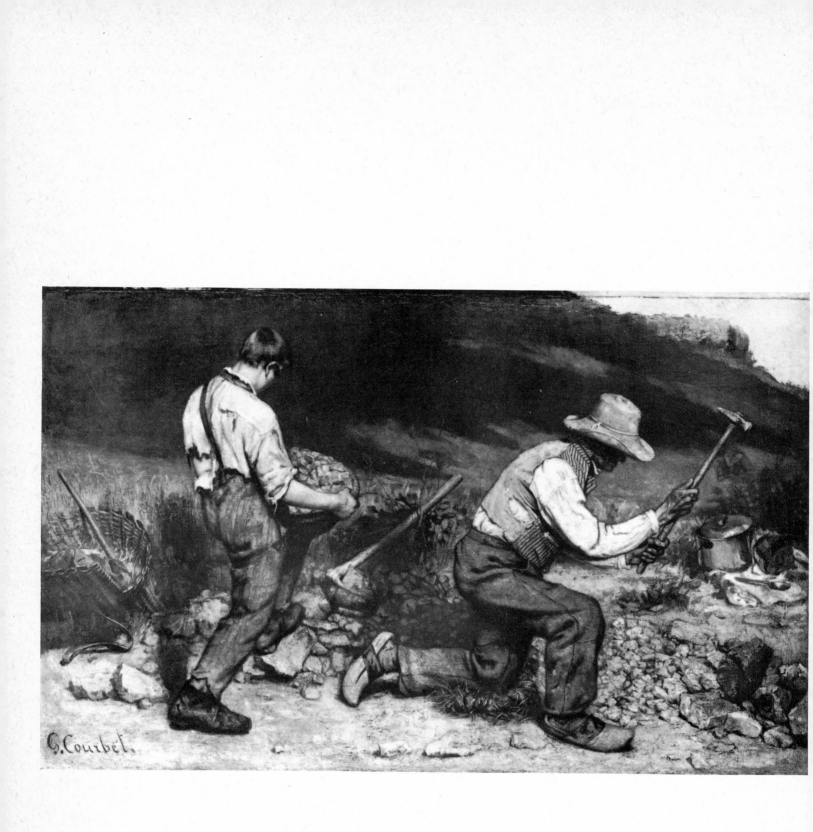

(1842) to the *Man with a Leather Belt* (ca. 1844) are all
the more significant for the fact that they do not show
any noticeable development, but merely progress in
the craft, a conquest of technical means.

The portraits of this period are perceptibly lighter
— those of Juliette and of his father Régis, for example.
It is as if Courbet reserved romantic chiaroscuro for
his self-portraits. But while the images are bathed in
atmosphere, the actual treatment is, for the period, in no
way "modern." In spite of everything, Courbet re-
mained classical in composition and timid in color.
Was this a concession to the selection committee of
the Salon, where he was burning to be admitted? Was
he still hesitating to take the final step? Whatever the
reason, the Revolution of 1848 gave him the impetus
he had been waiting for, the courage finally to be
himself.

With *After Dinner at Ornans* he inaugurated an
entirely new and personal repertoire of peasant and
rustic themes, but the treatment is still close to that
of his Dutch models. With *The Stone Breakers* Courbet
attained originality: that manner at once precise, swift
and incredibly skillful which was to be the style of his
maturity. He places his figures, he arranges the décor
and the accessories, and the canvas takes on its full
meaning in harsh and realistic lighting. The work,
whose last owner was the Dresden Gemäldegalerie, was
destroyed in an air raid in 1945.

Courbet himself related how the idea for this com-
position came to him, and his account shows that the
choice of this subject was less the result of preconceived
Socialist ideas than of a humanitarian reflex:

"I was walking to the château of Saint-Denis to paint
a landscape. Near Maisières I stopped to watch two
men breaking stones on the road. We rarely encounter
the complete expression of destitution, therefore an idea
for a painting immediately came into my mind. I made
an appointment with them for the following day in my
studio and thereafter I painted my picture. It is the
same size as the *Soirée at Ornans*."

Thus *The Stone Breakers* was less Socialist than
fortuitous. But through repetition, chance came to

acquire significance. Courbet took an interest in certain encounters only. From what the world offered him, he retained only that which in his eyes bore witness in favor of certain people — against the rest. Thus it is not surprising that paintings of a *Tinker* and *Knife-Grinders* date from the same period.

Another point to note: Courbet always painted the figures in his studio, but he was one of the first, prior to the Impressionists, to paint the landscape itself on the spot.

The ending of a letter to his friends the Francis Weys shows how conscious Courbet was of the provocation implicit in his painting:

"Yes, art must be vulgarized! For too long the painters, my contemporaries, have been producing art according to preconceptions and stereotypes."

Courbet had touched on a truth, his truth and truth as such, and it seemed that now nothing could stop him — especially since he now had, in the house of Grandfather Oudot who had just died, a new studio "of reasonable proportions; but the window was too small and badly placed; I immediately had one three times as large made; now you can see as clearly as out in the street. Furthermore I have had it painted dark yellowish green relieved by dark red; the ceiling, which is very high, is painted blue down to a quarter the height of the walls; this creates a fantastic effect, and the window-recesses are white."

Was Courbet assailed by funereal ideas in the house of his deceased Jacobin grandfather? Or did he wish to pay homage to the latter? Or was he dreaming of doing things in a big, and ever bigger way? *The Burial at Ornans* measures 10 feet 3½ inches by 21 feet 9½ inches. Was this megalomania or the desire to best Rembrandt, at least in the matter of scale? However that may be, *The Burial at Ornans* remains one of the most astounding items in the Louvre. Rarely has any picture caused the flow of so much ink, given rise to so many contradictory opinions — equally divided between foolishness and nonsense. In fact *The Burial*

at Ornans is like nothing known, except an interment in a Jura village in the nineteenth century. The man being buried is a notable, since we see none but middle-class people in the crowd assembled round the freshly dug grave; there are no peasants. Courbet wanted it this way. Models volunteered. Soon there was only one empty place on the canvas.

I cannot resist quoting Courbet himself in a letter written to his friend Champfleury while he was painting this "monument." It is the best possible description of it. "The following have already posed for me: the mayor, who weighs four hundred, the parish priest, the magistrate, the sacristan, the notary, the schoolmaster Marlet, my friends, my father, the choirboys, the grave-digger, two old revolutionaries of 1793 in clothes of the time, a dog, the dead man and his pallbearers, the beadles (one of the beadles has a nose like a cherry, but big in proportion and five inches long), my sisters as well as other women, and so on. I hoped to manage without the two parish cantors, but I wasn't able to; people came and told me they were annoyed because they were the only ones from the church I hadn't 'drawn.' They were complaining bitterly, saying they had never done me any harm and didn't deserve such an insult. One has to be mad to work under the conditions in which I find myself; I am working *blindly;* I never stop. Shall I never be settled the way I want? Well, at this moment I am on the point of finishing fifty figures, life-size, with a background of landscape and sky, on a canvas twenty feet long by ten high. It's enough to kill you; you can imagine that I have had no sleep."

From whatever angle we consider *The Burial at Ornans* it is impossible to find in it a symbol, an allegory or a hidden meaning; impossible to see in it anything but what Courbet put there — that is to say, precisely what he had seen in similar circumstances. No exaggerated or untimely manifestation of sorrow or despair (we can count only two or three handkerchiefs), only resignation, and we cannot tell whether it is inspired

The Peasants of Flagey Returning from the
Fair, 1850
(Private Collection)

The Burial at Ornans, 1849
(Musée du Louvre, Paris)
(pages 44-45)

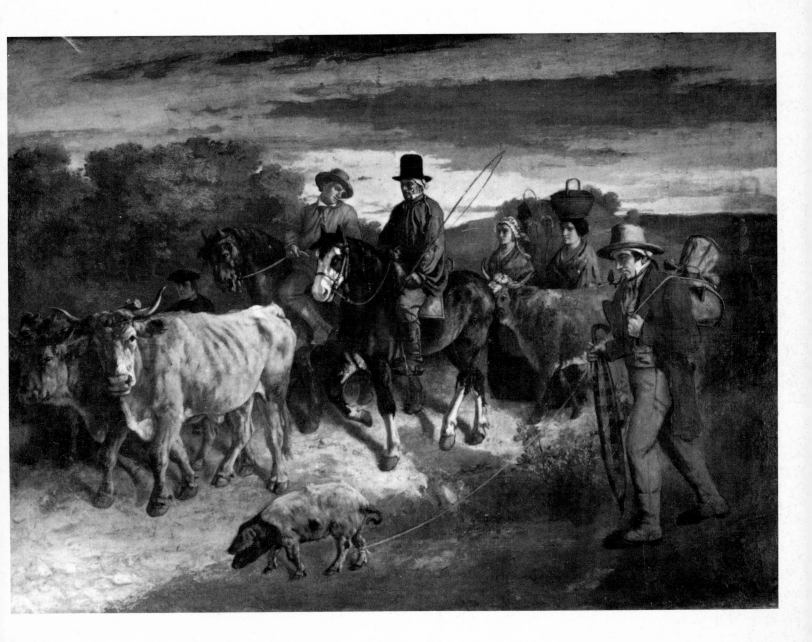

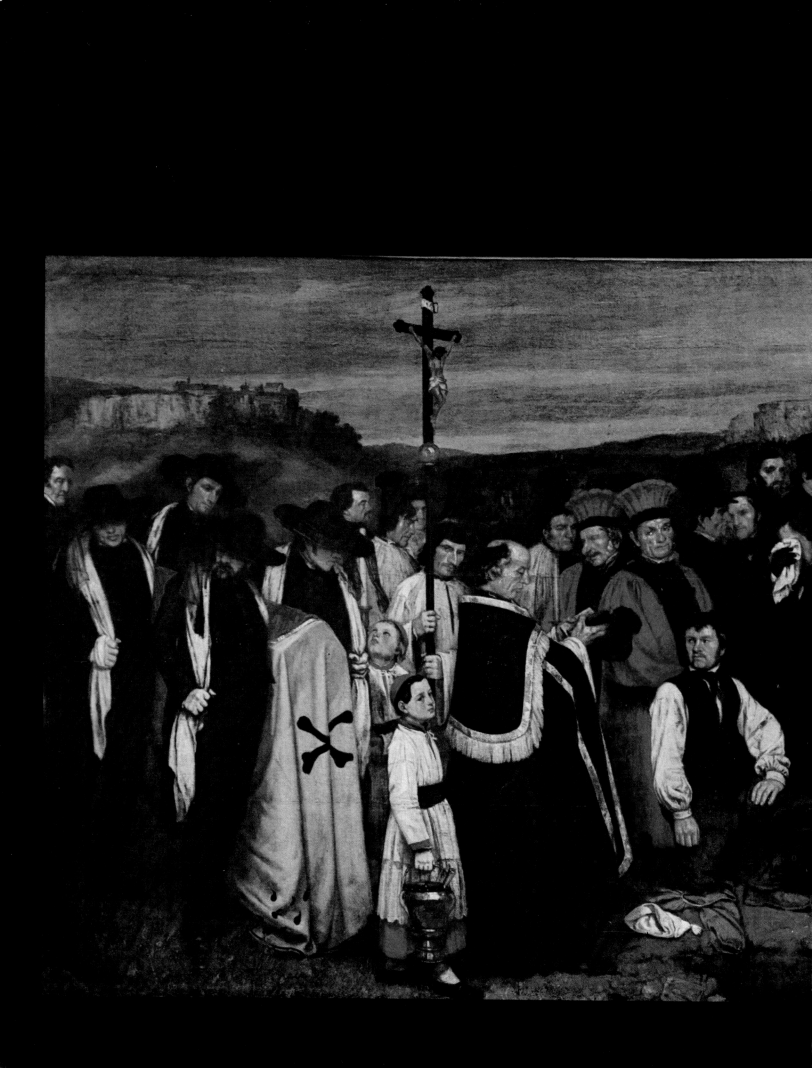

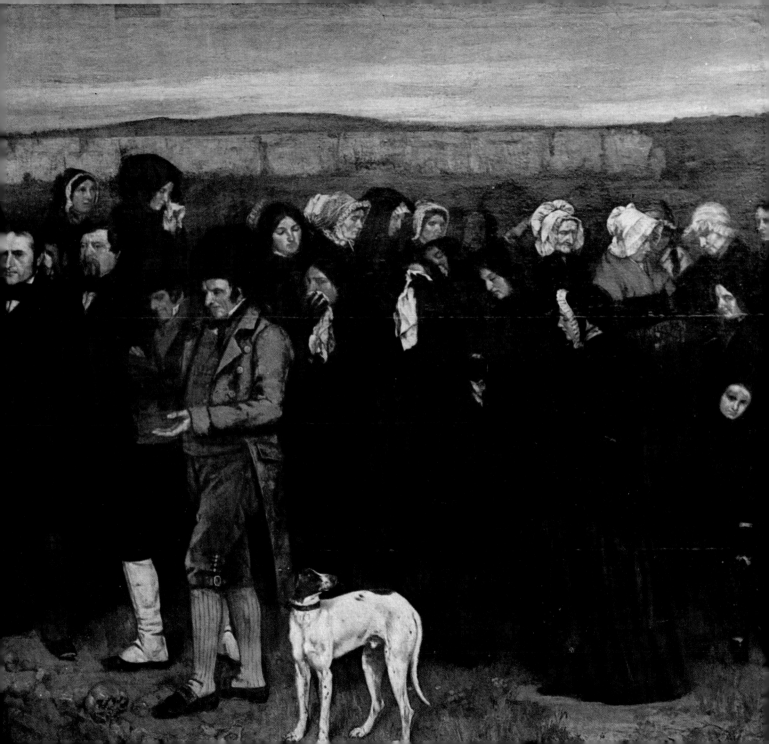

by death or by the absurdity of such ceremonies.

As to the composition, it is not chaos but a fine disorder organized not by the painter, but by traditions and habits. The people of the church stand behind the priest followed by the pallbearers, who hide the coffin from view: a diagonal runs towards the upper left-hand corner. On the left are the men, with the notables in the front row; on the right, the women. As for the dog, no one knows what it is doing in this scene and its presence is justified only by a concern for realism. Everyone is gathered in an arc around the grave. The gravedigger has a major role, but his face expresses nothing but anticipation tinged with defiance. The whole composition may be considered a fortuitous juxtaposition of a number of standing portraits. The faces express not so much emotion before death as the particular character of each person present. This is no doubt due to the fact that Courbet, who was initiating a form of pictorial reportage, was not able to catch any of his models at the actual moment of the event and was obliged to have them pose separately for him in his studio.

From the plastic point of view the whole composition — today reduced to a fine, homogeneous brown tint, despite the red robes of the magistrates — is animated only by the repetition of lights on the white sheets of those bearing the coffin, the surplices of the choirboys, the shirt of the undertaker's mute, a few handkerchiefs, and the women's caps. This creates a rather gloomy harmony in keeping with the subject. Champfleury speaks of it in curious terms, describing the picture both as "naïve" and as evocative of a "great master." "From a distance, as we enter, the *Burial* appears to be framed by a doorway; everyone is surprised by this simple painting as by the sight of those naive images cut in wood by a clumsy knife appearing at the head of the thrillers printed in rue Gît-le-Coeur. The effect is the same because the execution is equally simple. Skilled art strikes the same note as naive art. The appearance is as gripping as a picture by a great master.

The simplicity of the black costumes has something of the grandeur of the members of the *parlements* in their red robes in the paintings of Largillière. This is a full-length portrait of the modern bourgeoisie with its absurdities, its ugliness and its beauty."

If a reproduction of this painting leaves the art lover of today indifferent, a prolonged contemplation of the *Burial* itself creates a strange and painful impression through the multiplicity of insignificant but true details. No idea, no emotion emerges from it; there remain the feelings that anyone may experience before such a scene. In a word, the *Burial* affords us nothing of what we expect from a work of art and even less of what Courbet's contemporaries expected, and one is inclined to forgive their irritation when they saw it in the Salon of 1850-51.

Courbet continued his march toward Realism, deaf to criticism and in magnificent isolation at the heart of a rural universe that was his own. The workers break stones on the road; the bourgeoisie are at the cemetery; it remained for him to show the peasants. He chose those of Flagey returning from the fair.

The version most often reproduced is that of 1854. The painting of 1851 is comprised of only the two men on horseback (one of them Courbet's father), two women and, in the foreground, an old man in a frock coat with his umbrella. There was something about the dress, the attitude and expression of these figures in mud-spattered smocks and even tailcoats calculated to shock visitors to a salon. When Courbet added the two big oxen and the pig tied by the leg, it amounted to a provocation. Up to then only the noble animals, horses and dogs, had had the right to appear in painting. Delacroix introduced lions, but wild animals may be credited with a certain nobility. Cows posed in some Dutch landscapes, but they were part of the landscape, like the trees. Here, these animals were portrayed for their own sake and with a fidelity that smelled of the byre. As for the string tied to the pig's leg, a detail of such crude realism was considered sordid.

It is difficult today to understand the reactions of bourgeois society, the only section of the population that visited the Salon. Today we may or may not be interested in peasants, we may or may not find a painting attractive, good, or detestable, but it is no cause for scandal. But at that time art was the concern of a tiny minority whose taste condemned without appeal. Let us recall that although the nineteenth century saw the apogee of such giants as Delacroix and Ingres, these artists shared the public's favor with a group of skillful performers; Paul Delaroche, known for his historical scenes, Horace Vernet, author of *The Taking of the Smala of Abd El Kader,* Thomas Couture, famous for *The Romans of the Decadence.* I will not even attempt to describe these reconstructions, which make us laugh when we come across them in some provincial museum, and which appear naive even by comparison with Hollywood technicolor super-productions which aim to bring to life the Bible or amorous adventures of the times of the Pharaohs.

However, the Salon of 1850-51 marked a stage in Courbet's advance to fame. Such an impressive body of work (*The Peasants of Flagey, The Burial at Ornans, The Apostle Jean Journet*) could not leave people indifferent. The paintings provoked quarrels and discussions that were echoed in the press. Courbet became known, and he saw the appearance of the first caricatures ridiculing him. Realism had finally acquired an official existence and the right to public exhibition. Urbain Cuenot wrote some time later to Juliette: "Gustave is still the topic of every conversation in the artistic world. The most contradictory rumors and the most amusing information are circulated about him... There are drawing rooms in which people claim that Courbet used to be an artisan, a carpenter or a mason, who one fine day, impelled by his genius, started painting and produced masterpieces from the very first moment. In others people assert that he is a terrible Socialist, that he is at the head of a band of conspirators. You

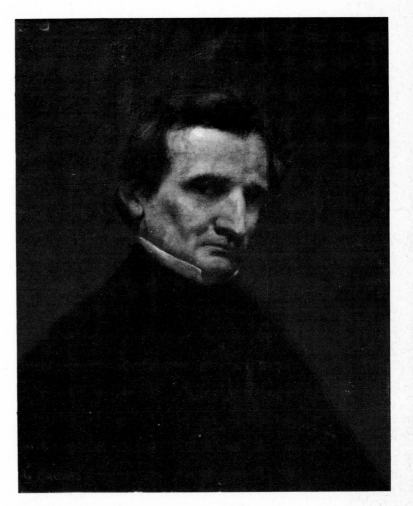

Firemen Running to a Fire, 1850
(Musée du Petit-Palais, Paris)

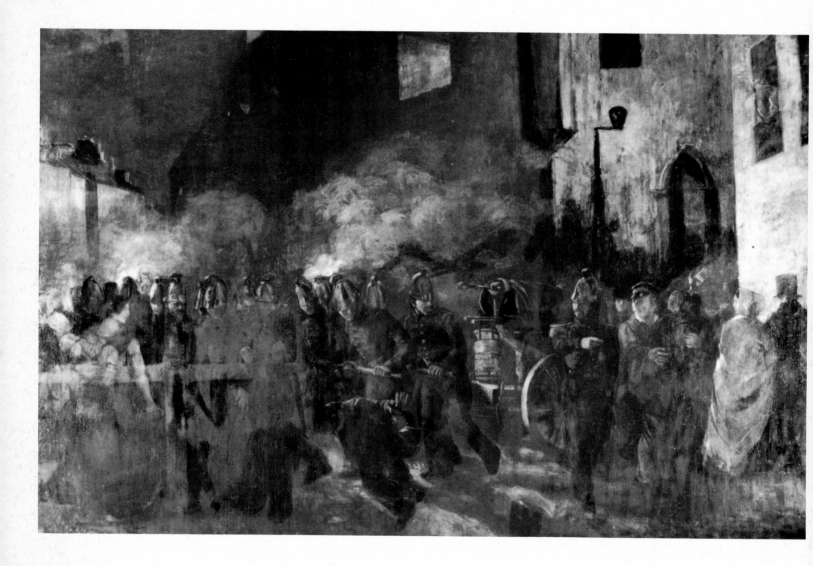

can tell this from his painting, they claim. The man is a savage, they say... and every day people think up fresh idiocies to credit him with." (Paris, February 13, 1851)

For his part, Francis Wey wrote to a Besançon friend: "Courbet's canvases are attracting a great deal of attention; they are heavily attacked and sturdily defended. This lad has his denigrators and his enthusiastic admirers. He is none the less one of the leaders of the Salon."

For the 1852 Salon, Courbet, who had returned to Ornans, made an effort at conciliation and sought to present the life of his region in a sunnier light with *The Young Ladies from the Village Giving Alms to a Cow-Girl*. What was the use? This aspect of life at Ornans appeared even more ridiculous to Parisians. This was a matter of fashion (which is very difficult to understand from a distance of a hundred years), but it was also a resistance arising from deep-rooted prejudices.

It is not at all within my competence to undertake a dissertation on the art of costume in the middle of the nineteenth century. And yet this is what was done by a number of journalists who claimed to be critics of art. For this large composition (77 x 103 inches) Courbet had his sisters Zélie, Juliette, and Zoé pose in light, fresh dresses, pleasingly dressed but not as overdressed as was thought appropriate in a small provincial town. Courbet was playing with contrasts, bringing two social classes into contact: "the young ladies from the village" in their elegant dresses on the one hand, the poor little peasant girl and her cows on the other. But to Parisian eyes the "young ladies" appeared just as rustic as the "cow-girl"! Fortunately for Courbet, time wipes out these ephemeral nuances; his intentions are again evident to us. The beauty of the landscape was already recognized by Théophile Gautier, and this amphitheater of green fields enclosed by rocky cliffs has preserved all its grandeur. The "ten o'clock crag," *la Roche de dix heures*, that served as a time-check for the inhabitants of Ornans, figures in many pictures.

Let no one imagine that such compositions with precise settings are the spontaneous fruit of genius or the result of a sudden impulse, a kind of illumination. Many pencil sketches still exist, as for the *Burial*, or did exist even if they have disappeared. As for Courbet's realism, it is a concrete expression of his will to portray the world as it is without poeticizing it, without betraying it, and not as it could be or as one would wish it to be, but let us note that the painter is never a slave to detail. As proof I cite only the two versions of the *Young Ladies from the Village*. In addition to the final version in the Metropolitan Museum in New York, there is a study in Temple Newsam House, Leeds, England. What do we see when we compare the two works? First a change in the viewpoint that totally alters the perspective. A process of displacement greatly enlarges the apparent size of the figures while decreasing the height of the rocks and the relative dimensions of the cows. Also and especially — the fact is significant — a tree of some size in the Leeds version has entirely vanished from the one in the Metropolitan Museum.

Courbet a realist? Certainly, but never subservient to literal exactitude.

La Fileuse endormie (The Spinner Asleep), posed for by his sister Juliette, the redhead, is a sensual portrait whose model might later have tempted Renoir. But Courbet — and it is in this that he shows himself a "realist" — did not wish to paint a simple portrait. He wished to give it full significance by setting it in a context. It was not enough for him to indicate by means of costume — the embroidered dress and the vast shawl — that the figure was that of a peasant; he was not afraid of "over declaring" its significance by adding a distaff and a spinning wheel. The distaff might have been a pretext for a study of hands, the spinning wheel an element intended to balance the composition. But to interpret them exclusively as such

would be to make a grave mistake about Courbet's intentions. This portrait is meant also to be a study of rural life. For us, however, all that remains is the portrait, that is to say the painting.

Back in Paris, Courbet embarked upon a new and gigantic composition (12 feet 6½ inches by 18 feet 6 inches), *Firemen Running to a Fire.* He worked on the site at the fire station in the rue Saint-Victor. Realism here draws its raw material from a news story. The painter turns to account the red glow and the clouds of smoke lit up by the flames. The firemen in their blue uniforms constitute a dark mass dominated by the reflections of the light on their helmets. There is still a little Rembrandt, perhaps, and a reminiscence of *The Man in the Gold Helmet.* But it is a different subject: there is movement which is made concrete by the effort of men pulling the archaic pump; two men, a workman and the captain, are pointing the way (incidentally, the opposite one to the flames, which we can see in the distance); a few frightened passers-by are getting out of the way, and as a setting we see flat housefronts bathed in a sinister light.

The unfinished canvas, interrupted by the coup d'état of December 1851, was rolled up, abandoned and forgotten. It was bequeathed by Juliette Courbet to the Musée du Petit-Palais in Paris, where it remained for a long time in the cellar. It still belongs to this museum and at the moment of this writing is being examined with a view to restoration in the laboratory of the Louvre.

On December 2, 1851 Louis-Napoléon Bonaparte, grandnephew of the Emperor, staged a coup d'état. Not content with his election as President of the Republic in December 1848, and still embittered by the failure of his coups of 1836 and 1840, he now ordered a vast number of arrests and seized complete power. Exactly a year later a plebiscite ratified the coup d'état and gave an appearance of legality to the Second Empire.

For Courbet, totally absorbed in his painting, it was a very harsh shock. His friend Max Buchon took refuge in Berne, Victor Hugo in Brussels. In an instant, everything was called into question. And Courbet immediately realized what was happening, even if he could not foresee all the consequences.

It is pertinent as well as amusing in retrospect to see how Courbet's most zealous biographer — whose unfinished book never appeared, so that we are reduced to deciphering its fragments in the Bibliothèque Nationale — situates the painter in history:

"December 2nd came, suppressing with one blow liberty and fear. The tremblers no longer trembled, but France was garrotted. Peasants and workers were deported 'to reassure the good and make the wicked tremble.'

"Shootings, a state of siege, and deportations are arguments it is impossible to refute. Courbet said to himself: 'Since the peasant men of Flagey terrify the conservatives, I shall show them our peasants and our townswomen. The women of the fields have nothing to do with subversive passions; perhaps mine, in their rustic grace, will please the new masters of opinion.' "

This is how Castagnary, intending to present an apology for Courbet, whom he sincerely admired, sought to explain *The Young Ladies from the Village, The Spinner Asleep,* the large *Baigneuses* in the Montpellier Museum, and *The Corn Sifters.*

This is an unlikely version of the facts. Courbet never did anything in order to please, except perhaps, as we have said, during his first years in Paris, when he so much needed to be accepted into the Salon. This does not mean that he was indifferent to other people's opinions; but his natural reflex was to go against the current, to shock, at any price. At the beginning he suffered from it; later he took pride in it. Yet, uncertain as the dates of his works are, we have every reason to believe that *The Young Ladies from the Village* was begun, and perhaps finished, before the coup of December 2. In short, we need only run through the perfectly logical development of Courbet's painting to see that *The Young Ladies* is only a new

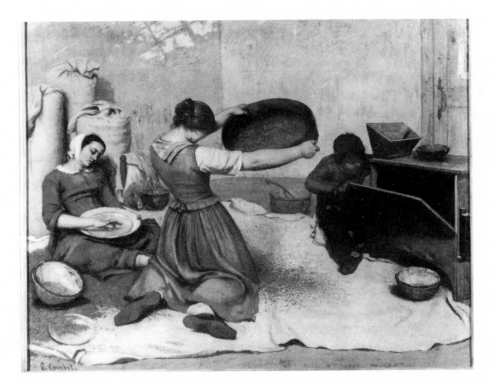

panel in an immense polyptych begun in 1849 with *After Dinner at Ornans;* that *The Corn Sifters* (to which we shall return) is a pendant to *The Stone Breakers,* while *Les Baigneuses* is an attempt to remove the nude from the confines of academicism and romanticism, a decisive step toward true realism.

We have not resorted to descriptions of the works, like Courbet's first biographers, whose books contained only mediocre black and white reproductions quite incapable of giving an exact idea of the pictures. Nevertheless, if we wish to reach the core of truth within the mixture of sincerity and provocation of which the artist was made, we must make use of what he himself has left us in the way of writings, which need to be interpreted with caution, and to his works, which also require some intuition to decipher.

Les Baigneuses probably dates from Courbet's return to Ornans, where he prudently "retired to the country" after the coup d'état. It would, after all, have been a commonplace study calculated to please the gentlemen of the Institut if Courbet had not, as always, broken two essential rules of the genre. The proportions of his bathers are not classical, since he chose not professional models, but solid countrywomen generously constructed and well-covered. Moreover, he did not place them in the abstract framework of the studio in front of an artistically draped cloth, but put them out in the open beside a stream — a logical place for women bathing, but one where only nymphs were entitled to appear so scantily clad. The obsessive modeling of the flesh and the concrete realism of the landscape give the work a presence unusual for the period. Neither Chassériau's chaste nymphs, nor Ingres' languorous odalisque with her refined eroticism, nor Delacroix's slaves of dying Sardanapalus — all of which are removed by their subject matter into a distant past and, above all, are treated in an essentially poetic style — impress the spectator as so thoroughly true.

It is the same with another painting of the nude, *Les Lutteurs (The Wrestlers).* Courbet found his figures in the hippodrome at the Champs-Elysées (where Promayet was playing in the orchestra) and had made a study of them. Here Courbet once more broke the rules by the veracity of his figures and their setting, because he situated his models in the present, in a real place, not in an age of myth and in a fairytale palace.

FRIENDSHIP WITH ALFRED BRUYAS AND THE UNIVERSAL EXHIBITION 1854-1855

In the name of decentralization he began to exhibit these pictures in 1850 at Ornans, Besançon, and Dijon, establishing himself as a master painter with enormous posters and the authorization of the mayors in places made available to him by the towns. In 1854 the Government of Louis-Napoleon Bonaparte offered Courbet terms which he could not accept [for the Universal Exhibition of 1855]. As a result, the committee headed by M. de Morny refused him a room in which to exhibit his works. M. Fould gave him permission to hold a paying and public exhibition, which he did at his own expense, showing sixty of his works which he was able to bring together. No such act of independence had ever been seen before in France. In spite of this, he covered his costs and was the only one to do so in 1855.
Gustave Courbet, Ibid.

Between two periods of work Courbet decided to show his paintings to those whom he painted, the peasants. He organized a little exhibition at Ornans, then exhibitions at Besançon and Dijon. His success was slight, but it was nevertheless a first attempt at artistic decentralization.

In 1851 he went to visit Maître Clément Laurier, a lawyer, near Le Blanc in the Indre, accompanied by the poet and *chansonnier* Pierre Dupont. He passed through Lille to see how his *After Dinner at Ornans* was hung and went on to Brussels, where he had accepted an invitation from the artistic and literary circle, which was exhibiting his *Stone Breakers* and *Spinner Asleep*. From Belgium he went to Germany.

In March 1853 in the Lederhalle at Frankfurt, he exhibited several canvases, including *The Stone Breakers* and *The Burial at Ornans*. He was warmly received by German artists and art lovers. If we are to believe him, he was the topic of every conversation. Courbet was more appreciated across the Rhine than in his own country.

At the Salon of 1852 the Duc de Morny, natural son of Queen Hortense and the Comte de Flahaut and half-brother of Napoleon III, bought *The Young Ladies from the Village*. Courbet expressed his opinions in public and his verbal excesses led to his being called before the police and lectured severely, but he suffered no further harassment. The Duc de Morny is said to have intervened in his favor.

The same year Courbet made a brief trip to Dieppe and discovered the sea for the first time.

At this time he learned that his mistress had left him, taking with her his child. He wrote: "May life treat her lightly, since she thinks she is acting for the best. I greatly regret my little son, but I have enough to do with art without bothering about family life. Besides, to me a married man is a reactionary."

Courbet always displayed astounding discretion in his love affairs. It seems that these were occasional and fleeting: servants, models or women of the world

EXHIBITION

ET VENTE

DE

40 TABLEAUX & 4 DESSINS

DE L'ŒUVRE DE

M. Gustave COURBET.

Prix : 50 centimes.

LE RÉALISME.

Le titre de réaliste m'a été imposé comme on a imposé aux hommes de 1830 le titre de romantiques. Les titres en aucun temps n'ont donné une idée juste des choses ; s'il en était autrement, les œuvres seraient superflues.

Sans m'expliquer sur la justesse plus ou moins grande d'une qualification que nul, il faut l'espérer, n'est tenu de bien comprendre, je me bornerai à quelques mots de développement pour couper court aux malentendus.

J'ai étudié, en dehors de tout esprit de système et sans parti pris, l'art des anciens et l'art des modernes. Je n'ai pas plus voulu imiter les uns que copier les autres ; ma pensée n'a pas été davantage d'arriver au but oiseux de *l'art pour l'art*. Non ! j'ai voulu tout simplement puiser dans l'entière connaissance de la tradition le sentiment raisonné et indépendant de ma propre individualité.

Savoir pour pouvoir, telle fut ma pensée. Être à même de traduire les mœurs, les idées, l'aspect de mon époque, selon mon appréciation, en un mot, faire de l'art vivant, tel est mon but.

CATALOGUE.

GUSTAVE COURBET, né à Ornans, département du Doubs, le 10 juin 1819.

1.	1855.	*L'Atelier du Peintre*, allégorie réelle déterminant une phase de sept années de ma vie artistique (1).
2.	1850.	*L'Enterrement à Ornans*.
3.	1850.	*Le Retour de la Foire* (Jura).
4.	1853.	*Les Baigneuses*, appartenant à M. Bruyas, de Montpellier.
5.	1853.	*Les Lutteurs*.
6.	1847.	*Portrait de mon ami A. P.*, artiste musicien.
7.	1853.	*Portrait de M. Champfleury*.
8.	1840.	*Portrait de Ch. Baudelaire*.
9.	1845.	*Sentiment du jeune âge*.
10.	1845.	*Le Violoncelliste*.
11.	1847.	*Portrait de mon ami U. C.*
12.	1844.	*L'Homme blessé*.
13.	1845.	*Une Femme nue dormant près d'un ruisseau*, appartenant à M. Lauwick.
14.	1851.	*Esquisse des Demoiselles de village*, appartenant à M. Lauwick.
15.	1850.	*Portrait de l'apôtre Jean Journet partant pour la conquête de l'harmonie universelle*.
16.	1844.	*Pirate qui fut prisonnier du dey d'Alger*.
17.	1843.	*Portrait de l'auteur* (essai).
18.	1841.	*Paysage de la Roche-Fournêche, vallée d'Ornans* (Doubs).
19.	1842.	*Paysage de Bois d'hiver*.
20.	1841.	*Paysage de Fontainebleau* (Forêt).
21.	1848.	*Paysage du château de Saint-Denis, vallée de Sey-en-Varay* (Doubs).
22.	1851.	*Paysage de Bougival* (Saulée).
23.	1847.	*Paysage de la vallée de Sey*, soleil couché.
24.	1848.	*Portrait de M.* ***
25.	1849.	*Portrait de l'Auteur* (étude des Vénitiens).
26.	1846.	*Les Rochers d'Ornans* (le matin).
27.	1847.	*Paysage* (les ombres du soir).
28.	1847.	*Le Matin* (vallon).
29.	1841.	*Paysage de Fontainebleau* (Franchard).
30.	1846.	*Paysage* (soleil couchant).
31.	1848.	*Paysage de l'île de Bougival*.
32.	1850.	*Génisse et taureau au pâturage*.
33.	1847.	*Tête de femme* (rêverie).
34.	1843.	*Tête de jeune fille* (pastiche florentin).
35.	1843.	*Paysage imaginaire* (pastiche des Flamands).
36.	1845.	*L'affut*, paysage (d'atelier).
37.	1847.	*Les Rochers d'Ornans* (le matin).
38.	1848.	*Portrait H. B.*
39.	1847.	*Portrait de femme* (dessin).
40.	1847.	*Jeune fille à la guitare*, rêverie (dessin).
41.	1848.	*Un Peintre à son chevalet* (dessin).
42.	1847.	*Un jeune homme* (dessin).
43.	1848.	*Le Suicide*, paysage, appartenant à M. Henry de Lancy.

Il faut joindre à ces quarante tableaux que j'ai pu avec peine rassembler pour cette exposition, onze autres exposés au Palais des Beaux-Arts. Il me reste à regretter un tableau qui aurait servi à faire saisir l'enchaînement de mon idée artistique ; ce tableau (*Après-Diner à Ornans*) fut exposé aux Tuileries et médaillé par le gouvernement ; il appartient aujourd'hui au musée de la ville de Lille. Je n'ai pu l'obtenir de cette ville.

to whom he made love on the studio divan after painting their portraits. According to Gros-Kost, Courbet wished to pass on his genius to his son and make an artist of him. But this son died at Dieppe in 1872 "without having reached the age of twenty," according to Castagnary. The logic of dates renders this impossible, since his mother had gone off with him soon after his birth in 1852. Other biographers claim that this son "went in for literature." One witness reports that he was an ivory-carver in Dieppe. It is impossible to form an opinion on this point.

During the last years of his life Courbet was free with his confidences — or his fondness for creating myths concerning the past. Let us cite the indirect evidence of Dr. Paul Collin concerning Courbet's mistress and son: "A sad and charming story. A lady had come to pose for her portrait. He was then twenty-eight. Love soon sprang up and one day the lady came to Courbet and begged him to keep her with him.

" 'I have left my husband,' she said, 'and now I want to be all yours.'

"They lived together and a child was the token of this union. Curiously enough, it seems that Courbet never painted the portrait of this beloved son. I have the story from Monsieur Pata who was Courbet's pupil and friend and to whom Courbet told the story in a moment of nostalgia."

The Salon of 1853 was marked by various events. The critics were divided. The Emperor struck the *Baigneuses* with his whip. This crude attack illustrates the passions unleashed by these nonconformist nudes. Delacroix wrote in his journal under the date April 15: "Before the meeting I went to see Courbet's paintings. I was amazed by the vigor and three-dimensional quality of his main picture, but what a picture! What a subject! The vulgarity of the forms wouldn't matter; it is the vulgarity and futility of the thought that are abominable. And even if, in the midst of all this, the idea, whatever it is, were clear! What do these two figures mean? A fat bourgeoise seen from the rear, entirely naked except for a carelessly painted scrap of rag covering the lower part of her buttocks, is stepping out of a little area of water that doesn't seem deep enough even for a foot bath. She is making a gesture that expresses nothing, while another woman, whom one supposes to be her servant, is sitting on the ground taking off her shoes. We see the stockings she has just taken off; one of them, I believe, is only half off. Between the figures there is an exchange of thoughts which we cannot understand. The landscape is painted with an extraordinary vigor, but Courbet has done no more than paint on a large scale a study which we can see next to the painting. The result is that the figures have been put down after the background and without any connection with their surroundings. This is tied up with the question of the harmony between the accessories and the chief object, which is lacking in the majority of great painters. This is not Courbet's greatest fault."

But the *Baigneuses* was not only the object of whip lashes and press campaigns. A purchaser appeared. His name was Alfred Bruyas. He had a fortune, already possessed a collection of paintings, and lived in the Midi, at Montpellier. He had a distinguished, rather ailing and romantic appearance, like a prematurely aged Alfred de Musset. And yet he was two years younger than Courbet (he was born in 1821).

According to Castagnary, Alfred Bruyas is said to have exclaimed: "There is free art. That canvas belongs to me!" Very declamatory words by comparison with his usual delicacy and discretion.

Alfred Bruyas and Gustave Courbet met in front of *Les Baigneuses*. A friendship was born, a friendship rare if not unique in Courbet's life, a friendship that was to enable him to carry out his work, to conduct a campaign in favor of Realism, and to conquer a place in the first rank of nineteenth-century painting. Money matters were important between them, but always took second place after ideas, after feelings. It was a friendship that inspired Courbet to write some of his finest letters, letters in which the sentences ring especially true because it was only with Bruyas that Courbet dared to be himself. The inner drive that impelled Courbet to regard himself as the greatest painter of

his day, if not of all time, ceases to be irritating; it becomes attractive because we can deeply feel its sincerity. If such self-confidence includes a certain element of naïveté, this is not ridiculous because it rests upon a mass of work, upon facts, ideas, paintings.

In relating such an encounter a biographer, however critical, is tempted to romance. I shall avoid this by referring exclusively to that correspondence through which, writes Pierre Borel (who has produced a very carefully edited edition), "the figure of Courbet takes form of its own accord and appears to us in striking relief. In these letters the master of Ornans has drawn one of the best portraits of himself."

Alfred Bruyas bought not only the *Baigneuses* but also *The Spinner Asleep,* and he commissioned his portrait. Bruyas had one passion: he loved to have his portrait done (Delacroix, among others, recorded his features). In fact Courbet painted not one but at least three portraits of Alfred Bruyas. In the course of these sittings Courbet outlined his ideas. On the days when Bruyas did not come to pose in the studio in the rue Hautefeuille the two men used to go for excursions in the countryside.

Back in Montpellier, Alfred Bruyas invited Courbet to stay with him. Courbet replied in a long letter that is often quoted because it constitutes a kind of profession of faith: "Yes, my dear friend, I hope in my life to bring just one miracle to pass; I hope to live by my art throughout my whole life without ever having deviated in the slightest from my principles, without ever having for one instant lied to my conscience, without ever having made a painting in order to please anyone at all, or in order to sell it.

"I have always told my friends (who were scared by my audacity and feared for me): 'Have no fear. If I have to traverse the whole world, I am sure of finding men who will understand me; if I only find five or six, they will support me, they will save me.'

"I am right, I am right! I am a thousand times right!

"I met you. It was inevitable, because it was not we who met, it was our solutions."

Courbet understood that he had at last found his patron — better than a patron, a true friend who was going to help him to make his work known.

Throughout this correspondence, and also on a portrait of Alfred Bruyas, one word recurs: "solution." At moments the reader is inclined to believe that this is a secret word, a word that had a special meaning between the two of them. And these words too are full of significance: "I am in a hurry to leave, because I am looking forward to this journey, to seeing you and to the work we shall do together." Courbet never traveled for pleasure or out of politeness. He was going to see his friend, his confidant, a man who was to associate himself morally and materially with everything Courbet undertook. He was no longer alone (his best friend Max Buchon was a refugee in Berne) and, thanks to this new friendship, he showed himself bolder than ever.

The common project was in no way mysterious. It was simply to free art from the academicism upon which Courbet had declared war, and to strike a great blow: to organize a one-man exhibition. Whose idea was this? Since the 1854 Salon had been postponed until the following year because of the Universal Exhibition, the two friends must have spent a long time discussing the best way of showing the new painting. According to another letter preceding Courbet's trip to Montpellier, it seems that Bruyas was already won over to the idea of an individual pavilion. Courbet was going to work; Bruyas would finance the building. As always, Courbet hoped to repay him handsomely and even to make a lot of money from the entrance fees that he counted on getting, as he had in Besançon and Dijon.

"Admit that the role of gravedigger is a fine one and that to clear the ground of all this accumulation of rubbish is not without its charm! 40,000 francs, that's a dream."

This was the ratification of the plan. The two friends,

The Ten O'Clock Crag, ca. 1855
(Musée du Louvre, Paris)

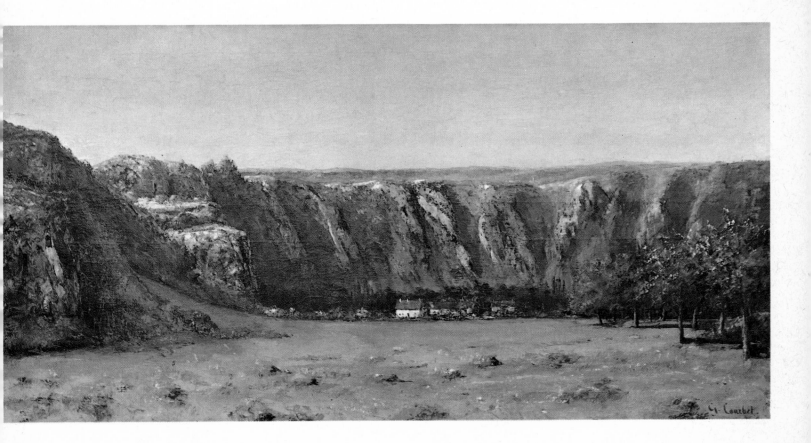

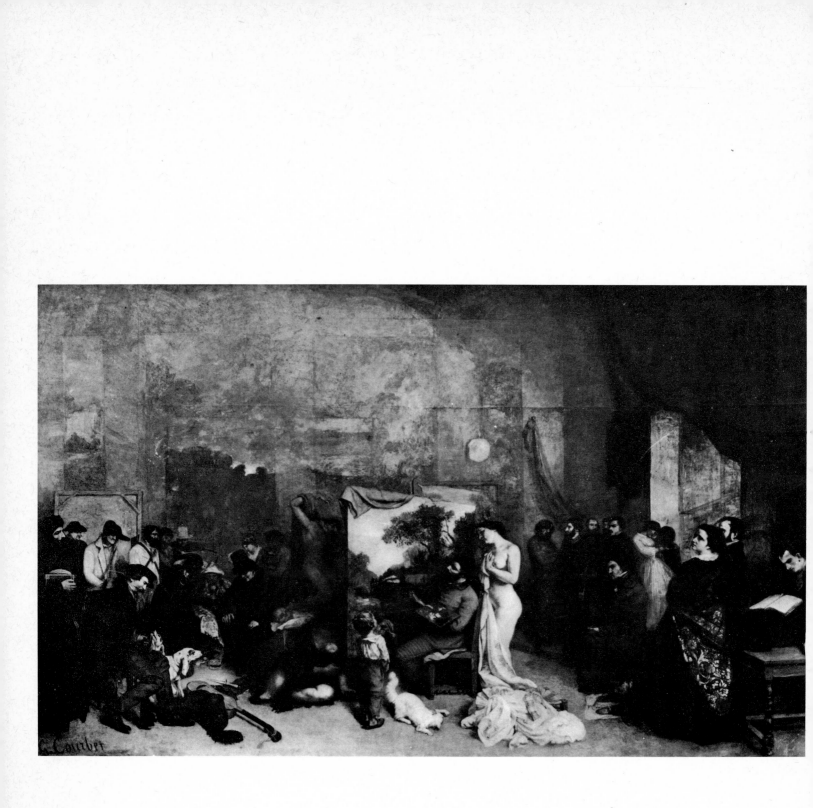

henceforth allies, wished to bury anecdotal, historical, and mythological painting.

And this was the plan itself:

"We shall be obliged to lease a plot of ground from the city of Paris, facing their big exhibition. I can see an enormous tent with a single column in the center, and as walls, frames covered with painted canvases, the whole thing mounted on a platform; then some hired policemen, a man in a black suit running the box office facing the canes and umbrellas, and two ushers.

"I think we shall make these 40,000 francs (even if we only speculate on hate and envy).

"For the moment, here is the title:

AN EXHIBITION OF PAINTING
BY MAITRE COURBET
AND THE GALERIE BRUYAS [1]

"It's really enough to turn the whole of Paris upside down. It will be without any question the most powerful play enacted in our time. It will make some people ill, that's certain."

At Montpellier, for the first time in his life, Courbet was treated with the esteem reserved for one of the great artists of his day and he enjoyed a luxury to which he was not accustomed. His reception was affectionate and respectful. Alfred Bruyas showed him Provence, a nature and light that were new to the painter. An excursion to Palavas revealed to him a sea quite different from the one he had discovered at Dieppe. Like Baudelaire he fell in love with it; he painted it.

He also painted portraits (Fajon's, among others) and above all, a work that has since become famous, *La Rencontre (The Meeting)*: the wealthy collector's salute to the Realist painter, an autobiographical picture

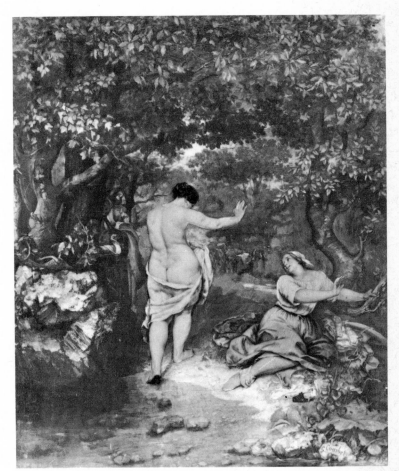

[1] In its final form the inscription over the door of the exhibition read: "REALISM" (in large letters) "Gustave Courbet" (in smaller ones), with no mention of Bruyas.

that gave rise to numerous commentaries and psychological interpretations of the arrogance of the artist and the humility of the wealthy collector. In actual fact, the two figures are marked by a slightly ceremonious and theatrical dignity. Courbet evidently wished to make plain the importance of this meeting; and as it turned out, the critics proved more sensitive than Bruyas himself, who not only saw nothing derogatory in it, but bought the picture.

According to tradition, Courbet really did give vent to his arrogance in *The Seashore at Palavas,* a picture in which a man seen from the bank appears to be greeting the sea and is said to be crying: "Oh sea, your voice is fearsome, but it cannot drown that of my fame shouting my name to the world!"

In autumn 1854 Courbet set out for Paris again. He passed through Lyons where he met a Spanish lady who cured him of the *"cholérine"* and whose portrait he painted. He went to Berne to visit his old friend Max Buchon. The large portrait of the poet standing probably dates from this meeting.

Back in Ornans, Courbet developed jaundice — but he continued work on *The Atelier:* "In spite of everything I have managed to do the sketch for my picture, and at this moment it is all drawn in on the canvas, which is twenty feet long and twelve high" [a valuable indication of his method of working].

"This makes the picture the most astonishing imaginable.

"There are thirty life-size figures.

"It is the moral and physical history of my studio.

"These are all the people who help me and take part in what I am doing.

"In the background are *Les Baigneuses* and *The Return from the Fair.*

"On my easel I shall paint a landscape in which there will be a miller and donkeys carrying sacks to the mill.

"I shall call this *First Series,* because I hope to introduce society into my studio, to make known my attractions and my repulsions. I have two and a half months in which to carry it out, and I shall also have to go to Paris to paint the *Nudes,* so that all in all I have two days for each figure."

By the end of the year Courbet was already completely taken up by material preparations for the exhibition, with the "borders" (as he called frames) for his pictures, with the transport to Paris, with the works he had to borrow — notably from Bruyas — and with the completion of *The Atelier.* He stated: "There are only four or five figures left to paint and I shall have finished my *Atelier.*

"There are thirty-three life-sized figures.[2] I swore I would do it. It is done.

"You occupy a magnificent position. You are in the same pose as in the *Meeting* but expressing a different feeling. You are triumphant and commanding."

It was while work on the Universal Exhibition was in progress that the incident of the lunch with the Comte de Nieuwerkerke, Superintendent of Fine Arts under Napoleon III, took place. Courbet, under the pressure of emotion — and indignation — related it in detail to Bruyas.

The scene took place at Douix's, a big restaurant at the Palais Royal. From the beginning of the discussion misunderstanding was total. Monsieur de Nieuwerkerke made advances to Courbet, tried to win him over, while the latter pretended not to understand. He offered to commission a painting for the Exhibition, "on the condition," Courbet said, "that I present a preliminary sketch, and that once the picture is finished it would be submitted to a council of artists chosen by me and a committee which he would choose.

"I leave you to imagine my fury after such an opening."

[2] In the meantime Courbet had added three figures.

60

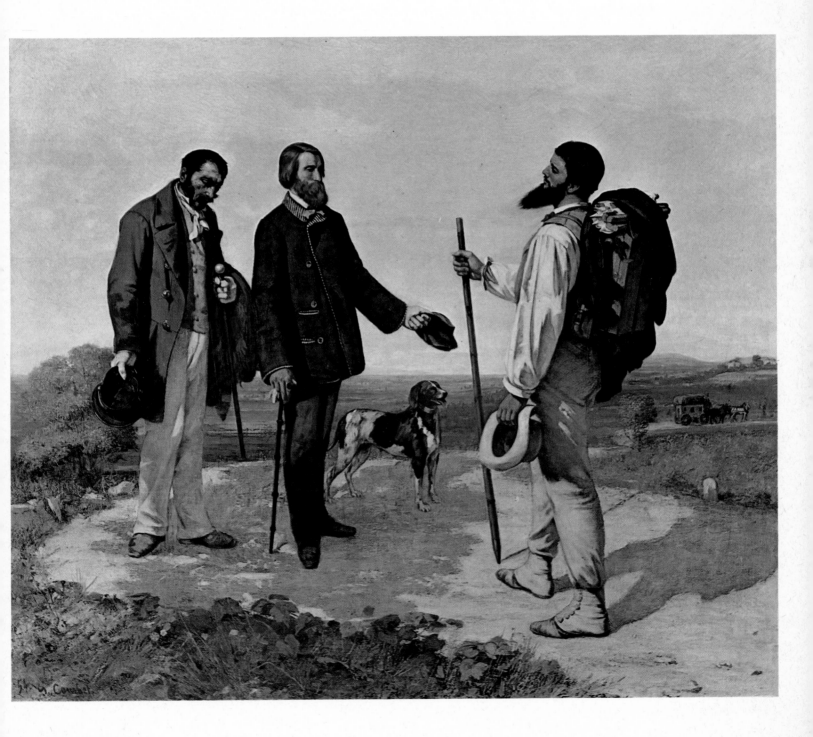

Portrait of Max Buchon, 1845
(Musée de Vevey, Switzerland)

Self-Portrait, Man with a Striped Collar,
1854
(Musée Fabre, Montpellier)

On this occasion Courbet clarified his position in the face of power, in the face of all powers, and his declaration of principle remains up-to-date even after more than a century:

"I immediately replied that I understood absolutely nothing of what he had just said to me, first because he told me that he was a Government and because I felt in no way included in this Government, because I too was a Government and I defied his to do anything whatever for mine that I could accept.

"I went on to tell him that I looked upon his Government as an ordinary private individual, that if he liked my pictures he was free to buy them and that I asked only one thing of him: to leave art free in his exhibition and not to support three thousand artists against me with his budget of 300,000 francs.

"I went on to tell him that I was the sole judge of my painting, that I was not only a painter but also a man, that I had painted not to create art for art's sake, but in order to gain my intellectual liberty."

At the head of the catalog to his 1855 exhibition he wrote:

"The title of Realist has been imposed upon me as the title of Romantics was imposed upon the men of 1830. At no time have titles ever given a correct idea of things; if they did, the works would be superfluous.

"Without expatiating upon the accuracy of a description which no one, let us hope, is obliged to understand, I shall confine myself to a few words on my development to put an end to misunderstandings.

"Outside any system and with no preconceived ideas I studied the art of the ancients and the art of the moderns. I did not wish either to imitate the former or to copy the latter. Neither was my idea to arrive at the pointless goal of *art for art's sake.* No! I simply wanted to extract from the entire body of traditional knowledge the reasoned and independent sense of my own individuality.

"*Savoir pour pouvoir* [to know in order to be able], that was my idea. To be equal to translating the customs, the ideas, the appearance of my epoch as

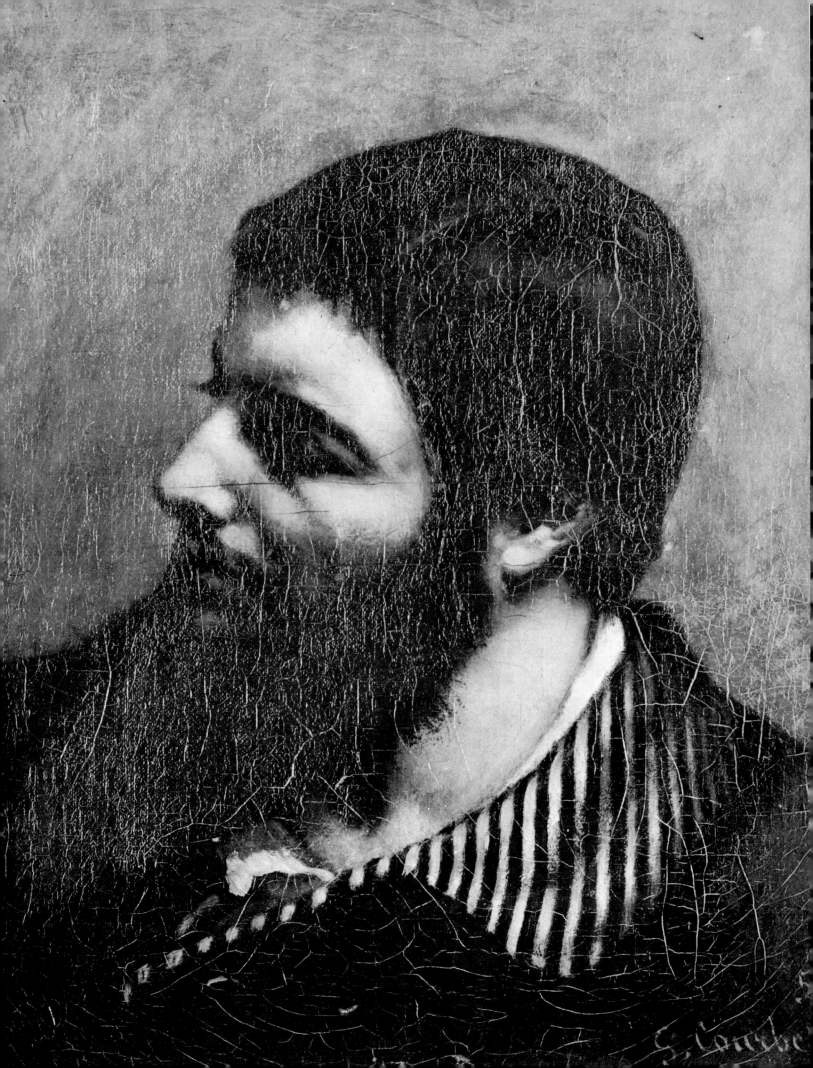

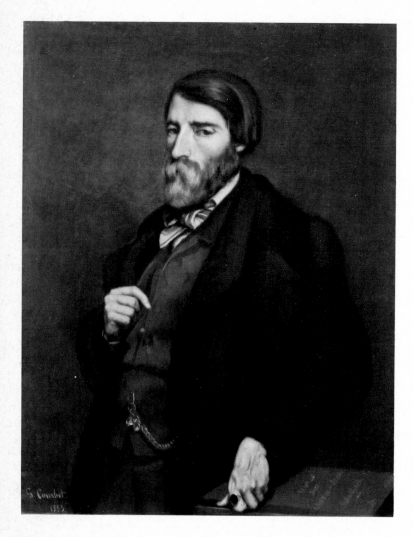

they appeared to me; to be not merely a painter but also a man; in a word, to create living art, that is my aim."

Up to the last moment Courbet hesitated to embark upon this adventure: a one-man exhibition in the very heart of Paris, face to face with the official Salon exhibition. This had never been done. To be sure, he knew he could count on Bruyas to deal with the financial problems, but as if to allow the Government a chance to avoid this scandal he made an extreme concession to the Salon. If this concession had been accepted in its entirety there might not have been a "Pavilion of Realism."

This is how Courbet presented the situation to the man from whom he awaited material assistance:

"My dear and tender friend,

"I am desperate. Terrible things are happening to me. They have just rejected my *Burial at Ornans* and my latest picture, *The Atelier,* along with my portrait of Champfleury.

"They declared that my tendencies in art must at all costs be halted, since they were disastrous for French art. Eleven of my paintings have been accepted...

"Everyone is pushing me to have a one-man exhibition. I have yielded.

"I am going to arrange another exhibition of twenty-seven of my new and old pictures, telling myself that I profit from the fact that the Government has accepted eleven of my pictures for its exhibition."[3]

"To put on an exhibition of the pictures from my studio would cost me 10 or 12,000 francs.

"I already have the site at a price of 2,000 francs for six months.

"The building will cost me 6 or 8,000 francs.

"The strange thing is that this site is enclosed within the very building of their exhibition.

[3] *The Meeting, The Stone Breakers, The Young Ladies from the Village, The Corn Sifters, The Spinner Asleep, The Spanish Lady,* two self-portraits, *The Ten O'Clock Crag, The Black Well, The Château of Ornans.*

"I am at this moment negotiating with the Prefect of Police to complete the necessary formalities.

"I already have the 6,000 francs which you gave me.

"If you will acknowledge the debt you still owe me and send me the *Baigneuses* I am saved.

"I shall earn 100,000 francs at one blow."

The Universal Exhibition of 1855 was an event of world importance. The Emperor, anxious to maintain his prestige in the eyes of the world and to compete with the great powers, stimulated by the success of the Great Exhibition of industry in London in 1851, wanted to do better. Technology was to be supplemented by the Arts, but not all the arts, only accepted and recognized forms of art.

In Lefuel's building, on the site of the old Carré Marigny, there was a German gallery, an English gallery and a Belgian gallery. In the French section, Bouguereau, Couture, and Chassériau had the honor of the Salon carré, while Delacroix, Ingres, and Horace Vernet were each given a "gallery" of their own.

Courbet thought himself as worthy as any of these, and since it was for political reasons (remember his argument with Monsieur Nieuwerkerke and his friendship with Proudhon) that he was refused the position to which he was entitled, he gave it to himself.

Courbet renounced his "artistic" garb in favor of morning dress. Théophile Gautier was the first visitor, quickly followed by Proudhon, Champfleury, Théophile Silvestre and by many other friends and enemies.

More than *The Meeting,* it was *The Atelier* which was the subject of everyone's comments. To Courbet this work was more than a symbol, it was a banner, and it was not without reason that he entitled it *"A Real Allegory Describing Seven Years of My Life as an Artist."* For it was also an autobiographical work. But the apparent contradiction between the words "real" and "allegory" immediately lent itself to mockery. And yet this picture is indeed an assemblage of real elements in a composition that might have been true, but which assumes an allegorical value in Courbet's life and work. He has brought together in a single composition individuals who might have met in his studio but who were never all there at the same time. The word "allegorical" thus bears witness, in a certain sense, to a concern for honesty; but above all it signifies that each of the persons represented assumes a symbolic value. The presence of Alfred Bruyas, for example, is not due solely to the part he played in Courbet's life; he symbolizes the disinterested patron without whom the artist cannot pursue his work and fulfill his mission. Similarly, Baudelaire does not represent solely the friend of the years following 1848 but poetry, and he takes his place alongside all those here who embody such things as literature (Max Buchon, Champfleury), philosophy (Proudhon), and music (Promayet). We will not take time to identify and situate each of the figures — the work is too rich and it would take pages — but it will assist our understanding if we trace the somewhat involved itinerary, rather than the composition.

In the center Courbet painted himself, since everything revolves around him. His dress, rural without being careless, illustrates his tastes. The position of the head is approximately the same as in the self-portrait, *Man with a striped Collar,* painted at Montpellier, and in *The Meeting.*

Courbet has placed himself between the landscape he is painting and the model; she is naked — like truth — in order to show that he is a complete painter. He has divided the figures into two groups, perhaps because he considered himself the interpreter — the link between two worlds, two societies — so positively as to inspire controversy from a strictly Socialist point of view. Unless Courbet wished to symbolize the class struggle, which seems unlikely.

To the painter's right, "those who are for him," those who aid him in one way or another, writers, art lovers; to his left, "those for whom he is," the models

whom he draws, common folk, peasants, a gamekeeper, a merchant or Jew, a curé, an undertaker's mute, a rabbi, an Irishwoman, Grandfather Oudot as a wine-grower, a clown (symbolizing the theater), a laborer, a workman (unemployment?). But why are the embracing lovers, representing free love (say Courbet's biographers), on the right and not on the left?

The Realist painter goes beyond reality, transcends it. Compare the picture left by Courbet with that described by the caricaturist André Gill:

"His studio — I think it was the only one he ever had in Paris — was on the mezzanine of an old house in the rue Hautefeuille which has today disappeared.

"The window looked out on a courtyard and the light that entered was harsh and melancholy. It reached only to the center of the room, dimly illuminating at the far end a confusion of abandoned canvases, broken chairs and unused picture frames jumbled together with a few worthless pieces of old furniture covered in dust.

"In shirt sleeves, with dangling suspenders, the occupant wandered about the studio, shuffling his worn-out shoes, stopping in front of each easel in turn, scraping this picture, dabbing that one, rarely attacking a white canvas."

Entry to the exhibition was reduced from one franc to fifty centimes, because there was no rush to get in. But it was much talked about! Twelve years later, when he wished to repeat the experiment and was appealing to Alfred Bruyas for help, Courbet drew up the balance sheet. "For us money does not count; it is the action that is our aim. In 1855, thanks to you, I had 12,000 francs to spend on carrying out my ideas. I spent the whole sum with no fear for the future."

In fact the exhibition, which was a disastrous financial operation, paid splendidly in terms of fame. Courbet's name was on everyone's lips. He was a favorite subject for *chansonniers* like Gustave Mathieu. Théodore de Banville wrote a funeral ode in which he asked Nature: "You whom I saw yesterday so powerful and so beautiful, who has twisted you like this?" To which Nature replies: "Monsieur Courbet has just passed this way!"

In his review of the Salon, Baudelaire, opposed to Ingres, saw Courbet as "a young painter whose remarkable début took place recently with all the violence of an armed revolt." He attributes to him "a fierce and indomitable will" and ends by referring to him as "a dissenting spirit, a slaughterer of faculties."

Castagnary wrote an article "to help Courbet recover his costs." He called it "Letter to Madame George Sand."

Edmond About's article mingled insults with recognition of qualities he did not dare deny. He recalled that since 1851 "the critics have served Monsieur Courbet. Some applauded while others denounced him. Some claimed that Monsieur Courbet painted solidly, frankly, and with verve; that his brush did not lack finesse. Others deplored loudly that such a valuable talent was wasted in painting 'ugly mugs.' Monsieur Courbet, served by both praise and criticism, gained a reputation that was half scandal and half fame. When he saw all eyes trained upon him his head was turned; he was seized with vanity, but it was a vanity that is not hateful since it is sincere. Frank vanity is preferable to false modesty."

L'Illustration of July 21, 1855 published several pages of humorous drawings by Quillenbois parodying the principal pictures exhibited at the Salon. In *The Meeting,* Bruyas and his valet are on their knees before the Master. The captions give some idea of the spirit: "A spinner who has never washed her face"; "A Spanish woman in Russian leather"; *The Cellist* becomes "Monsieur Courbet singing his own praises"; and the cows are wooden toys on wheels.

Courbet was also the subject of drawings by Cham, Bertall, and many others. But in *Le Charivari* Daumier went further, by virtue not only of the quality of his

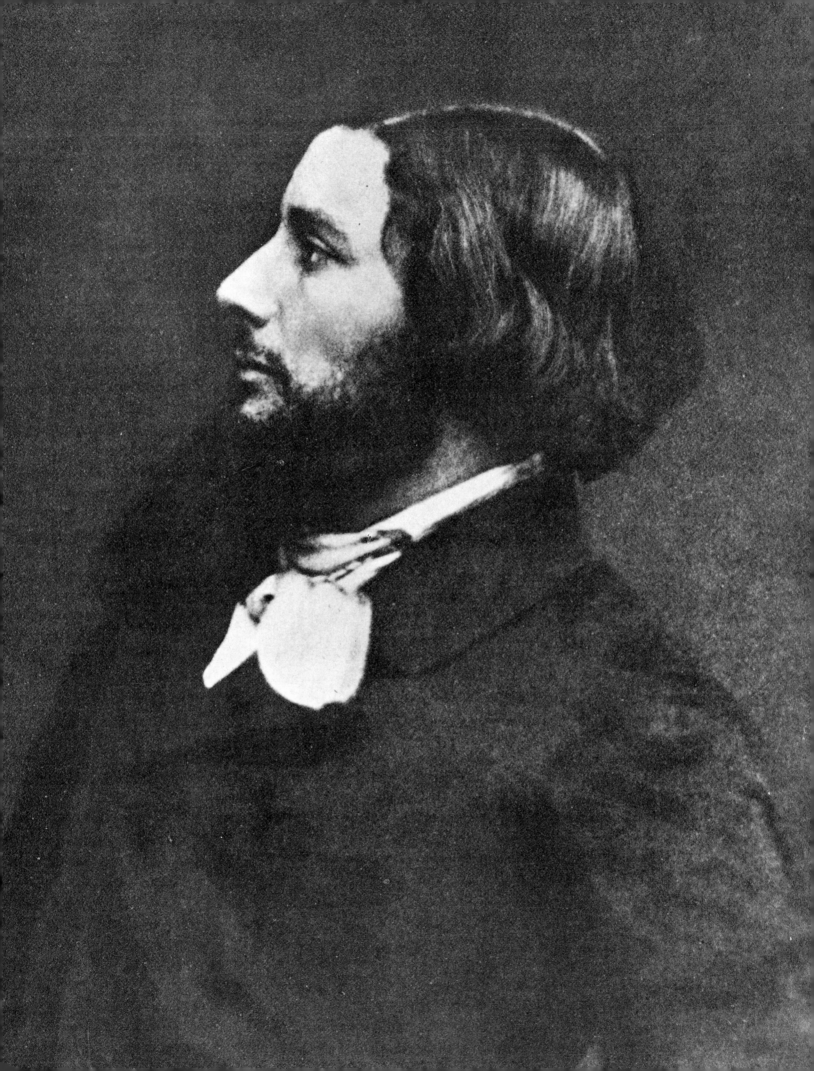

drawing, but also of his understanding. He shows a combat between the peasant-painter and an academician dressed as a Greek warrior. Among the crowd filing into the Salon are two bourgeois with "ugly mugs," men such as only Daumier could draw; they are saying: "That Monsieur Courbet paints faces that are much too vulgar; there is no one in nature as ugly as that!"

Henceforth the caricaturists of the Second Empire found in Courbet not merely an easy subject but also a theme which filled their bourgeois readers with satisfaction. They never let him go and they made him famous. They illustrate the painter's fame for us, a fame difficult to imagine nowadays, even though it was limited to France and Belgium.

To conclude this review of the press of 1855 let us quote the most clear-sighted and laudatory text, a few lines Delacroix noted down in his journal: "After leaving [the Universal Exhibition] I went to see Courbet's exhibition, which he has reduced to ten sous. I remained there alone for about an hour and I discovered a masterpiece in his rejected picture [*The Atelier*]. I could not tear myself away from it. In rejecting this picture they have rejected one of the most striking works of our day. But he is not the sort of fellow to be discouraged by so little."

Courbet was then thirty-six.

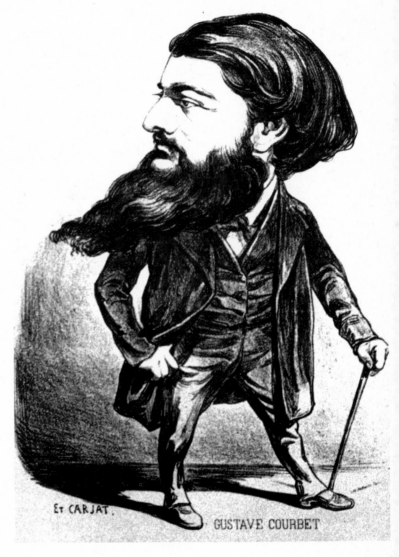

ET CARJAT.

GUSTAVE COURBET

THE GLORIOUS COMPLETE PAINTER
OPPONENT OF GOVERNMENT AND CHURCH
1855-1870

Courbet produced serially when his ideas or his situation brought him to a subject belonging to modern society. The result was twenty or thirty pictures. For example, peasants, townspeople, contemporary women, hunts, flowers, the landscapes of the region in which he happened to be living, animals, horses, dogs or game. Most recently, at Trouville, seascapes.
Gustave Courbet, Ibid.

After the great exhibition of "Realism" at the Carré Marigny in 1855, and as a result of the passions it aroused, Gustave Courbet was famous. He began to sell his paintings more easily and to dedicate himself more freely to his work. Growing financial success made him a rich man by 1870, when he bought a collection of paintings.

Though Courbet succeeded in imposing the term "Realist" on the world and in gaining recognition of his personality and talent, he remained fiercely individualistic. He was isolated up to the day of his death, in spite of a few friends. Whatever he may have said, whatever his partisans may have written, there was never a Realist school — at most, a movement in Belgium and a tiny group around the studio in the rue Notre-Dame des Champs in which talent, the most unequally distributed thing in the world, was the prerogative of Courbet alone.

Literature evolved differently from painting and there are a few masterpieces of the Realist novel. Champfleury called himself a Realist, but this kind of literature, with its facile and summary descriptions, led to the serial story and the cartoon strip. Courbet's "homologues" in literature were George Sand, with her peasant novels like *La Petite Fadette* and *La Mare au diable,* Gustave Flaubert with *Madame Bovary* (1857) (Louise Colet served as a model both for Flaubert and Courbet), and Balzac with his *Comédie Humaine.* Even these forms of narrative were still tinged with Romanticism. Is Realism in literature exemplified by Emile Zola's Naturalism? Or by Guy de Maupassant's stories written in a concise, incisive style?

Courbet, the champion of Realism, found himself caught in a vise whose two jaws were Romanticism, proclaimed in Delacroix's overwhelming lyricism; and Classicism, still alive even under its cadaverous colors, embodied by Monsieur Ingres and his horde of followers.

Courbet knew his true allies, his potential friends, the lovers of nature and truth, but he did not have

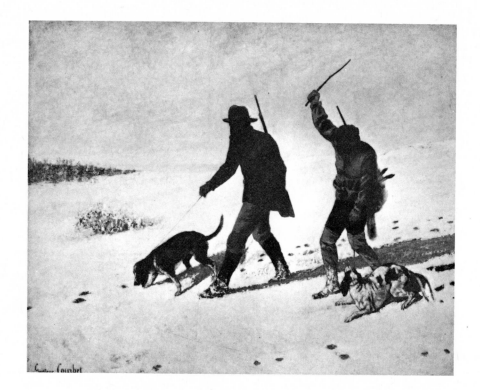

the ability to attach them to his cause or to unite their energies. His immediate forerunner was Géricault when he painted the *Raft of the Medusa;* Courbet never referred to him.

The great painters in whose company one is rightly tempted to place him — Jean-François Millet, Honoré Daumier, Corot, and the painters of the Barbizon School — had their paintings hung side by side with his in the Salon, where he met them. Certainly they were all different, but they had much in common. Perhaps Courbet, in his immeasurable pride, preferred to be alone and to have enemies rather than allies. The quarrel that lined up many critics behind either Courbet or Millet in the sixties tends to suggest this.

As is usual with such arguments, controversy centered on dates — on questions of priority — and not on the spirit. As one article recalled, from 1848 at the latest Millet had drawn his subjects from peasants and the rural life of the fields which he studied around Barbizon — his famous *Gleaners* and his *Angelus.* Like Millet, Courbet presented workers, *Stone Breakers* or *Corn Sifters.* This desire to lean down towards the humble and to draw attention to suffering and poverty might have united them, especially since that was the extent of their affinity and there could be no rivalry between them. Courbet's paint is as thick as Millet's is thin; Courbet is as provocatively realistic as Millet is poetic. A painting by Courbet is a protest and a demand; a painting by Millet is a prayer, a supplication so resigned as to verge on despair. Millet was not a Socialist, but he was fighting for the same cause.

The common ground between Courbet and Daumier, whom he knew well, is still more significant. Daumier had a political mind and drew his inspiration from social facts. His whole output is satire of the most severe kind, the cruelest satirical comment on the society of his day. But he is above all a draftsman, an illustrator, a caricaturist, and his daily work for the newspapers and illustrated magazines left him little time for painting. His graphic works are innumerable, the catalog of his paintings very brief. And yet, after a century's delay, we have discovered in him an artist of extraordinary ability. His painting, in which he works with paint at least as thick as Courbet's, is dominated by a brownish light barely heightened with touches of color. It reveals to us a stirring world bathed in dramatic atmosphere. He is not merely the painter of the Republic of 1848, but also of art lovers and workmen, of laundresses, of women bent with work and fatigue. Daumier, who did not cease to use his incisive line to comment upon current events, never attacked Courbet, even when including him in the picture. No doubt he appreciated the battle Courbet was fighting. But to Courbet, Daumier was only a lithographer, not a painter.

The nineteenth century saw the rise of landscape painting in France in a still-classical form that sought its models among the Dutch. All the painters who lived at Barbizon — Théodore Rousseau, Diaz (whose musician son Courbet knew) and Daubigny — may be considered descendants of Van Goyen and his fellows. But as far as we know, Courbet, who also learned from the Dutch, showed no special friendship for the Barbizon group. And yet even though Courbet's landscapes, especially those of the Jura, are more vigorous and more personal, they are imbued with the same atmosphere as those of the Barbizon painters, an atmosphere at once true and poetic, which moves us even when man is absent from the painting.

I believe Courbet was too egocentric, too absorbed in the work to be done and the battle to be fought to pay attention to the painting of his contemporaries and to realize what an immense revolution was already taking place in the art of his day. He said that he liked Boudin's seascapes, and he noted Manet's first pictures in the Salon des refusés, but he never foresaw Impressionism although he was present at its birth and was one of its precursors.

It was the same in relation to Corot. The two were friends; Courbet worked alongside him, but he remained

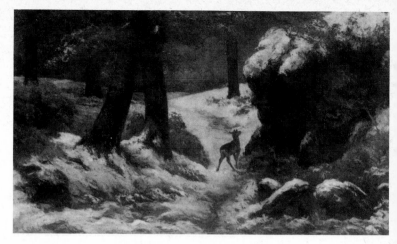

Roebucks in the Snow, ca. 1866
(Cincinnati Art Museum)

The Rocks at Ornans
(Musée du Petit-Palais, Paris)

Forest Interior, ca. 1856
(Boymans-van Beuningen Museum,
Rotterdam)

blind to the light in the landscapes of this "Roman" who prepared the way for Claude Monet.

Gustave Courbet, the famous painter, recognized everywhere, lauded by some, detested by others (and the attitudes were not based on social class; he had friends among the aristocracy, while the masses did not particularly understand him and the bourgeoisie loathed him) — this was one of the great figures in opposition to the Imperial regime. A faithful Republican, Courbet's disapproval was sincere, constant, intransigent. By his work as well as by his words he never ceased to contest the power of Napoleon III, even when the Government, feeling that its last years had come, timidly began to liberalize itself and took the first conciliatory steps toward the artist, not to win his favor, but in the hope of neutralizing and silencing him.

Courbet was no Victor Hugo; he never had such an audience; he did not go into exile on the morrow of the coup d'état; he was not the author of such an attack on Napoleon III as *Les Châtiments.* But for an artist whose work can only be seen, known, appreciated through direct contact with the public (that is to say, through exhibitions), for a man so in love with glory, fame, and honors, to refuse official commissions and decorations was proof of an unshakeable conviction. It is true, as his enemies would say, that such a public stand brings as much glory as a tacit acceptance. But calculation of this kind was foreign to Courbet.

Courbet had an innate and deeply-rooted Republican outlook, but he was not a political thinker. His instinctive opposition was directed against the politics of the Emperor and the esthetic attitude of his Minister of the Fine Arts, Achille Fould; but he could not reject the — relative — prosperity of the régime; he liked to sell his pictures as expensively as possible, just as he liked the hospitality of wealthy aristocrats such as the Duc de Choiseul. Moreover, with his mind of a wily peasant and in spite of his dreams of greatness,

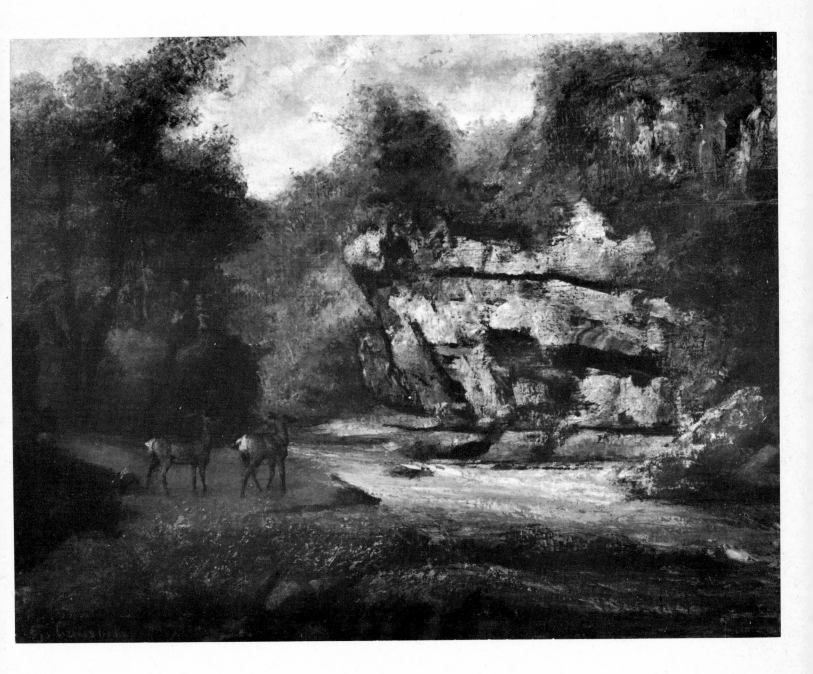

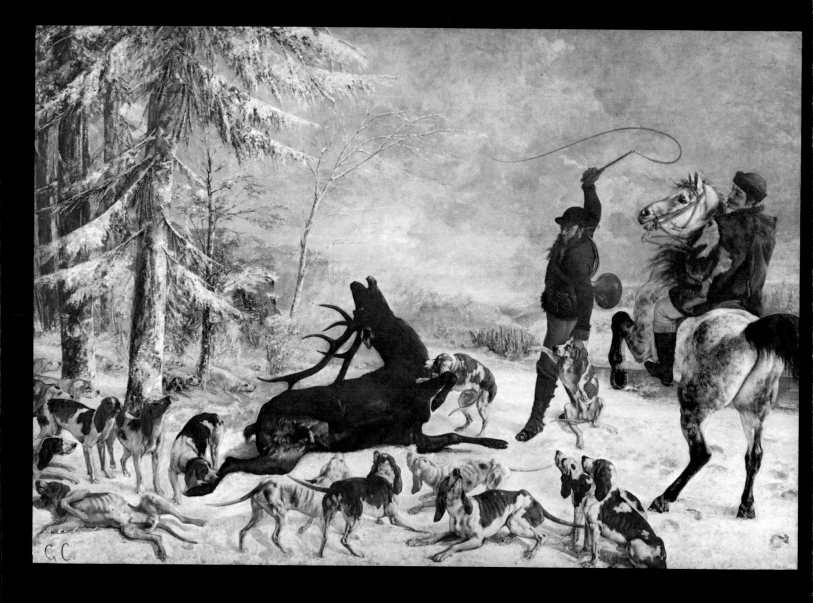

Courbet was sensitive only to the development of the French internal situation. He seems to have been quite unaware that Europe was on the move, that great colonial empires were beginning to be formed. The Crimean War, the British intervention in China, the Mexican adventure, the fight for independence in Italy, may not have left him indifferent but they do not seem to have excited him greatly if we are to judge by the only true witnesses left to us: his correspondence and his work. It was Manet who painted *The Execution of Maximilien.* It took the Franco-Prussian war to arouse Courbet's concern for external affairs; his *Open Letters to the German Army and German Artists* was in fact a speech written at the request of Victor Considérant.

Courbet was not a passive citizen. He maintained constant contact with several political exiles (such as Madame de Brayer, whose portrait he painted), making repeated trips to Belgium, Switzerland, and Germany, and it is surprising that his numerous journeys, his contacts and his friendships did not draw upon him the attention of the Imperial police and the harassments usual in such cases.

The art world in the year 1856 was dominated by arguments over Realism conducted in the press. Courbet, as though to give the controversy a better chance to develop, made a discreet submission to the Salon of portraits in which the model was of greater significance than the workmanship: *The Amazon,* who was none other than the ex-mistress of Flaubert, Louise Colet, and *The Woman with a Glove* (Marie Crocq). He also submitted *The Hind at Bay,* which initiated the series of hunt scenes. This year was also marked by a long journey through Belgium, where the painter had many admirers and a Realist group had been formed. After Ghent, Antwerp, Bruges, Louvain, Liège, and Dinant, he visited Cologne, Mainz, and Strasbourg before returning to Ornans and then Paris.

The war between the Académie des Beaux-Arts and Realism, with its political background, continued. In a speech to young artists on the day following the opening of the 1857 Salon, Fould, the Minister of Fine Arts, cried: "Art is very close to being lost when it abandons the pure and lofty regions of the beautiful and the traditional paths of the great masters in order to pursue the teachings of the new school of Realism, seeking only the servile imitation of the least poetic and least elevated of what nature has to offer." And this was the year in which Courbet exhibited *The Young Ladies on the Banks of the Seine, La Curée (Fleshing the Hounds), The Hind at Bay in the Snow* and *The Banks of the Loue.*

The minister's reaction was motivated by the more or less favorable attitude of the whole press. Courbet had won several points. Gustave Planche, Maxime du Camp and many critics recognized his talent, even if they still expressed reservations. But no victory is ever total, and Théophile Silvestre, who always maintained extreme freedom of thought and expression, kept his distance. His praise of the painter was accompanied by unflattering comments on the man: "His efforts to appear a thinker cover him with ridicule."

In 1857 Courbet made the acquaintance of Castagnary, an ex-lawyer, who replaced the word "Realist" by the word "Naturalist" in his *Philosophie du Salon de 1857.*

In 1857 too, Courbet, seeking to escape the tumult that had sprung up around his work, went to spend several weeks with his friend Bruyas; some of his finest seascapes date from this visit.

THE HUNTS AT FRANKFURT

From September 1858 to February 1859 Courbet stayed at Frankfurt-am-Main. There were two reasons for the length of this stay. Courbet had numerous contacts across the Rhine, such as Victor Müller, who lent him his studio, Otto Scholderer, and Jules-Isaac Lunteschütz, who appears to have been a friend of Schopenhauer. Every evening they held banquets far better than those in the old days at the Brasserie Andler

and in an atmosphere of warm admiration. Several art lovers there were interested in Courbet's works. But above all, during his Frankfurt visit Courbet became an ardent devotee of hunting as practiced in Germany.

Strictly speaking, hunt scenes were not new in Courbet's work, but they assumed new dimensions. What had sometimes been no more than an excuse for snowy landscapes, still lifes (the beauty of skins, the position of the dead animal) or studies of dogs, became the occasion for positively theatrical scenes, calm *(Fleshing the Hounds)* or dramatic *(The Stag at Bay)*. Courbet arrived at complex syntheses into which he put all his knowledge of painting and all his love of hunting: *Stags Fighting* (or *Spring Rut*), *The Death of the Roebuck* (or *The Hunting Lunch*), and later *The Death of the Stag*.

He became aware of the need to portray movement, and when he painted a bounding stag he reverted to the foreshortening employed by Géricault to render galloping horses. To record movement and to define his model, he came to use effects close to those of the high-speed action photograph, immobilizing the animal in space. Courbet was truly an exact observer. The sharp definition of the dark pelts against the snow appeared to me for a long time artificial, until the day I saw scenes of animal life on the movie screen. The contrast was just as strong, just as violent as in Courbet's paintings.

The hunt scene is a very special genre that has its own admirers, a genre of particular interest to wealthy or cultured sportsmen rather than to art lovers as such. There are few such hunters in France; there are more in Britain and Germany, where the sport has more followers. Courbet was above all an observing eye, a hand with the ability to render the precise nature of a gesture or situation. He introduced no more sentiment into his hunt scenes than he did into *The Burial at Ornans*. Dramatic as the attitude of the quarry fighting against inevitable death may be, Courbet took great care not to introduce any personal note: neither emotion, nor lyricism, nor tearful sentimentality.

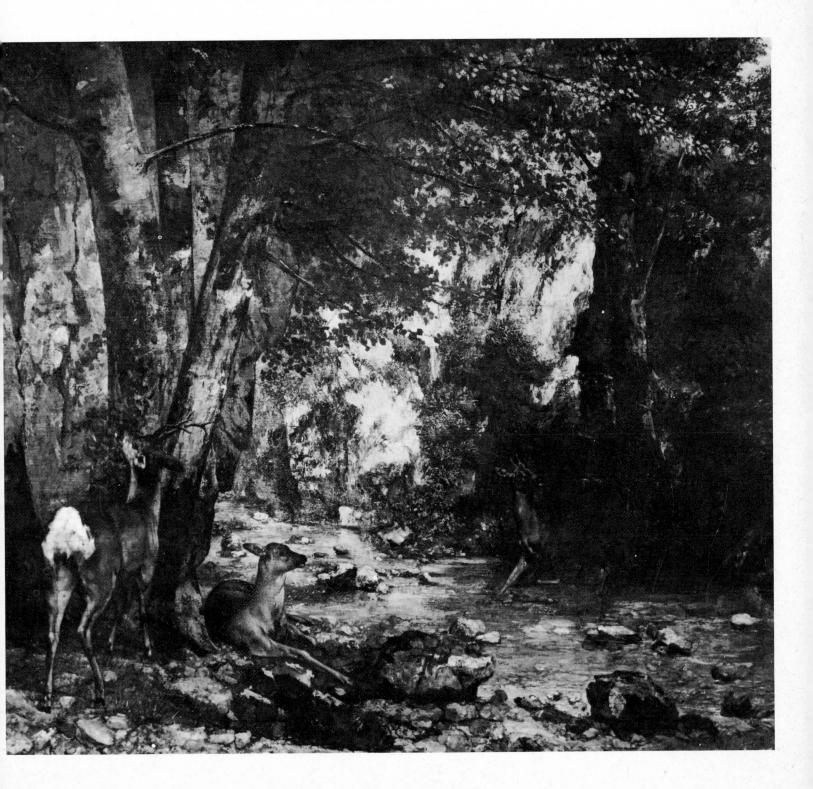

Fleshing the Hounds, 1856
(Museum of Fine Arts, Boston, Henry Lilly
Pierce Fund, George Tappan Francis)

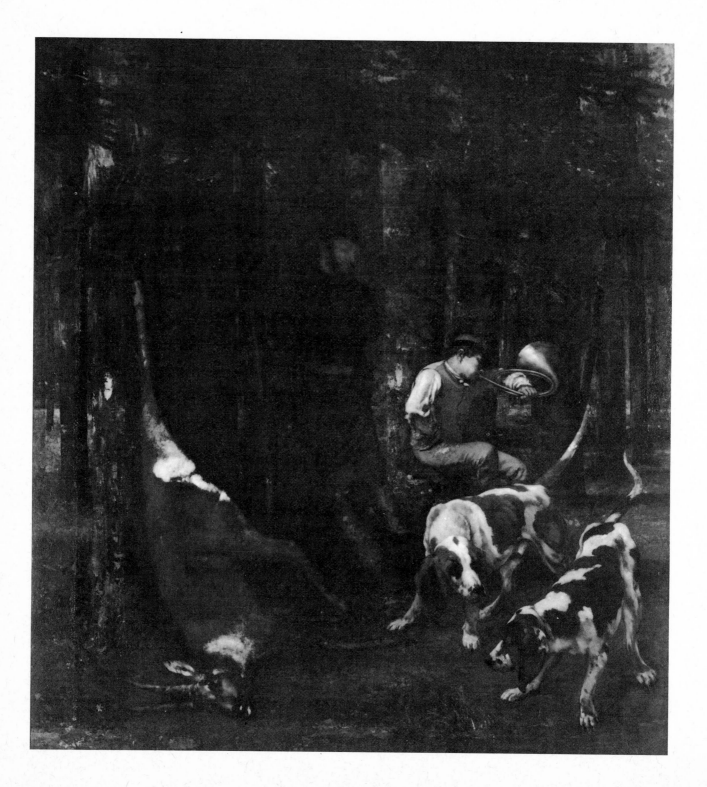

A hunter himself, he did not see, as the French tend to see, the tragedy of the dying animal. Rather, he saw the grandeur of the spectacle, the fierce beauty of a combat without mercy but with its rules — I was about to say, its rites — like a cult that has had its set forms for centuries and which cannot be performed without respecting its precise and exacting traditions, like the *corrida*. That is why this part of Courbet's work was always more appreciated beyond the Rhine and across the English Channel than in France.

A list of the hunts in which he took part demonstrates his passion for the sport. To him art is not a compensation, but an exaltation of life, of action, a safety valve through which a surplus of vitality escapes; and the most impersonal works, such as these hunting pictures, are, like all his work, autobiographical. "A superb adventure. Hunting in the German mountains I killed an enormous stag, a twelve-pointer, that is to say a thirteen-year old stag. It was the biggest killed in Germany for twenty-five years. Eviscerated it weighed 274 pounds. During the summer season, alive, it would have weighed more than 400 pounds. This adventure has aroused the jealousy of all Germany. The Grand Duke of Darmstadt said that he would have paid a thousand florins not to have had it happen... I have been presented with a photograph showing the dead stag with my gunshot wounds. In my right barrel I had a bullet and five pellets of buckshot and a few double zero shots. The shot entered the flank, missing the shoulder, and my bullet came out the other side. As he did not fall, I fired again with five pellets of buckshot and a dozen double zero shots, which struck in the rear, in the right thigh. Those were certainly the two finest shots I shall ever fire in my life. Following this, a hunter gave me a dinner at which 700 glasses of Bavarian beer were drunk. We remained at table until morning."

Other, more esthetic details are contained in a letter to Francis Wey. "This *Spring Rut* or *Stags Fighting* is something I went to Germany to study. I have seen these fights in the forest reserves in Hamburg and Wiesbaden. I took part in German hunts at Frankfurt for six months, the entire winter, until I killed a stag which served as a model for this picture, along with those killed by my friends. I am absolutely certain of this action. Among these animals no muscle shows; the battle is cold, their fury deep; they strike one another with terrible blows and yet they look so harmless; it is easy to imagine what blows they can strike when you see their formidable antlers. Moreover, their blood is as black as ink and their muscular strength is so great that they cover thirty feet at a single bound, with no effort, as I have seen with my own eyes.

"These three pictures[1] constitute a sequence for hunters and treat a theme that is all my own; there is nothing like them either in traditional art or in modern times; there is nothing idealized about them; they are as exact as mathematics.

"The way in which this stag is lit increases the impression of speed in the picture. His body is entirely in shadow and yet modeled, the ray of light that strikes him is sufficient to determine his form; he seems to be passing like an arrow, like a dream; the expression of the head ought to please the English — it recalls the feeling of Landseer's animals." (April 19 and 20, 1861.)

If we look beyond his usual braggadocio, we can see here a vigorous expression of the passion that Courbet put into everything and can observe the extent to which hunting was as much a part of his life as of his painting. He was to find inspiration in it for many years more, until about 1869.

WITH BOUDIN AT HONFLEUR

1859 was the year in which Courbet met Eugène Boudin at Honfleur. If we are to believe the anecdote, Courbet had gone off to Le Havre with his friend "Schanne" to see what they could find. In a shop near the harbor they found some seascapes which excited Courbet and which led them straight to Boudin himself, who was then thirty-five years old. Boudin took

[1] *Spring Rut, The Stag at Bay, The Huntsman (Le piqueur).*

Study for Young Ladies on the Banks of the Seine, 1850 (detail)

Woman with Flowers (Study for Young Ladies on the Banks of the Seine), 1856 (Private Collection)

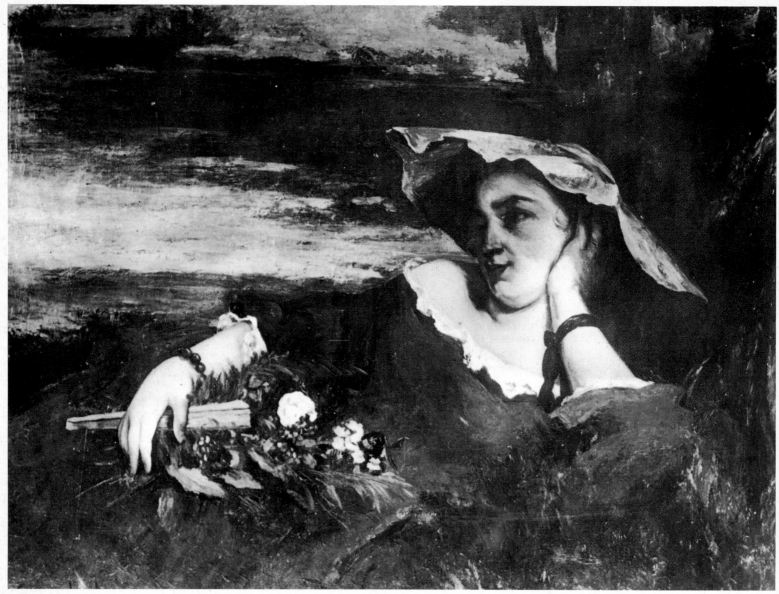

*Study for Young Ladies on the Banks of
the Seine*
(Collection Jean Matisse)

them to the Saint-Siméon Farm at Honfleur, owned
by Mère Toutain. There they spent several days paint-
ing the same subjects, side by side. On the eve of
their departure they met Baudelaire, who lived with
his mother, General Aupick's wife, in the next villa.
As thanks for a dinner Courbet presented the poet
with a painting bearing a dedication, the *Bouquet of
Asters* now in the Basel Museum.

This first contact of Courbet with Impressionism,[2]
or at least Boudin's pre-Impressionism — entirely the

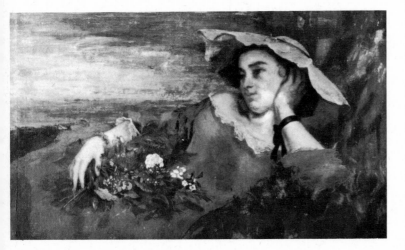

play of light — remained without influence on his work.

From the winter of 1859-60 dates a composition that
is somewhat unusual by virtue of its distribution of light
in broad sheets, *The Preparation for the Wedding*; he
also painted at this time *The Wreck in the Snow*, an
accident scene inspired by an item in the newspaper,
executed on a monumental scale and exhibited the
following year with fourteen other paintings at the
Universal Exhibition in Besançon.

Courbet painted a tremendous amount, at the same
time leading a public and social life, and producing so
much work that it seems impossible to catalog it. Our
guides are his submissions to the Salon. In 1861 he
showed *Stags Fighting, The Huntsman, The Stag at
Bay, The Fox in the Snow* and *Oragnay Rock*. For
the last the jury awarded him a second gold medal.
This gesture was probably made with offensive intent,
but Courbet did not take offense.

In August 1861, at the Congress of Antwerp (where
he had numerous disciples),[3] he enjoyed a triumphal
reception alongside Millet, who showed his *Sheep
Shearer*.

Called upon unexpectedly to expound his ideas,
Courbet wrote: "The basis of Realism is the negation
of the ideal, a negation to which I was led fifteen years
ago by my studies and which, until then, no artist had
dared to advocate categorically. *The Burial at Ornans*
was in reality the burial of Romanticism and has left
nothing of this school except... the pictures of Delacroix
and Rousseau... Today, according to the latest state-
ment of philosophy, we are obliged to exercise reason,

[2] Monet had passed through Honfleur with Boudin in 1852, and it
was later, at the Brasserie des Martyrs, on the boulevards, that Monet
and Courbet met. Boudin was five years younger than Courbet, Monet
more than twenty years younger.

[3] Of his disciples, who included Louis Dubois, Charles de Broux, Henri
de Braekeleer, J. Stobbaerts, Charles Verlat and J. van Beets, those best
known to us today are Joseph and Alfred Stevens (the latter was painted
by Courbet) and the painter and sculptor of the working-class world,
Constantin Meunier.

The Lady of Frankfurt, 1858
(Wallraf-Richartz-Museum, Cologne)

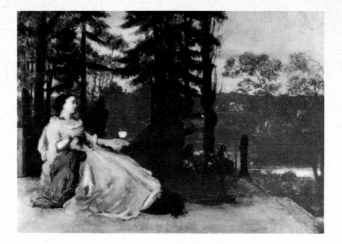

even in art, and never to allow logic to be conquered by sentiment. Reason in everything must be Man's dominant note. My form of artistic expression is the ultimate one because it is the only one until now to combine all these elements. By reaching the negation of the ideal and everything that follows from it, I arrive at the complete emancipation of the individual and finally at democracy." (*Le Précurseur d'Anvers,* August 22, 1861.)

These ideas indicate a profound state of revolt.

THE STUDIO
IN THE RUE NOTRE-DAME DES CHAMPS

In December 1861, under pressure from Castagnary and in order to combat the influence of the Institut, Courbet opened a studio at 83 rue Notre-Dame des Champs. Forty-two students, some of them dissidents from the Ecole des Beaux-Arts, agreed to pay 20 francs to hear Courbet expound his theory of Realism. As a model they used a white-spotted red bull tied to an iron ring. This provoked sarcastic comments in the press and the caricaturists pounced on it joyfully, thus giving the enterprise publicity. Castagnary, better than Courbet, knew how to defend the new conception of the Studio:

"You are tired of the precepts and methods of your teachers. You vaguely realize that they are running counter to the social current; that by following them to the limit you would end by speaking a language that society would no longer understand...

"In the time of the Renaissance the studio was a collaboration. The pupil served his apprenticeship as a painter by painting with and for the master...

"Present-day individualism has rendered the Renaissance studio impossible.

"The inadequacy of the teaching has rendered the modern studio unacceptable.

"A reconciliation has to be effected between these two extremes.

"Make yourselves into a free studio: I shall work in the midst of you. Among us there will be neither masters nor pupils. We shall be, if this humble word does not offend you, workers in the same trade, companions in the same task, joined together to complete our intellectual and manual education...

"For models we shall have all the visible representations that make up Creation: bulls, horses, stags, roebuck, birds, and so on; all the examples that make up society, from the bourgeois to the worker, from the soldier to the peasant, from the ploughman to the sailor. In this way the whole of nature and society will pass before your eyes in their infinite variety." (Castagnary, *Les Libres Propos,* 1864)

But Courbet, if he was passionate in defence of Realism, was not blinded by pride. He did not want to be a teacher like those at the Beaux-Arts, whose tyranny he had rejected; he did not want to "pontificate"; he did not want to be a mandarin. He gave only one piece of advice: "Don't follow advice!"

He pasted up these four commandments in the studio:

"1. Do not do what I do.

2. Do not do what the others do.

3. If you did what Raphael used to do, you would have no existence of your own. Suicide.

4. Do what you see and what you feel, do what you want."

Courbet was the most modern of his contemporaries. He was a century ahead of his time, as is admirably shown by the conclusion of his "manifesto" dated December 25 and printed in the *Courrier du dimanche* of December 29, 1861.

"There cannot be schools, there are only painters. Schools serve only to investigate the analytical procedures of art. No school on its own could lead to synthesis. Painting cannot, without falling into abstraction, allow one aspect of art to predominate, whether it be drawing, color, composition or any of the many other means which in combination alone constitute this art.

"Therefore I cannot claim to be opening a school,

Young Ladies on the Banks of the Seine,
1856
(Musée du Petit-Palais, Paris)

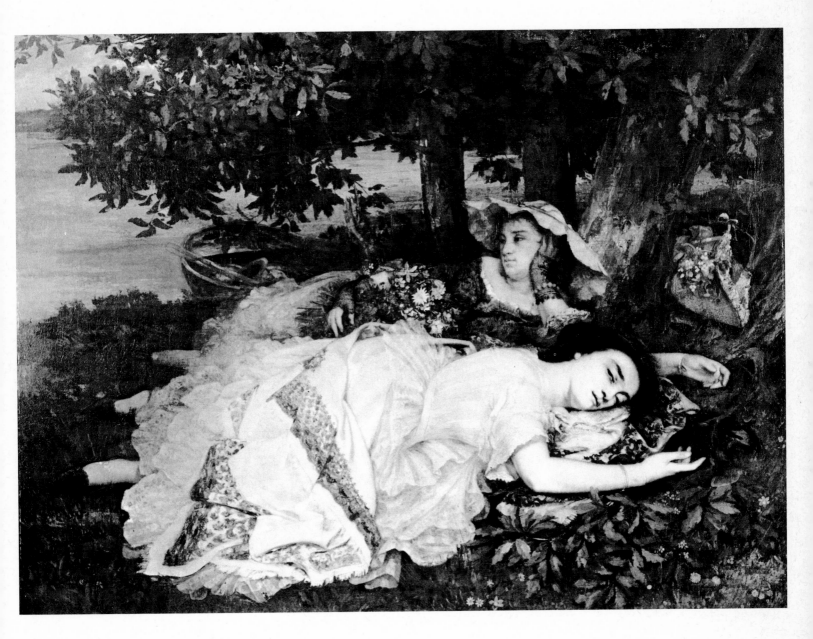

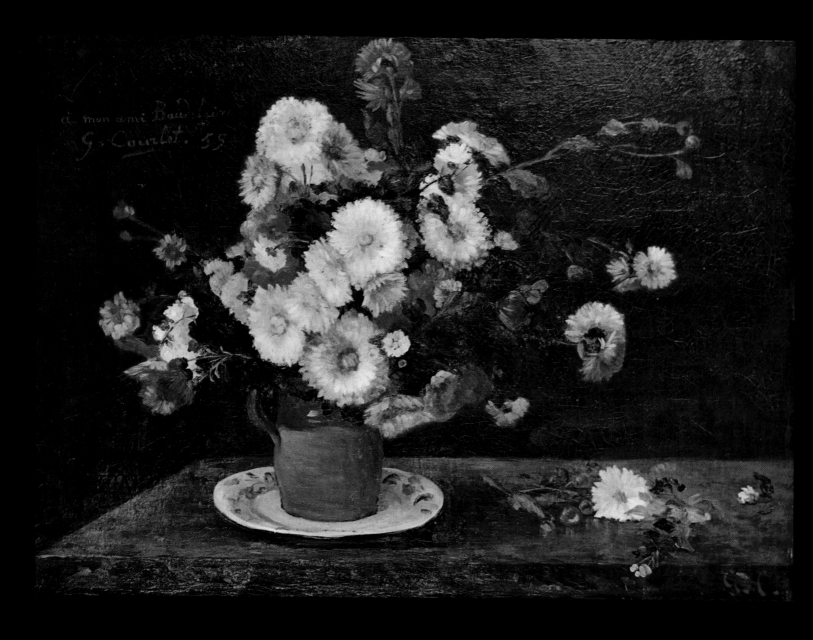

to be training pupils, to be teaching this, that, or the other partial tradition of art. I can only explain to artists, who will be my collaborators and not my pupils, the method by which, in my opinion, one becomes a painter, by which I have myself tried to become one since I started, leaving to each one the entire direction of his individuality, the full liberty of his own expression in the application of this method. To this end the formation of a common studio, recalling the fruitful collaborations of the studios of the Renaissance, may certainly be useful and help towards inaugurating the era of modern painting."

The bull was succeeded by a pony and then by human models. Courbet modeled in front of his pupils his *Fisher for Chavots.* It was his first sculpture and he was very proud of it. But his pupils lacked passion and perseverance. Only Fantin-Latour is still known. The studio closed about a year after it was opened.

IN SAINTONGE

In July 1862, Courbet, freed from the responsibilities of the studio, allowed himself to be carried off by Castagnary to visit Etienne Baudry, a curious character who painted, wrote, and collected art (among other things, he bought *The Young Ladies on the Banks of the Seine*). In Baudry's château at Rochemont, a mile and a quarter from Saintes, Courbet was received as he liked to be — with respect, consideration and warmth. He had many friends there, including Théodore Duret (the author of a book on Courbet) and Corot, who came over from La Rochelle. Feasts were organized and, as usual, ended as drinking bouts. This life pleased Courbet all the more because he had embarked upon quite a deep idyl with a pretty woman of Saintonge, Madame Boreau (*The Lady with the Black Hat*).

All these distractions did not prevent him from working with his customary ardor: first a series of landscapes, sometimes painted alongside his friend Corot: *Rochemont Park, The Banks of the Charente, At Port Bertaud, The Milkmaid of Saintonge, The Valley of Fontcouverte,* et cetera, and a *View of Saintes* that has been compared

profitably with the one Corot painted from the same viewpoint. Rarely have two such different artists painted so similarly.

Up to this time the Jura landscapes had been painted in dark, thick paint, with impetuous energy. In Saintonge, Courbet, who was living in a state of euphoria engendered by friendship and love, showed a gentler side of himself; his paint became more fluid, the light softer, as though he were going to let himself be drawn in Corot's wake. He also painted flowers with a confident strength, although they were a relatively new subject for him. Never again did he paint so many lilacs, magnolias, roses, marigolds, peonies, blossoming cherry branches! He went as far as Fouras, near Rochefort, to paint seascapes.

Courbet was working at such a rate that the studio placed at his disposal by Etienne Baudry became too small for him. He arranged with the director of the Imperial stud farm, at Saintes, to have the use of a large shed and a horse to pose for him. The result was the admirable portrait of the stallion *Emilius.*

Courbet's success in Saintonge was undeniable, and in January a big exhibition was organized in three rooms of the Saintes town hall. Courbet showed no less than forty-three pictures, all painted in Saintonge except one (a view of the *Sources of the Loue*), while Corot (who was now sixty-six and whose work had come to be appreciated since 1855) proved more discreet, showing four canvases. A few works by young painters, notably Fantin-Latour, completed the exhibition and served as a pedestal for Courbet.

In accordance with his principles, Courbet insisted on an entrance fee, 1 franc during the week and 25 centimes on Sunday for the peasants and workers.

"People pay money to go to the theater; aren't my pictures an attractive spectacle? I shall never seek to live by the favor of Governments and I despise patrons. I address myself solely to the public; if they like my painting, let them pay for the pleasure!"

The exhibition created something of a stir in this calm province in the middle of the nineteenth century. Stimulated by the reaction, Courbet conceived for the

The Lady in the Black Hat (Madame Boreau), 1863
(The Cleveland Museum of Art)

1863 Salon a large composition entitled *The Return from the Conference.* A group of priests, some of them drunk and staggering, others riding a small donkey half crushed by their weight, are returning from a banquet washed down with too much wine. The anticlerical character of the picture was quick to cause a scandal. The director of the stud farm, who had been so helpful, requested that Courbet move out immediately. The picture was rejected by the Salon, but *The Huntsman's Horse* and *The Lady with a Black Hat* were accepted. *The Return from the Conference* was later sold by the Galerie Georges Petit — to a no doubt fervent Catholic who is said to have bought it only to destroy it. In the meantime it traveled a great deal and was received with such understanding in England, then in Belgium, that Courbet started to paint a sequel, which he later abandoned, unfinished. He also did a series of drawings on the same theme which were published in an album in Belgium in 1868.

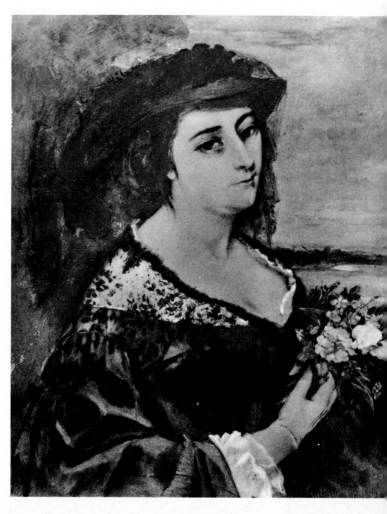

THE SCANDALOUS LARGE NUDES
AND THE PIOUS PORTRAIT OF PROUDHON
AT THE 1867 EXHIBITION

Don't exaggerate my value. The little I have done was difficult to do. When I, like my friends, arrived, you had just absorbed the whole world, like a humane Caesar.

In the prime of your lives you and Delacroix did not have the Empire to say to you, as it said to me: Outside us there is no salvation. You did not have orders to appear in court issued against you; your mothers did not, like mine, make tunnels under the house to keep you away from armed men.

Delacroix never saw soldiers break into his house and erase his pictures with a can of gasoline on orders from a minister. His works were not arbitrarily rejected from the Exhibition; ridiculous chapels were not made with his pictures outside the halls of the Exhibition; annual official speeches did not point him out for public censure; he did not, like me, have this pack of mongrel dogs howling at his heels in the service of their likewise mongrel masters. The struggles were artistic, they were on questions of principle, you were not threatened with banishment.

Gustave Courbet (letter to Victor Hugo, November 28, 1864)

Courbet's situation was steadily improving because he was selling more and more.

It is difficult to compare prices of the reign of Napoleon III with today's. But Courbet's correspondence leads us to note one thing: Today artists sell their small canvases for relatively higher prices than their large ones. Thus a canvas ten times larger than another will be sold for only about five times as much. Courbet seems to have operated the inverse system. While he sold portraits at 300 to 500 francs, or asked 1,000 francs for an unusual portrait or for a landscape that had already become well known, the painter did not hesitate to ask as much as 10,000 or more for his big compositions. No doubt negotiations often led to lower prices, but it seems that Courbet always demanded comparatively exorbitant sums for pictures to which he himself attached particular importance.

From this time on Courbet was assisted by the engraver Amand Gautier, whom he saw constantly, who reproduced his works, published them as engravings, and became, in a sense, his agent — paying close attention to the consignments of Courbet's works and their showing in exhibitions abroad, and finally acting as an intermediary in negotiations made difficult by the painter's intransigence.

Back in Ornans, Courbet was at last able to make use of the new studio which he had had built on the road to Besançon. Its dimensions were appropriate to the huge formats he liked. He sent for a model from Paris and tried his hand at a genre which until then he had not practiced very frequently: the nude.

He went back to the study that he had made at Montpellier of *Venus and Psyche,* which he now called *The Awakening* or *The Two Friends.*[1]

This picture was rejected at the 1864 Salon on

[1] The picture was worked over on several occasions and the parrot was added at the request of the owner during Courbet's exile at La Tour de Peilz.

Blonde Woman Sleeping, ca. 1868
(Private Collection)

Portrait of Countess Karoly of Hungary,
1865
(Private Collection)

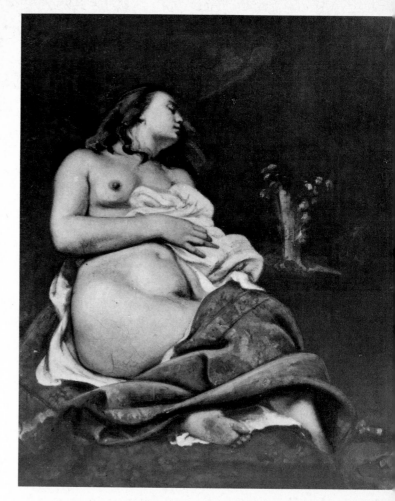

grounds of immorality. Two women tête-à-tête excited people's imagination. In this connection Proudhon recalled George Sand's *Lélia* and Théophile Gautier's *Mademoiselle de Maupin*. Others saw in it a satire on the morals of the age — though I do not know that female homosexuality was particularly widespread under the Second Empire.

From the end of 1861 to 1866 Courbet no doubt painted other nudes besides those which have become famous. We are reduced to hypotheses when we try to imagine what impelled him to paint these women whose luminous flesh makes us appreciate the lightness of the brush of this normally harsh painter.

According to Castagnary, who made himself Courbet's apologist in a way that was as clumsy as it was naïve, the painter was "chaste and modest... chaste and virtuous. Those who were acquainted with him know as I do that he was repelled by lewd thoughts and incensed by the refined hypocrisy of morals under the Empire... This so-called preacher of immorality was always an apostle of morality." I should be more inclined to attribute Courbet's sudden interest in the nude to causes at once fortuitous and profound.

The fortuitous cause was the hiring of models for the studio in the rue Notre-Dame des Champs in 1861; this is the probable date of *The Woman with the White Stockings*, which might be taken for a pastiche of the eighteenth century, and of *The Reclining Woman*, which represents the same model, wearing the same white stockings. Emboldened, perhaps liberated from his shyness with women, Courbet, as head of a school and a studio, dared to hire nude models. (We know by his correspondence with Bruyas that the nude in *The Atelier* was painted from a photograph.)

The "official" reason for his interest in nudes was the repeated accusation made by critics that he was incapable of painting a reasonable nude (I am translating into the language of the twentieth century the flowery metaphors employed by writers on art in his day).

Courbet's previous experiments in this field were few, varied and less personal than his incursions into other domains — with the exception, of course, of the large *Baigneuses* of 1853 and their provocative attitude. Was this provocation intentional? There will always be doubt. Since the works of his youth, *Lot and his Daughters, The Bacchante* and *The Naked Woman Sleeping Beside a Stream,* Courbet had practically never again attacked this subject.

There was a deeper cause — but here we are entering the domain of supposition: in 1864 Courbet was in his mid-forties, rubicund and living on red meat generously washed down with full-bodied wines. This is the age in which sensuality, especially if it comes late, bursts out with the maximum force. Such a sensuality was already latent in *The Young Ladies on the Banks of the Seine.*

We note that if the nudes are indeed realistic, they are not aggressively so. On the contrary, Courbet did not choose as his models working women or peasants deformed by toil and childbearing, but appetizing creatures whose lives seem to have no other object than love.

As always, Courbet's biography is interwoven with legend, and it is impossible for the historian to disentangle the truth from the embellished anecdotes. In any case, the rejection of *The Awakening* by the Salon jury drew numerous sight-seers to his studio, among them Sainte-Beuve, an influential and dreaded critic, who in his turn brought Khalil Bey, former ambassador of the Ottoman Empire to St. Petersburg now living a gay life in Paris. This Oriental with refined tastes [2] fell in love with *The Two Friends* and wished to buy it. Courbet could not accept his offer. ("It has already been sold for 20,000 francs," he said. In fact the purchaser, an exchange-broker named Lepel-Cointet,

[2] His collection contained several Corots, six Delacroixs, including *The Massacre of the Bishop of Liège,* paintings by Ingres, including *The Turkish Bath,* works by Théodore Rousseau, etc.

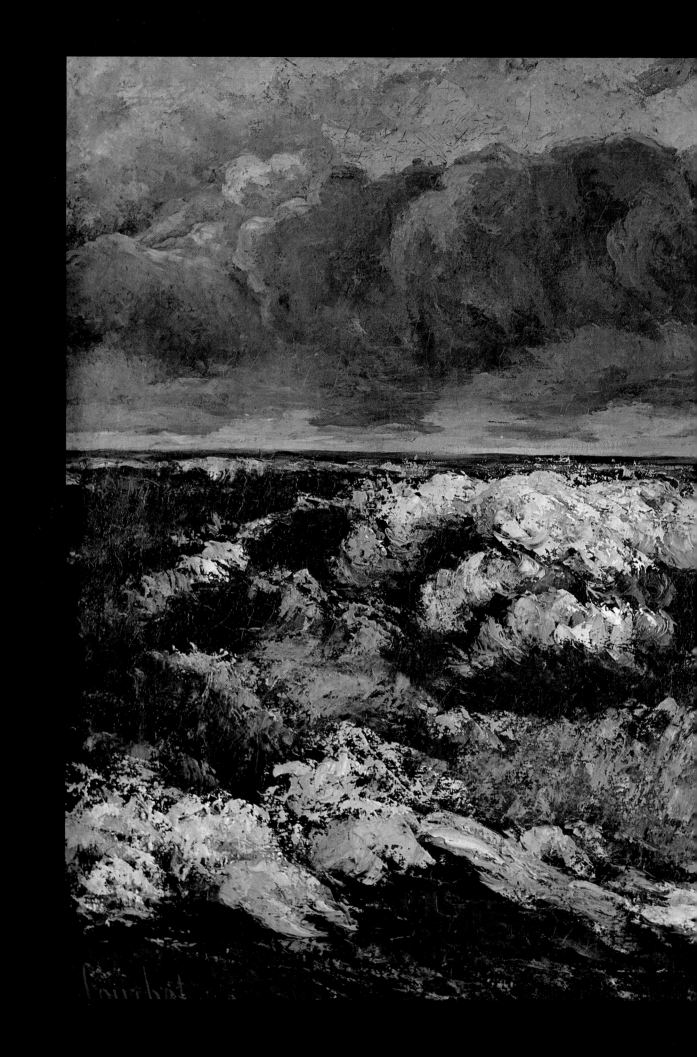

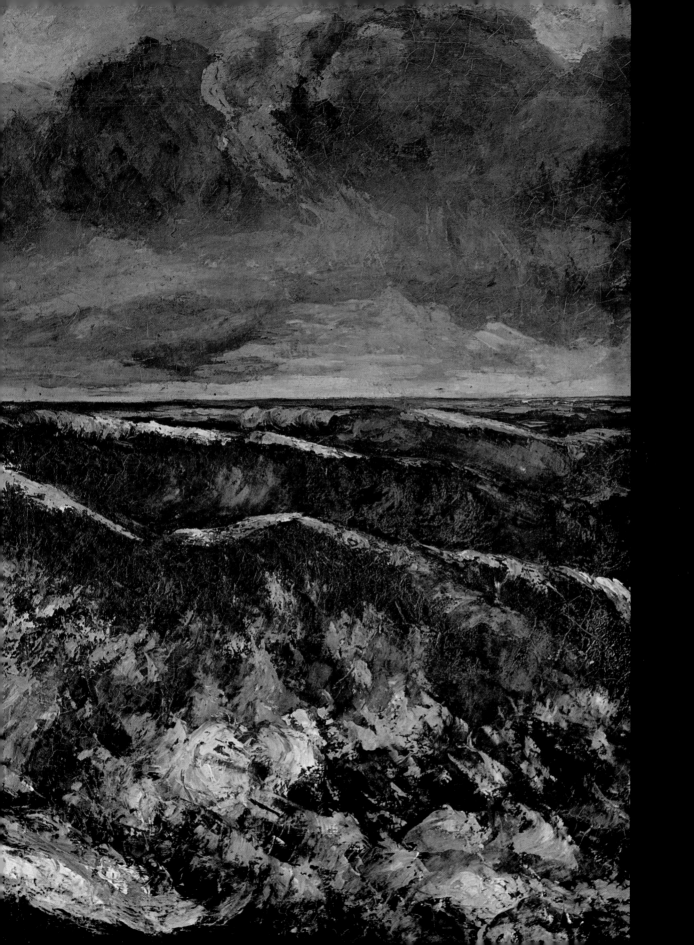

The Brook of the Black Well, ca. 1860
(Private Collection)

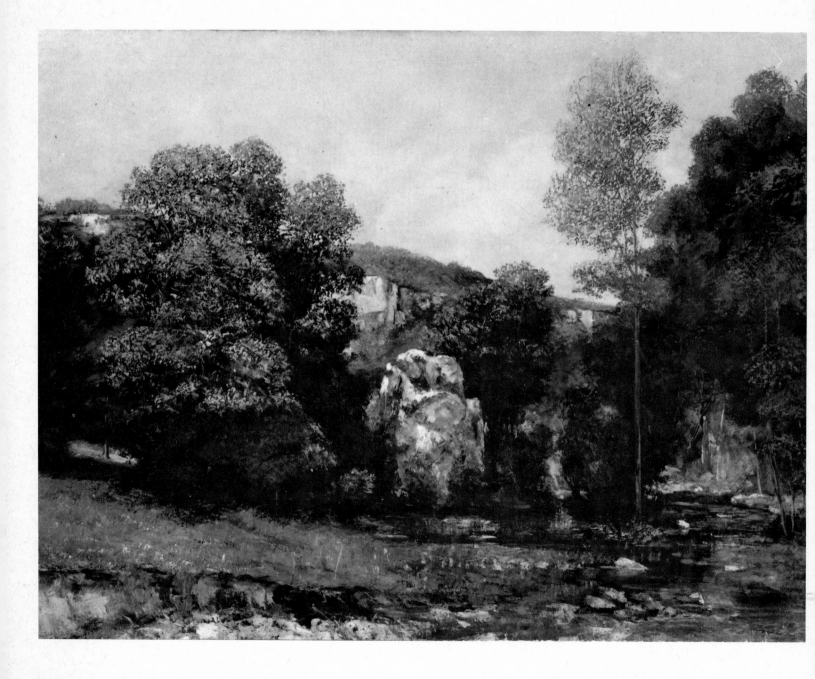

had only reserved the painting.) Courbet therefore proposed to paint the "sequel" for Khalil Bey. This was the origin of that remarkable picture now in the Petit-Palais in Paris, *The Sleeping Girl,* or *Sleep,* the original title of which was *Idleness and Luxury.*

It was also for Khalil Bey that Courbet painted a smaller canvas entitled *The Origin of the World,* which Maxime du Camp described as "a naked woman, front view, extraordinarily moved and convulsed, remarkably painted, reproduced *con amore,* as the Italians say, and constituting the last word in realism. But, through an inconceivable oversight, the craftsman who copied his model from nature has neglected to portray the feet, the legs, the thighs, the belly, the buttocks, the chest, the hands, the arms, the shoulders, the neck, and the head." The painting was concealed inside a coffer on which Courbet had painted a landscape (a château or church in the snow). Confronted by this painting Edmond de Goncourt finally rendered homage to Courbet on June 29, 1889: "Before this painting, which I had never seen, I must make honorable amends to Courbet; this belly is as beautiful as flesh painted by Correggio."

The Awakening and *Sleep* are Courbet's best known nudes, but they are not the only witnesses to this period. *The Woman with a Parrot,* exhibited at the Salon of 1866, *Rest, The Three Bathers, The Spring* and *The Bather at the Spring,* which go together, the *Torso of a Woman* (with the cherry branch) which uses the same models as the *Young Girl with a Kid,* and finally *The Sleeping Nymph* and *The Woman in the Waves* — these form an independent series in Courbet's work, because in them sensuality is mingled with love of nature, because his realism is exercised without satire

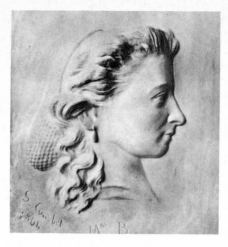

Medallion of Madame Max Buchon
(Musée d'Ornans, Ornans)

through the charm of his models, because there is no provocation unless we consider, as did certain of his contemporaries, that to recreate the texture, the brilliance, and the light of flesh by the skill of a brush was a cause for scandal.

But if Courbet continued to provoke scandal, it was more through his personality than through the content of his painting.

The painting of nudes did not make Courbet forget his friends. As if in need of disinterested affection, he spent some time at Salins with his friend Max Buchon. (He made a medallion showing Madame Buchon's head.) An admirer, Alfred Bouvet, commissioned portraits of his wife, his daughter Béatrice and himself. After this Courbet spent some time at Pontarlier with the Joliclers, and Madame Jolicler acted as his go-between in discussions of marriage with a certain Céline N.... who, reports Georges Riat, considered Courbet "too fat and too old." The affair came to nothing, but Courbet does not seem to have been affected by the rebuff.

THE PORTRAIT OF PROUDHON

While his success, fame, and material security increased — in spite of all the petty harassments to which he was subjected — Courbet remained what he was, what he was born, what he would remain until the end: pure and grandiloquent, pugnacious and magnanimous, intolerable and determined to stand up for his rights. He never laid down his arms; better, he never lost an opportunity to demonstrate his anti-Napoleonic feelings.

An exchange of letters with Victor Hugo gave him such an opportunity. He wrote to the poet: "If you would like to have your portrait painted by me, I owe it to you; I should be very honored to do it." Victor Hugo replied from Jersey: "Thank you, dear great painter, I accept your offer. Hauteville House throws its doors wide open to you.... I shall yield to you my

head and my thoughts. You will produce a masterpiece, I know. I love your proud brush and your firm spirit." Courbet answered with enthusiasm, turning his letter into a profession of Republican faith ending with the words: "Yes, yes, I shall go, even though I do not know to what extent I shall prove equal to the honor which you do me in posing for me." (November 24, 1864) But in the course of the winter, which he spent at Ornans, Courbet learned of the death of his friend Proudhon on January 21, 1865. He never went to Jersey and his relations with Victor Hugo remained at this point. The following summer he went no further than Deauville and stayed there throughout the season. In 1870 he stopped there on the way to Etretat.

Proudhon's death would have a deep influence on Courbet. For several years the philosopher and the painter had been in close contact. Courbet admired Proudhon unreservedly. For his part, Proudhon planned to write a few pages on the artist after *The Return from the Conference* (which he called *Les curés*) had been rejected by the Salon. His point of departure was not esthetic, but anti-clerical. He spoke of his intention to Courbet, and the latter, enthusiastic and proud, made a number of notes for him. Although Proudhon thought the painter inarticulate — Courbet "can neither speak nor write... He has the figure of a Hercules, and the pen weighs in his hand like a bar of iron in a child's" — he wrote that "Courbet is an artist of true genius." Proudhon, a prolific writer (the posthumous edition of his works is monumental), allowed himself to be carried away and the little note on his painter friend became a treatise, *On the Principle of Art and its Social Usefulness*. The work was published a year after his death by Garnier.

Courbet was moved by the death of his friend and shattered by the loss of a man whom he considered one of the most solid pillars of the Opposition. As an act of homage he set about painting his portrait. Strangely enough, however, Proudhon was one of the few members

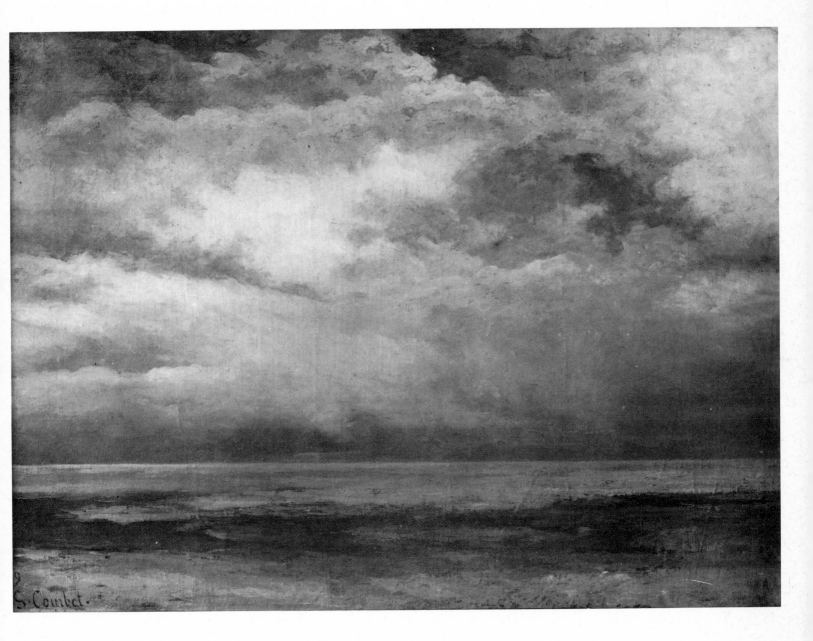

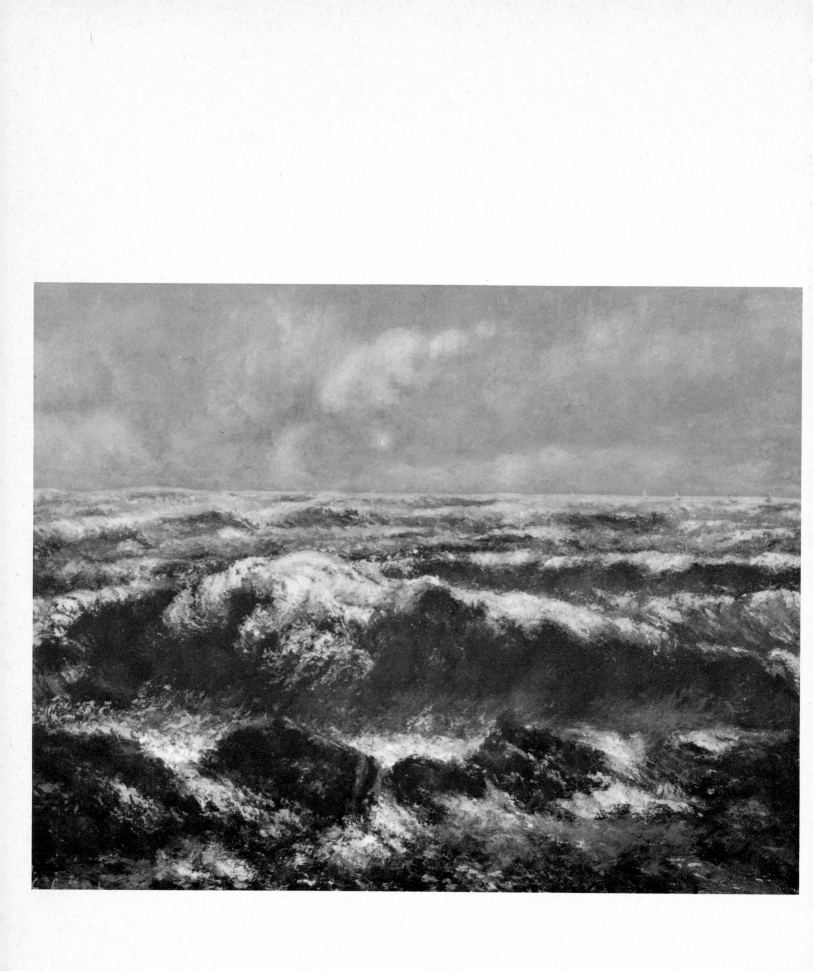

of his circle whom he had never even sketched. He called for photographs, the death mask, and had Proudhon's wife and children pose for him. The result satisfied no one. In order not to displease Madame Proudhon he removed her figure from the picture and shortly afterwards painted a separate portrait of her. In the original painting he replaced her likeness by her workbasket, casually abandoned in her armchair. But the gray wall behind the philosopher also aroused a great deal of criticism. It was later covered by a curtain of foliage. In short, the picture ceased to bear much resemblance to the garden in the rue d'Enfer where, as soon as the sun appeared, Proudhon used to like to come and work on the steps to the lawn. Only the man himself remained extraordinarily true to life, always present, marvelously dreamy, and totally unadapted to practical reality. The following year, for the first anniversary of Proudhon's death, Courbet did a drawing for *La Rue,* the paper published by Jules Vallès. But the censor forbade its appearance and it was replaced by a letter in the painter's handwriting paying homage to the philosopher.

In his report on the 1865 Salon, Thoré-Burger exclaimed: "What a lot of trouble he caused me at the Salon! Every day people said to me, 'Have you seen the portrait of your friend Proudhon by your friend Courbet?' and so on... until I had to admit: 'It is very strange and very precious, very ugly and very badly painted. I don't think I have ever seen such a bad painting by Courbet,' and to conclude: 'This curious picture has been discussed to the limits of intelligence and good sense, particularly by those who have read the eminent writer's posthumous tract, in which he takes Courbet as the basis for an esthetic thesis. Perhaps this esthetic of Proudhon is no less open to criticism than his portrait by Courbet. In spite of his great talent as a logician and his profound awareness, Proudhon lacked all trace of artistic instinct, of feeling for beauty and poetry.' "

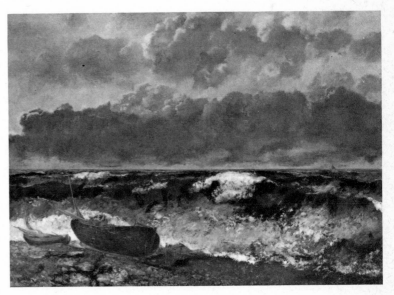

The Source, 1862
(The Metropolitan Museum of Art, New York. Bequest of Mrs. H. O. Havemeyer, 1929. The H. O. Havemeyer Collection)

The Overgrown Stream, 1865
(Musée du Louvre, Paris)

Portrait of Madame Proudhon, 1865
(Musée du Louvre, Paris)

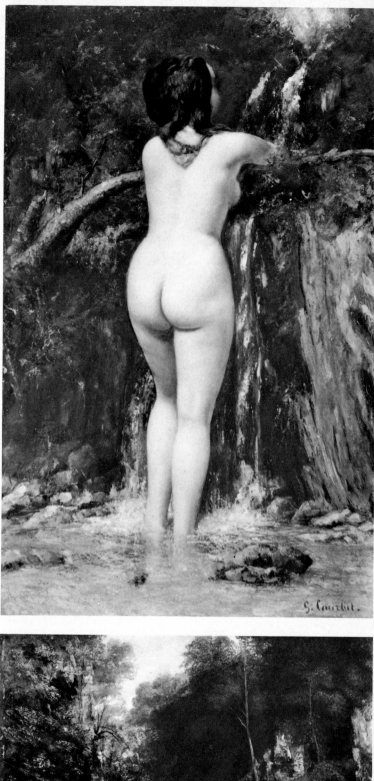

The following year, 1866, Emile Zola went even further in *Mes Haines* (*My Hates*), writing: "Proudhon says he wished only to speak of the pure idea, and his silence on all the rest — on art itself — is so disdainful, his hatred of personality so great, that he would have done better to call his essay *On the Death of Art and its Social Uselessness.* Courbet, who is a personal artist in the very highest degree, has no cause to thank Proudhon for having named him chief of the clean and moral daubers who are collectively to slap their paint over his future humanitarian city."

An analysis of Zola's comments, violent as they are, is nonetheless pertinent. He reproaches Proudhon for not seeing painting as such, for seeing only the idea which emanates — or can be extracted — from the subject. He reproaches him for explaining painting exclusively in terms of its meaning, or its political or religious value, or simply its value to the "vice squad." He reproaches him for preaching the advent of a form of painting having nothing but a social or political function, which would be the death of art. "He forces the picture to mean something; not a word about form.... Leave it to the philosopher to give us lessons, leave it to the painter to give us emotions." In short, Zola delivers the most up-to-date and lucid criticism of the ideas of Zhdanov generally referred to as Social Realism. "You wish to render painting useful and employ it for the perfecting of the species. By all means let Courbet perfect, but I ask myself in what context and with what efficacy he perfects. Frankly, if he piled picture upon picture, if you filled the world with his canvases and the canvases of his pupils, the world would be just as vicious in ten years as it is today. A thousand years of painting, of painting carried out according to your taste, would not be worth one of those thoughts which the pen writes neatly and the intelligence retains forever." The argument between the partisans of "protest painting" and those concerned above all with efficacy, whatever their passion for art, is still at exactly the same point.

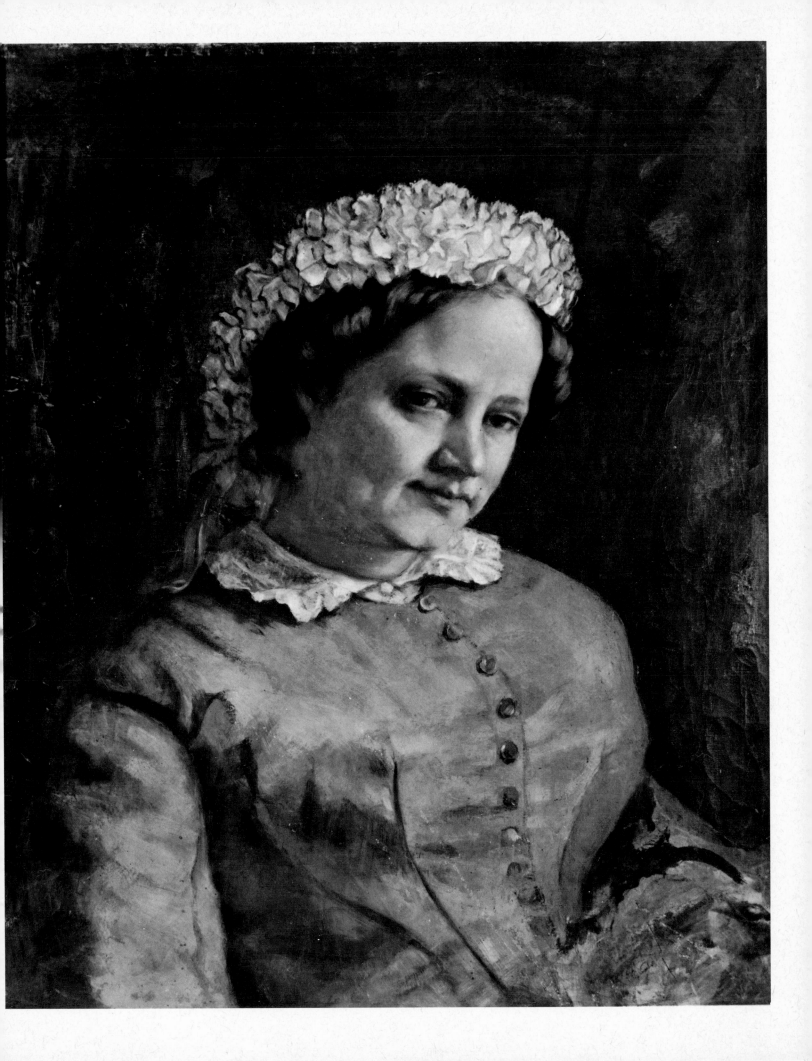

Woman Paddling a Small Boat, 1866
(Collection Roger Hauert)

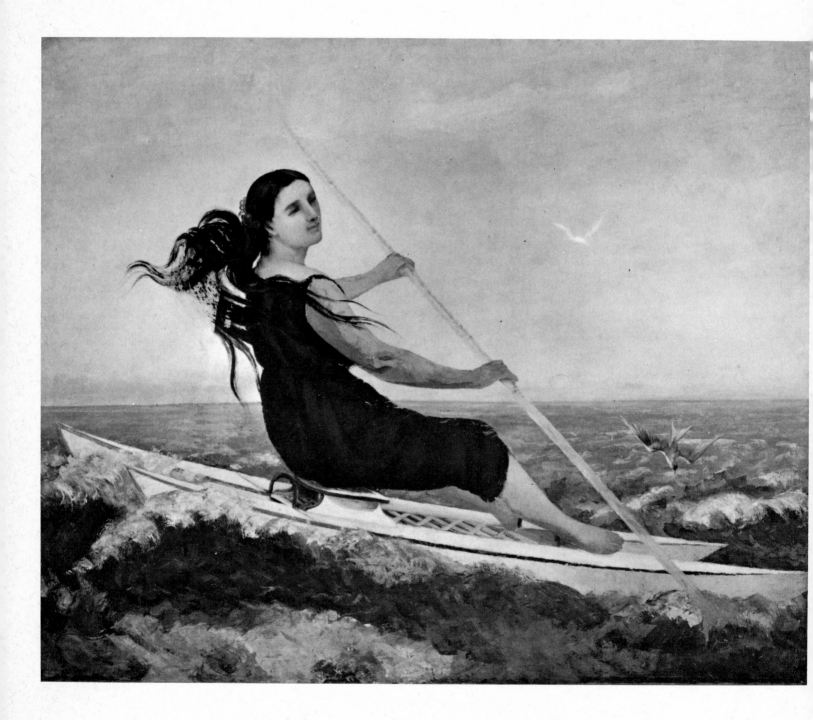

I ought to quote the whole of Zola's premonitory text, but I doubt whether Courbet appreciated it, because the author dethroned his own idol, even if he credited him with genius. Courbet meanwhile occupied himself with Proudhon's widow, not merely by painting her portrait but also by collecting money for her to live on (Bruyas, as always, contributed); the assistance was all the more necessary as the Belgian publisher of Proudhon's *Collected Works,* Lacroix, had just been heavily fined in France.

AT DEAUVILLE

Courbet spent the summers of 1865 and 1866 at Trouville and Deauville, those new resorts made fashionable by the Duc de Morny and the Empress Eugénie. The Opposition painter did not disdain the places where society met. He was invited to stay with the Duc de Choiseul, whose dogs he painted. He also painted Madame de Morny's villa. In 1865 he painted above all numerous seascapes and dune landscapes, and explored the locality, including the Abbaye de Jumièges, in the carriage placed at his disposal by his host. He invited his friends Boudin and Monet to join him. In 1866 he painted primarily portraits of women: *The Young English Girls at the Window, The Lady with the Umbrella, The Lady with the Podoscaphe* (an athletic young woman who rowed from Le Havre to Trouville), *The Girl with the Gull* and the *Portrait of Jo (La Belle Irlandaise).* Jo was mistress and model of James McNeill Whistler, the painter from Baltimore who was influenced by Turner and was a friend of the Impressionists.

The friendship between two such different artists may seem surprising. Whistler was an ethereal poet whose fluid and luminous glazes were aimed at recreating the subtle variations of the atmosphere — the reason he liked the Normandy coast. Courbet, even at Deauville, remained the solid, sturdy and rough Franche-Comté peasant he had always been. Nevertheless their relations continued beyond the season at Deauville and Jo went to pose several times in the studio in the rue Hautefeuille.

It is hard to imagine Courbet living through the early days of a new bathing resort, moving among the aristocracy of the Second Empire, taking daily sea baths. Yet he enjoyed his life so much during these visits that he prolonged them as long as possible. No doubt he spent all his time with a few friends, mostly collectors, but he was so well known both for his painting and for his opinions that his appearance must have roused murmurs that were very flattering and agreeable to his ears. And if he painted seascapes and landscapes with a palette knife with all the vigor of a plasterer handling a trowel, when he painted the portraits of beautiful women he manifested a delicacy and refinement astounding in a man who liked to play the crude peasant. Did Courbet change? Not at all. He preserved all his pugnacity, as the incident at the 1866 Salon with the Comte de Nieuwerkerke may reassure us. The Superintendent of Fine Arts commissioned (or reserved) two pictures from Courbet: a landscape, *The Overgrown Stream* or *Stream of the Black Well,* and a nude, *The Woman with a Parrot.* But in the end he took only *The Overgrown Stream,* for which he paid 2,000 francs and which went into the Empress Eugénie's collection. Courbet then refused the 6,000 francs compensation that he was offered.[3]

[3] An incident recorded in a note in the catalog of the 1867 exhibition.

The Cliffs at Etretat, 1870
(Musée du Louvre, Paris)

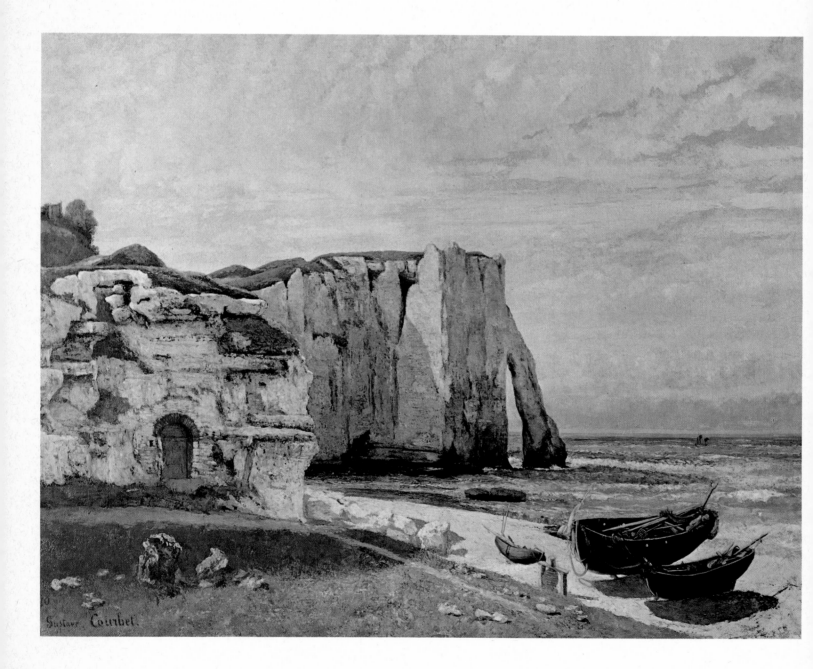

Stormy Sea with Three Boats, 1869
(Private Collection)

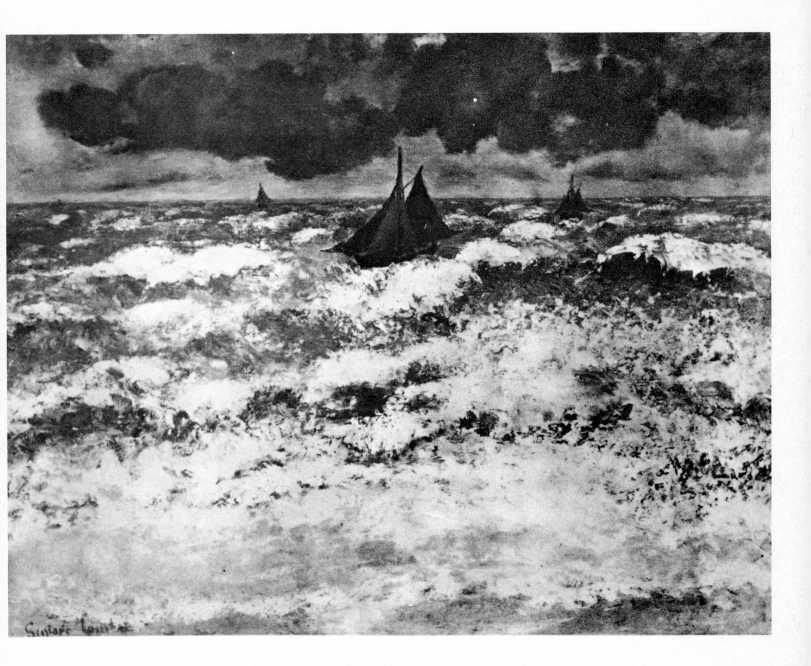

As the Universal Exhibition of 1867 approached, Courbet, who had done a great deal of work at the house of the Comte de Choiseul with this exhibition in view, feared that he would be subjected to the same affront as in 1855. For this reason he sent only four pictures to the exhibition at the Champ de Mars and decided to build a pavilion of his own, this time at the Rond-Point de l'Alma, in order to be close to the heart of the show. To carry out his plan, Courbet appealed, as usual, to Bruyas. He dreamed of a permanent museum. "I have had a cathedral built in the most beautiful place in Europe, on the Pont de l'Alma, with boundless horizons, on the banks of the Seine and in the middle of Paris! And I am astounding the whole world.

"You see that money can produce other things than it does when egotistically placed in the hands of notaries.

"We have lived two-thirds of our lives, alas, what would you do with money, mortal man's money?...

"Another thing: all the painting in Europe is at this moment being exhibited in Paris. I am triumphing not only over the moderns but over the ancients.

"The question is in the balance; I have two hundred pictures on exhibition; I could exhibit twice as many if I took the trouble.

"As an art lover you exercise an influence similar to mine. Bring your gallery; I shall complete it; we will create a second salon to follow the one I have already built. We shall make a million by being right.

"What do 50,000 francs mean to you? If you lost them that would not prevent you from living according to your tastes, with your fortune.

"With another area like the one I already have, we shall have two hundred and four meters in length by ten meters in width and thirty meters in height [about 665 feet long].

"It is the gallery of the Louvre. There is no longer any Champs-Elysées, any Luxembourg, any Champ-de-Mars.

"We shall settle the question all the more easily because it is already done.

"Just think. Your life will be crowned with honor. This is within your power. You will give the slanderers the lie." (May 28, 1866)

In April 1867 Courbet felt obliged to give his friend details of the expenditure, an account that is more entertaining than tedious and illustrates the care that Courbet brought to everything he did. "Julien Belloir, upholsterers, 806 francs; Chéron-Chapoutot, contractor, avenue des Ternes, joinery, 3,415 francs; Gaittet, printer, rue du Jardinet, 514 francs; Gustave Grossard, asphalt, 1,014 francs; Genaille, masonry, 5,500 francs; Galli, stove-setter, 195 francs 30; Leleu, sculptor, 400 francs; Zuccuella, stove-setter, 273 francs 55; Protat, carpenter, 7,252 francs; Georges Masson, iron-worker, 7,000 francs; Morsaline, painter, 3,000 francs; Panière, locksmith, 7 francs 75; Albert Quart, caretaker of the exhibition, 1,684 francs 55; Prudhomme, 215 francs; Michelet, photographer, 733 francs 25; Landart, roofer, 1,800 francs; Laurent, gilder, 66 francs 30; Desachis, molder from the Beaux-Arts, 200; Salmon, picture restorer, 250; Montaignac, restaurant, 784 francs 65; Richer, portable w.c.s, 220 francs; Trotignon, coal, 93 francs 40; Gagin, waterproof cloth, 296 francs 25; Haro, paints, 57 francs; Henri Martin, 2 awnings, 28 francs 45; total 30,000 including small sundries I have forgotten."

Finally on April 27, 1867, he reported: "The building will be handed over on May 5 and opened on May 15. Art lovers and museums have promised their cooperation."

The total number of displays for the Universal Exhibition was considerable. At the Trianon of Versailles an exhibition recalled Marie-Antoinette. At Malmaison another paid homage to Josephine and Queen Hortense. Several artists had followed Courbet's example and put on one-man shows, among them Clésinger, the sculptor dear to Baudelaire, Théodore

Rousseau, and Edouard Manet, whose pavilion was close to Courbet's. People were soon talking about "Courbet's and Manet's gang."

A few notes from the catalog, which had no preface, reveal a Courbet untroubled by self-doubt or modesty.

"This exhibition contains barely one quarter of the works of M. Gustave Courbet.

"In order for it to be complete, a number of important pictures would have had to be brought together, such as *Fleshing the Hounds,* today in Boston, *After Dinner at Ornans,* in the Lille museum, *The Corn Sifters,* in the Nantes museum, *The Stag in the Water,* in the Marseilles museum, *The Roebuck Cover,* in the possession of M. Lepel-Cointet, *The Hind at Bay in the Snow, The Russian Bathing Girl,* in the possession of M. Khalil Bey, *The Atelier, The Return from the Conference,* et cetera, and nearly three hundred canvases scattered among the principal museums in France and abroad, Paris, Bordeaux, Lyons, Marseilles, Saintes,

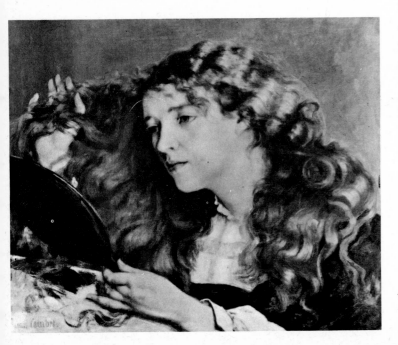

Le Havre, Lille, Arras, Besançon, Brussels, Ghent, Amsterdam, London, Frankfurt and Düsseldorf.

"Since the smallness of the gallery does not permit the painter to exhibit all his works at once, he proposes to change the pictures in the exhibition several times over as new works are sent to him."

He wanted glory during his lifetime and he erected his own triumphal arch: more than a hundred canvases classified by subject in the catalog. A great many visitors passed beneath this arch, but not as many as he would have liked.

A brief survey of the press of 1867 shows a notable change from 1855. Courbet now had his faithful supporters, Théodore Duret, Théophile Thoré-Burger, Edmond About, Castagnary. The other critics proved neither blasé nor indifferent, but more tolerant. Courbet existed, and since they could not suppress him they tended to pick out from his work what they found acceptable, without entering into discussions of principle. The specialists drew back for fear of ridicule, but the caricaturists let themselves go and did their best to ridicule him and make their readers laugh by drawing pastiches of his best-known works. Gill remained moderate, but G. Randon in *Le journal amusant* spared no exaggeration. The number of drawings he devoted to Courbet and the prominence which the paper gave them illustrate the artist's fame and importance.

Naturally enough, as in 1855, Courbet lost a great deal of money in the undertaking. All the more since one of the ticket sellers, a retired Zouave, blatantly robbed him. A court case followed in which Courbet showed himself magnanimous towards the thief, but demanded a stiff indemnity: pictures had been stolen and he insisted that they be tracked down in England.

As relief from this uproar that he himself had provoked, he left in August for a holiday with Monsieur Fourquet at Saint-Aubin-sur-mer, leaving his "museum" in the care of his sisters Zélie and Juliette. He loved

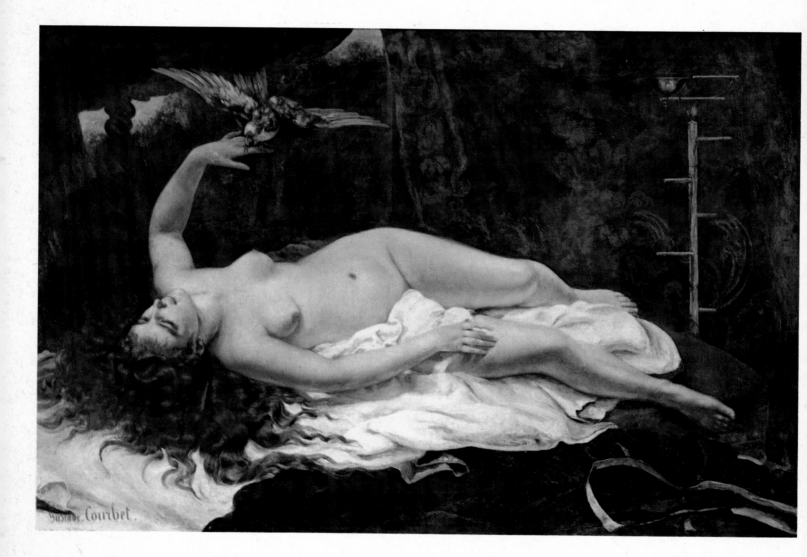

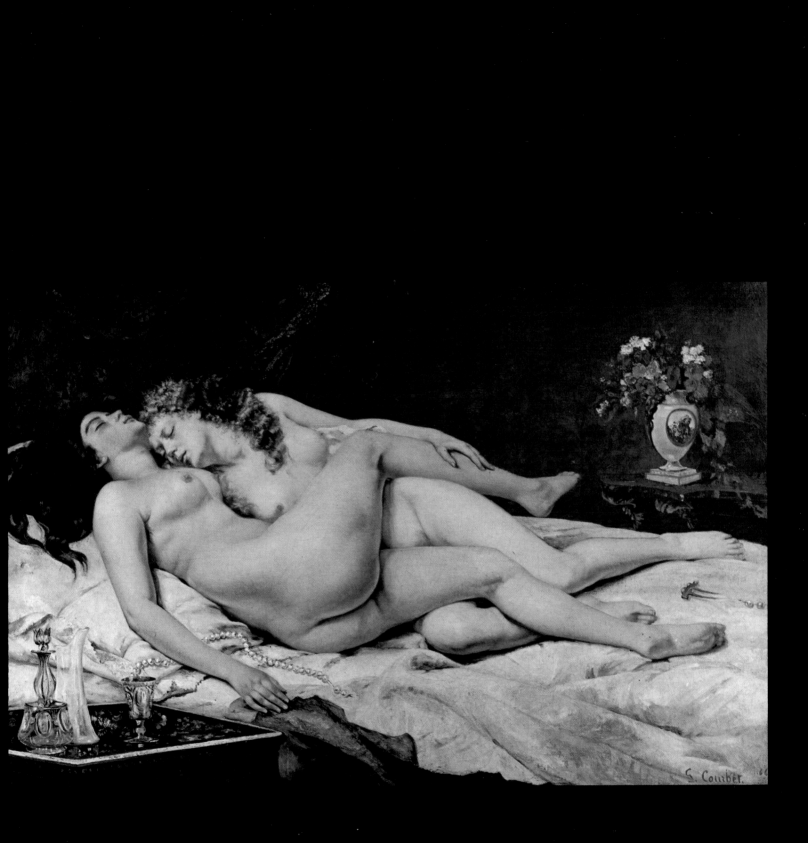

Proudhon and his Children, 1865
(Musée du Petit-Palais, Paris)

Portrait of Pierre-Joseph Proudhon, 1865?
(Musée du Louvre, Paris)

this museum; he would have liked it to be permanent and he suffered when he had to hand it over to the demolition company.

1867 was not only the year of the Universal Exhibition and of the affirmation of Courbet's fame. It was also the year in which Baudelaire and Ingres died, the first insane, the other covered in honors and decorations; the year in which Ferdinand de Lesseps finished cutting the Suez Canal and Karl Marx published *Das Kapital;* but we find no trace of Courbet's reactions to these events. He turned toward other problems. Stimulated by the works of his friend Proudhon, he conceived of a simpler and more direct relation between artists and public. He thought that museums were too pompous and frightened the workers: he imagined permanent and public exhibitions in such places as railroad stations, and he communicated his idea to Etienne Baudry. (A century later, artists have made very little progress in this direction and still meet refusals when they offer to hang their works free in factories!)

In 1868 he sent to the Salon — among other more traditional canvases, including *The Hunted Roebuck Listening — A Beggar at Ornans Receiving Alms,* a grandiloquent canvas with a touch of the caricature about it that was intended to be moving and humanitarian. Criticism of this strange composition was severe and even cruel. But Courbet found consolation in the enthusiastic, not to say triumphal, reception of his exhibition at Ghent. It was there that he published his anti-clerical drawings that were a sequel to *The Return from the Conference* and a reply to the attacks made upon this work in France.

In 1869 he stayed at Etretat with Eugène Diaz, a composer and son of the painter, in order to make numerous studies of waves and the effect of the sun on the sea. There he learned that the King of Bavaria had just decorated him with the St. Michael's Cross, first class order of merit, and bestowed upon him the title of Baron. Courbet was very proud but felt it

109

necessary to explain the difference between such an honor recognizing his merit as an artist and other decorations which he would not accept.

Courbet hurried to Munich, where several of his works were on exhibition, to thank the King. In his exhilaration, he made a spectacle of himself, taking part in beer-drinking competitions and on a bet, painting a large nude, *The Lady of Munich,* in public. He also went to museums and made copies of Rembrandt, Hals, and Velázquez. He met many well-known artists; he was fêted and yielded to the intoxication of his ever-growing fame.

Events seemed to accelerate. He no longer stayed in one place but moved about constantly. From Ornans he went to stay with his friends the Joliclers at Pontarlier. He learned of the death of Max Buchon. Courbet had sold a great deal following the 1869 Salon;[4] he felt rich and wanted to enjoy life. The political situation also seemed to be taking a turn for the better. At the elections in May 1869, ninety-two Opposition deputies were returned to the Chamber, among them Courbet's friend Dr. Ordinaire, deputy for Doubs. In January 1870, the ministry of Emile Ollivier held a plebiscite for the liberal Empire. Courbet, understanding the situation, ridiculed these maneuvers which seemed to foretell of the end of a regime. Increasingly engaged personally in a merciless struggle against power, he held an exhibition at Dijon to aid the wives of the workers of Creusot, where strikes and serious troubles had broken out.

It was at this point that there appeared in the *Journal Officiel de l'Empire Français* on June 22, 1870 the announcement of Courbet's nomination to the rank of Chevalier in the Order of the Legion of Honor. It is easy to imagine the uproar the news caused in the Café de Madrid, frequented by Courbet and his friends, by Jules Vallès, Delescluze, Rochefort, Gambetta, Carjat, and a whole crowd of turbulent revolutionary youth.

Courbet's reply to the Minister of Letters, Sciences, and Fine Arts, Maurice Richard, exists in two versions: Courbet's first draft and the version corrected by Castagnary which appeared on the following day, June 23, in several newspapers. We reproduce the second, which is similar in sense, less violent in form, but even more impertinent than the first in its nuances.

"Monsieur le ministre,
"It was at the home of my friend Jules Dupré, at Isle-Adam, that I learned of the insertion in the *Journal Officiel* of a decree naming me Chevalier of the Legion of Honor. This decree, which my well-known opinions on artistic rewards and titles of nobility ought to have spared me, was issued without my consent, and it was you, Monsieur le ministre, who felt it your duty to take the initiative.

"Do not fear that I misunderstand the sentiments which guided you. Having come to the Fine Arts after a disastrous administration that seemed to have given itself the task of killing art in our country and would have succeeded in doing so by means of corruption or violence if there had not been a few men of courage to bring it to a halt, you wished to signalize your arrival by a measure that contrasted with the ways of your predecessor.

"These procedures do you honor, Monsieur le ministre, but permit me to tell you that they cannot alter either my attitude or my determination.

[4] *The Woman with a Parrot* (15,000 francs) and five seascapes: *Midi* (500), *Heavy Seas* (500), *Storm* (400), *Sunset* (400), *Small Seascape* (100); *Roebucks Crossing the River* (4,000); *Small Nude Woman of Frankfurt* (2,000); *Seascape of Saint-Aubin* (300); another *Seascape of Saint-Aubin* (300); *Nude Woman* (400); *Landscape* (300); landscape of the *Decayed Rock* (400); *Seascape* (300); *Seascape* (300); *Naked Woman of Munich* (4,000); *Landscape with Roebuck* (800); *Swiss Landscape* (600); *Etretat* (400); *Seascape* (300); *Seascape, Saint-Siméon* (300); *Seascape, Sunset* (300); two *Seascapes* (1,000); *Greyhounds* (2,000); *Ecoutot, Mill near Ornans* (3,500) and a *Spring; Mirror of Scey in Varais* and *Scey Mill* (3,500); *Etretat Cliffs* (8,000), a seascape; *Rough Sea* (1,000); *Lake of Brienz* (2,000).

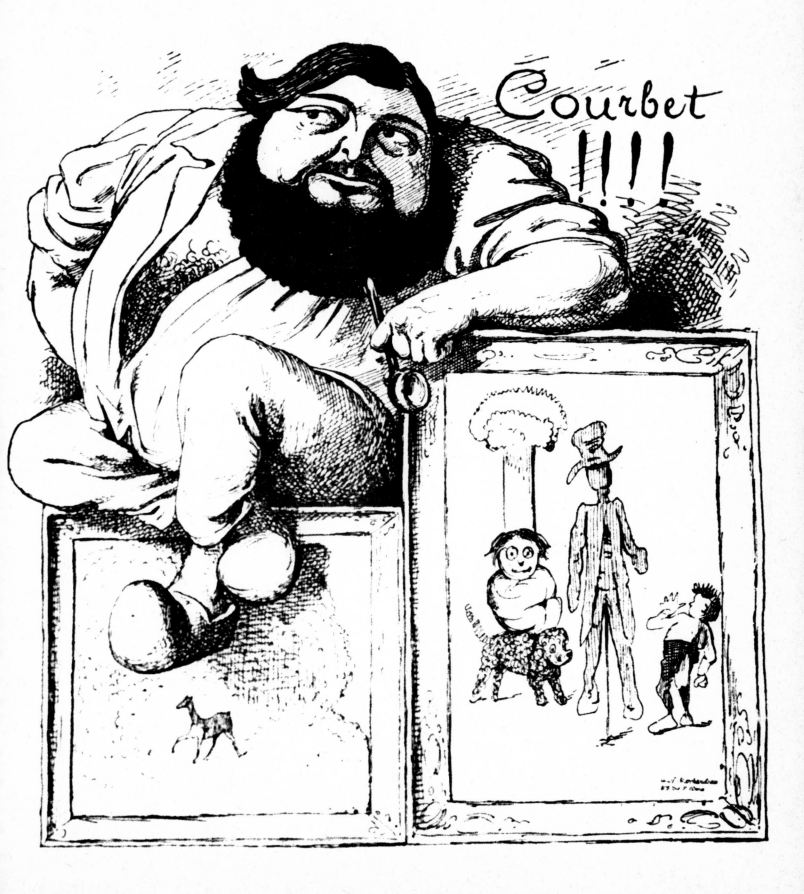

"My opinions as a citizen prevent me from accepting a distinction which comes essentially from the monarchical order. My principles reject this decoration of the Legion of Honor which you decided upon in my absence.

"At no time, in no case, for no reason, would I have accepted it. Far less would I do so today when treason is rife on all sides and the conscience of mankind is saddened by so many self-interested recantations. Honor lies neither in a title nor a ribbon; it lies in acts and in the motives for acts. Respect for oneself and one's ideas makes up the major part of it. I honor myself by remaining faithful to the principles of my whole life; if I deserted them I should abandon honor in order to acquire the outward sign of it.

"My views as an artist are no less opposed to my accepting a reward bestowed by the State. The State is incompetent in matters of art. When it undertakes to reward, it is usurping the function of public taste. Its intervention is entirely demoralizing, detrimental to the artist, whom it deceives as to his own value, detrimental to art, which it imprisons within official expediencies and condemns to the most sterile mediocrity. The wise thing for the State to do would be to refrain from interfering. The day on which it leaves us free, it will have fulfilled its duties toward us.

"Allow me, Monsieur le ministre, to decline the honor you have wished to do me. I am fifty and I have always lived free; let me end my life free; when I am dead I wish people to say: he never belonged to any school, to any church, to any institution, to any academy, above all not to any government, unless it was the government of liberty.

"Allow me, Monsieur le ministre, along with the feelings which I have communicated to you above, to express my profound consideration."

Courbet was fêted by everyone who mattered in the anti-Napoleonic ranks of Paris. Letters poured in; the head of the Liberal opposition, Adolphe Thiers himself, came to congratulate him; a banquet was organized in his honor, and in Daumier's, who was named in the same list of awards and also refused the decoration, but did not make his letter public. This banquet at Bonvalet's marked the apogee of Courbet's fame. On July 15 the Chambers voted a declaration of war on Prussia. A new period began for Courbet, that of struggle, decline and death.

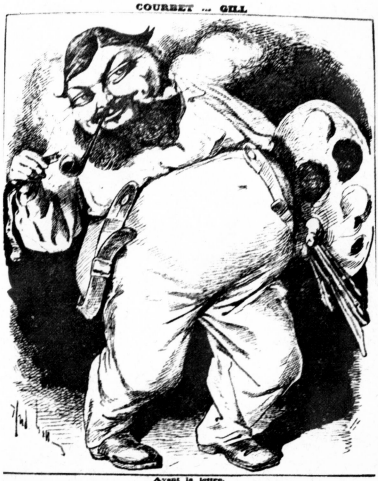

COURBET ... GILL

Avant la lettre.

Courbet's studio at Ornans
(Collection Lienhart, Bibliothèque Nationale,
Paris)

Courbet, photograph
(Collection Lienhart, Bibliothèque Nationale,
Paris)

Chapter 8

COURBET THE COMMUNARD
AND THE AFFAIR OF THE COLUMN
1870-1872

The disinherited of society once more tried to free themselves from exploitation and oppression by their fellows by means of violence. But this time in spite of themselves, as I can bear witness. The men of September 4 pushed them into it to serve their plan and their detestable politics. The revolution was peaceful and a matter of propaganda, which explains why I took part in it. But the massacre took place in spite of us. This was part of the plan of this hateful government, because the liberals of 1830 wanted a repetition of the days of June in order to cover their shame since 1870.

Gustave Courbet (letter to Alfred Bruyas, March 1, 1873)

The historical facts that shook France in the course of the years 1870-71 also turned Courbet's life upside down. Courbet never regarded the artist as an man above laws and political events, as a man soaring above disasters. He always took his place in life; he wanted to be a Frenchman like the others, at the heart of current affairs and concerned by the situation of his fellow men. His status as a painter meant that his struggle was not merely his own, but that of the workers, the exploited, those who suffered.

In 1870, when France was ravaged, when the people took up arms, Courbet was there; he refused to leave Paris; he was ready to take an active part and to complete the tasks he was given. One is tempted to write that Courbet's life emerged from the history of art and entered into history as such, but this would be inaccurate. Courbet's life was so intimately linked with the history of the Second Empire that it straddled both art and politics. As for his role during these crucial years, his participation in the Commune, it would be as tendentious to exaggerate as to minimize it.

Those who see Courbet as an active revolutionary, a political leader, are his enemies: they seek to exaggerate his responsibility in order to condemn him. Those who try to reduce his action to nothing, those who describe him as a characterless individual who allowed himself to be carried away by events and then regretted it, those who consider him to have been ignorant of public affairs and confused by the pernicious theories of Proudhon, are, in spite of their good intentions, dangerous friends. That they wished to save Courbet's work from the disrepute into which it was cast by resentful bourgeois collectors is no excuse. It is impossible — and illogical — to credit the painter with genius and accuse the man of irresponsibility. One does not curry favor at such a price, and Courbet would never have accepted such a cowardly subterfuge.

It is true that when brought before the military court, Courbet, without denying his participation in the

Apples and Pomegranates, 1871, painted in
the Sainte-Pélagie prison
(Mesdag Museum, The Hague)

Still Life with Apples, 1871
(Staatsgemäldesammlungen, Munich)

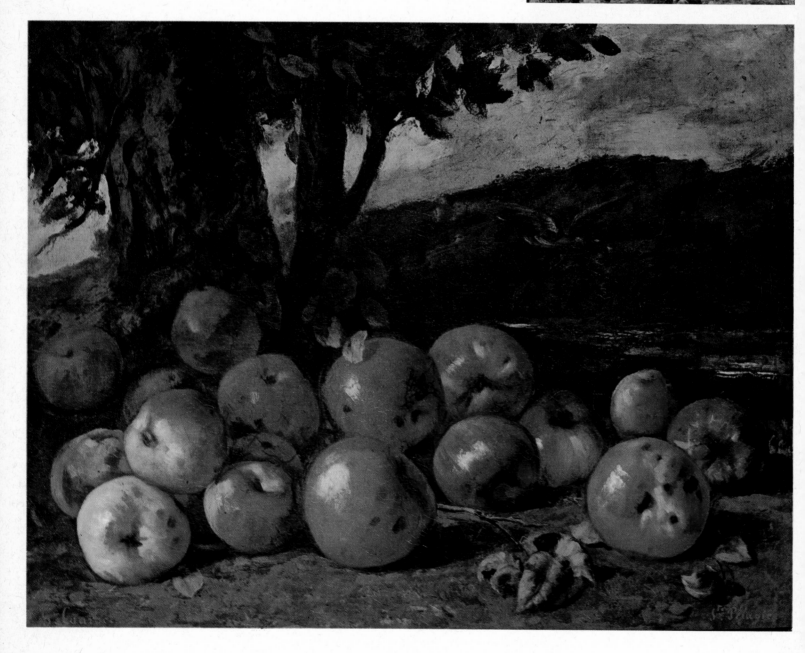

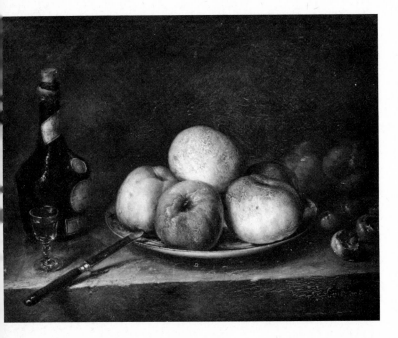

Commune, insisted on the limited nature of his action. It is true that certain people, among them Manet, accused him of weakness, but his attitude throughout was one of great dignity.

In these circumstances it seems necessary to confine oneself to the strictest possible objectivity in tracing Courbet's acts in the course of these dramatic years. I must recall events that are well known but constitute indispensable reference points. The law of silence which the French bourgeoisie of the Third Republic imposed upon everything that took place in Paris between March 18. and May 28, 1871 requires this review.

In September 1870, following a series of military defeats, the Emperor was encircled by the Prussian Army in Sedan and surrendered. Taken as a prisoner to Germany,, he ended his days in England.

On September 4 the National Assembly proclaimed his dethronement. He was replaced by a Government of National Defence known as the "Government of September 4" which brought together General Trochu, Gambetta, Rochefort, Jules Ferry, Arago, and Crémieux.

On September 6 the artists elected a commission to safeguard art works. Daumier was a member and Courbet was made its president. With the agreement of the minister Jules Simon the commission established itself, not without difficulty, in the Louvre and took effective steps to safeguard the masterpieces threatened by the Prussian bombardment of Paris. Pictures and statues were put in crates, doors and windows protected. Similar measures were taken at the museums of the Luxembourg and the Cluny, at the Gobelins tapestry works, and at the Sèvres porcelain factory. Later, Courbet took the same care to preserve the collections of Thiers when the Commune decreed the destruction of the minister's house. His behavior was by no means that of an iconoclast, but that of a man devoted to art and determined to save all the testimonies to the past, irrespective of all esthetic or personal considerations.

117

On September 14, in his capacity as president of the commission, Courbet transmitted to the Government a petition from the artists demanding the "removal" of the column commemorating Napoleon in the Place Vendôme, on the following grounds:

"On the ground that the monument is devoid of all artistic value, tending by its expression to perpetuate the ideas of war and conquest inherent in the imperial dynasty but rejected by the feelings of a republican nation... that for this reason it is antipathetic to the genius of modern civilization and the idea of universal brotherhood... on the ground also that it wounds their legitimate sensibilities and makes France ridiculous and odious." At the same time the commission demanded that streets bearing the names of victories should have their names changed. In Courbet's view, the column ought to be transferred to the Hôtel de la Monnaie (the Mint) and the reliefs from the plinth to the Hôtel des Invalides. The choice of the Mint leaves a doubt: was the column to be preserved or melted down and struck into coin?

On September 24 Courbet was elected to the Commission of Archives charged with investigating the activities of the previous officials of the Beaux-Arts.

On October 29, in the course of a public debate organized at the Atheneum by Victor Considérant, Courbet, in his *Open Letters to the German Army and the German Artists,* proposed the idea of a monument to Peace consisting of a cannon with its muzzle in the air, topped by a Phrygian bonnet and mounted on three cannon balls, to be erected in the Place Vendôme. It seems that he had already discussed this idea four years earlier with the sculptor Clésinger, when the latter was working on a memorial conceived by Napoleon III which never advanced beyond the model stage.

In the middle of January 1871, Paris was encircled by the Germans and battles were fought on its outskirts.

On March 18, when the Germans, having obtained satisfaction, lifted the siege, the National Guards refused to hand over their arms to Government troops of Thiers. The people of Paris, humiliated by the defeat and by the attitude of the new Thiers government, rose in revolt, occupied the Town Hall and opposed the Provisional Government of September 4. The Commune was established; Paris was the first city in the world to experience Socialism.

On this same March 18 Courbet went to the Père Lachaise Cemetery, where Victor Hugo was burying his son Charles, and bowed before the great poet's grief, a meeting recorded by the latter in *Choses vues.*

On March 26 elections took place. Courbet won 50,000 votes but was not elected. He was elected on the next occasion, on April 16, in the VIth *arrondissement.* On April 21 the decree ordering the demolition of the Vendôme Column was passed.

Meanwhile Courbet did not remain inactive.

On April 5 he launched an appeal to the artists and called them together in the great amphitheater of the Ecole de Médecine. There he set out his proposals for the reorganization of the arts on democratic principles. The Salon would be free from all governmental interference; it would be directed by artists who would themselves decide the awards. Medals would be abolished; a separate room would be set aside in which those who refused even the judgment of their peers could exhibit. His plan included reorganization of the administration of the museums according to the most democratic rules, and the suppression of both the Académie des Beaux-Arts and the Ecole des Beaux-Arts; the pupils themselves would elect their teachers, who in their turn would vote prizes enabling students to go abroad to study the arts in the country of their choice. Reading these proposals we imagine ourselves to be projected a century ahead, to Paris in May 1968.

On April 17 Courbet was elected President of the Federation of Artists, which had forty-seven members, including Manet, Corot, Daumier, Amand Gautier, Bracquemond, André Gill — and Millet, who was then

Portrait of Castagnary, 1870
(Musée du Louvre, Paris)

Portrait of Jules Vallès, ca. 1866
(Collection Charles Boreux)

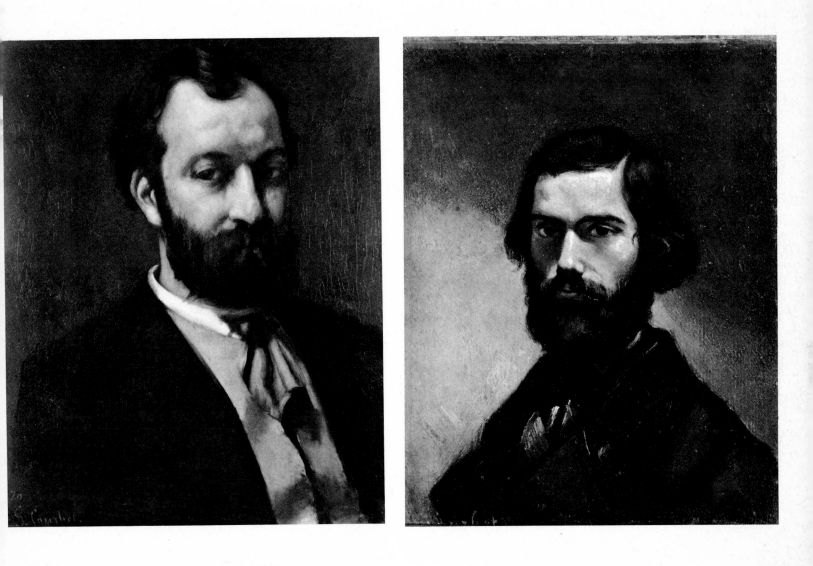

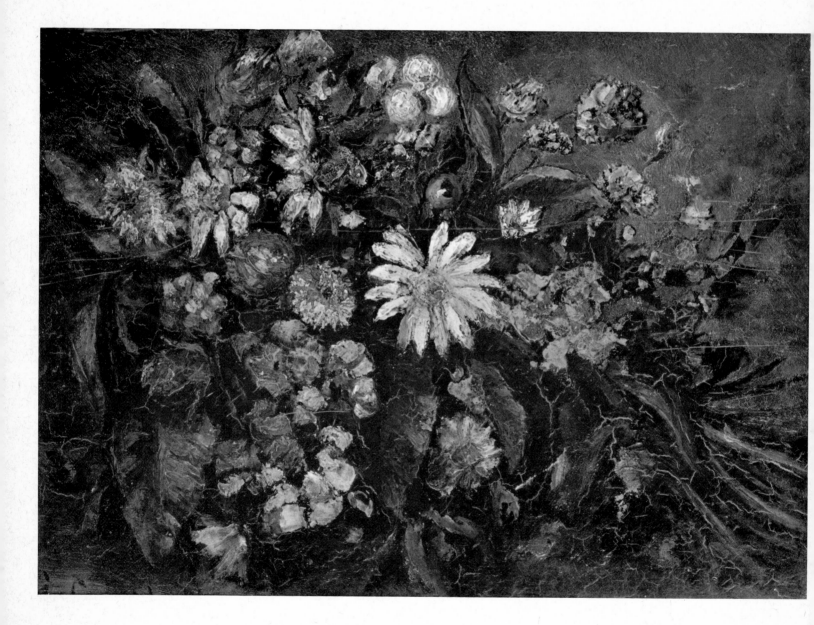

at Cherbourg and who declined "this honor." On April 23 Courbet was elected to the Paris Commune and appointed delegate to the Beaux-Arts and member of the Education Commission.

Courbet was happy because he felt himself useful and hoped, not without vanity, to be able to realize the great humanitarian dream that had haunted him since his childhood. He wrote to his parents: "Here I am, at the wish of the people of Paris, up to my neck in political matters. President of the Federation of Artists, member of the Commune, delegate to the Town Hall and to the Ministry of Education: four of the most important functions in Paris. I rise, breakfast, sit in committee and preside twelve hours a day. My head is beginning to feel like a baked apple. In spite of all this racking my brains to understand things I am not familiar with, I am in seventh heaven. *Paris is a true paradise:* no police, no stupidity, no extortion of any kind, no argument. Paris is going along on its own, as though on rollers. It ought to be able to remain like this always. In a word, everything is enchanting. All State bodies have formed a federation and are linked together.

"In our leisure moments we fight the pigs [*saligots*] of Versailles. Each one does it in turn. They could fight for ten years as they are doing now without being able to force their way in, and when we let them in it will be their tomb." (April 30, 1871)

The demolition of the column was set for May 5, the anniversary of the death of Napoleon I, but for technical reasons it was postponed several times and did not take place until the 16th. It seems that Courbet was not kept informed of the development of the preparations and, for his part, was uninterested, preoccupied as he was by his various duties and his plans for reform. It is not even certain that he was present at the fall of this column. He detested it but for him it was only a symbol, and he had other, far more concrete and effective tasks to fulfill.

The event has been described by Maxime du Camp in *Les Convulsions de Paris* and by Catulle Mendès in *Les soixante-treize journées de la Commune.* Mendès is ironic: "People now wanted pieces as relics. It was like the time of the 'souvenirs of the siege,' when little pieces of black bread were sold, framed and put under glass. The rush for the spoils was about to begin when the National Guards crossed their bayonets over the barricades."

The *Journal Officiel* was more sober: "The decree of the Commune of Paris ordering the demolition of the Colonne Vendôme was carried out yesterday to the acclamations of a dense, observant, serious and thoughtful crowd, watching the downfall of a hateful monument raised to the false glory of a monster of ambition.

"The date of February 26[1] will be glorious in history, for it consecrates our break with Militarism, that bloodstained negation of all the rights of man.

"The Commune of Paris had the duty to throw down this symbol of despotism; it has fulfilled it."

It is not our purpose to analyze the reasons for the collapse of the Commune — privations, exhaustion, lack of organization. After the "Versaillais," the government troops, had taken the fort of Issy, Paris lived through the most dramatic hours of its history. Terror reigned; there was total confusion. The Palais des Tuileries and the Town Hall were in flames, but from the Louvre Courbet continued to direct salvage operations. On May 28 the troops of Thiers' government entered through the Porte de Saint-Cloud. All resistance had ceased, but not all violence.

The "Versaillais" arrested all suspects and shot them on the spot. Repression had begun.

Courbet vanished.

During this time some Ornans Bonapartists mutilated Courbet's little statue, the *Fisher for Chavots,* that decorated the fountain, and the municipality had

[1] A preliminary peace treaty was signed at Versailles on this date.

*The toppled statue of Napoleon after the
fall of the Vendôme Column*
(Bibliothèque Nationale, Paris)

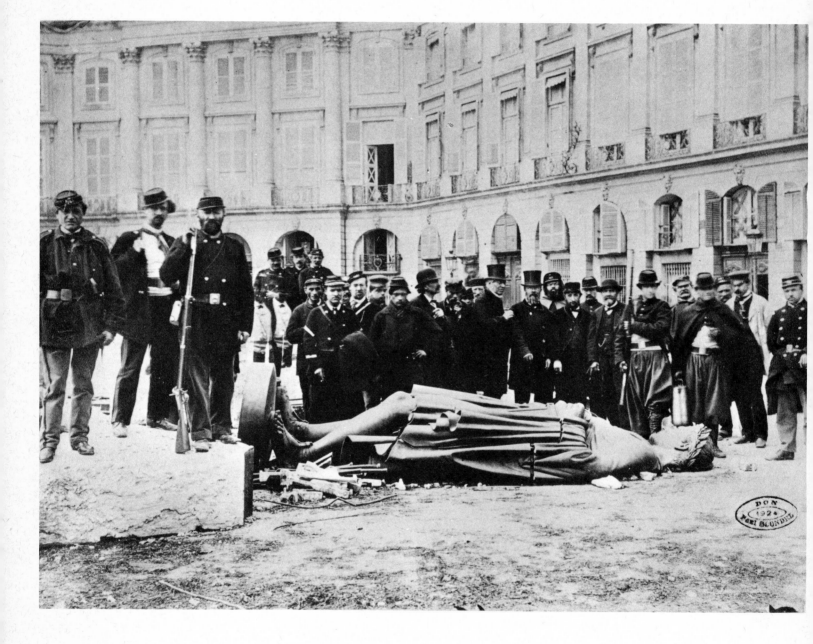

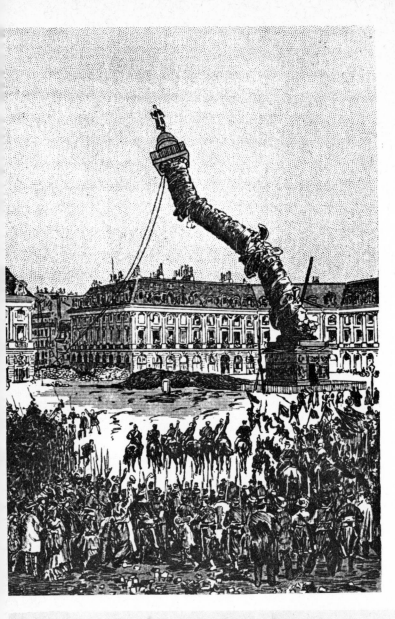

Fall of the Vendôme Column, engraving by D. Vierge (*Le Monde Illustré*)

Fall of the Vendôme Column, The Illustrated London News, May 27, 1871

The Place Vendôme, May 29, 1871, watercolor by Pils

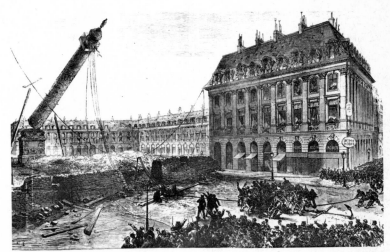

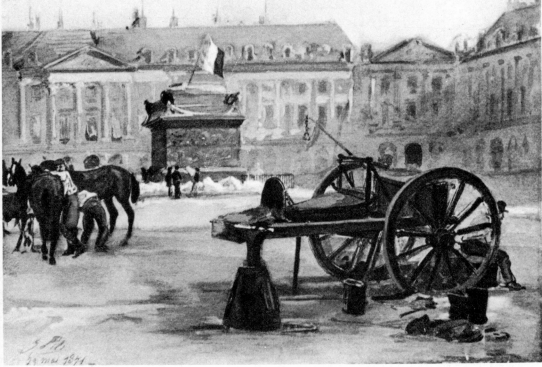

COURBET

it removed. Rumors were rife: Courbet had committed suicide, Courbet had died at the barricades. On June 3, after hearing this news, his mother died. Meanwhile the family received sympathy letters whose loyalty was deeply moving. They were signed by Alfred Bruyas and Champfleury.

Courbet was being hunted.

On May 30 the house of his cousin, Mademoiselle Gérard, was searched on suspicion that he had taken refuge there. In vain. A second police search was followed by the seizure of 206 canvases. On June 2 his studio in the rue Hautefeuille was searched. Once more in vain.

Finally, on June 7, Courbet was arrested in a musical instrument shop belonging to a certain A. Lecomte, at 12 rue Saint-Gilles. Emerging from a closet, he is said to have exclaimed: "I would have grown old in there; thank you for setting me free." According to Georges Riat, he opened the door himself and the police officer said to him: "Without hair and without a beard you are practically unrecognizable; but you did not count on your accent, which gave you away."

Questioned at the Palais de Justice, he declared that he had been part of the Commune only since April 20, participating in order to prevent excesses, and that he did not accept any responsibility for the excesses that had been committed.

Courbet was interned in the Château de Versailles, where he made some sketches of prisoners, in the Orangerie and in the Large Stables. He suffered from the conditions of the internment and his health deteriorated.

Meanwhile he repeatedly wrote letters to the Minister of Education, Jules Simon, and to Jules Grévy, President of the National Assembly; he drew up a memorandum giving precise details of his activities under the Commune, intended to facilitate the defense offered by his lawyer, Maître Lachaud, and containing these lines:

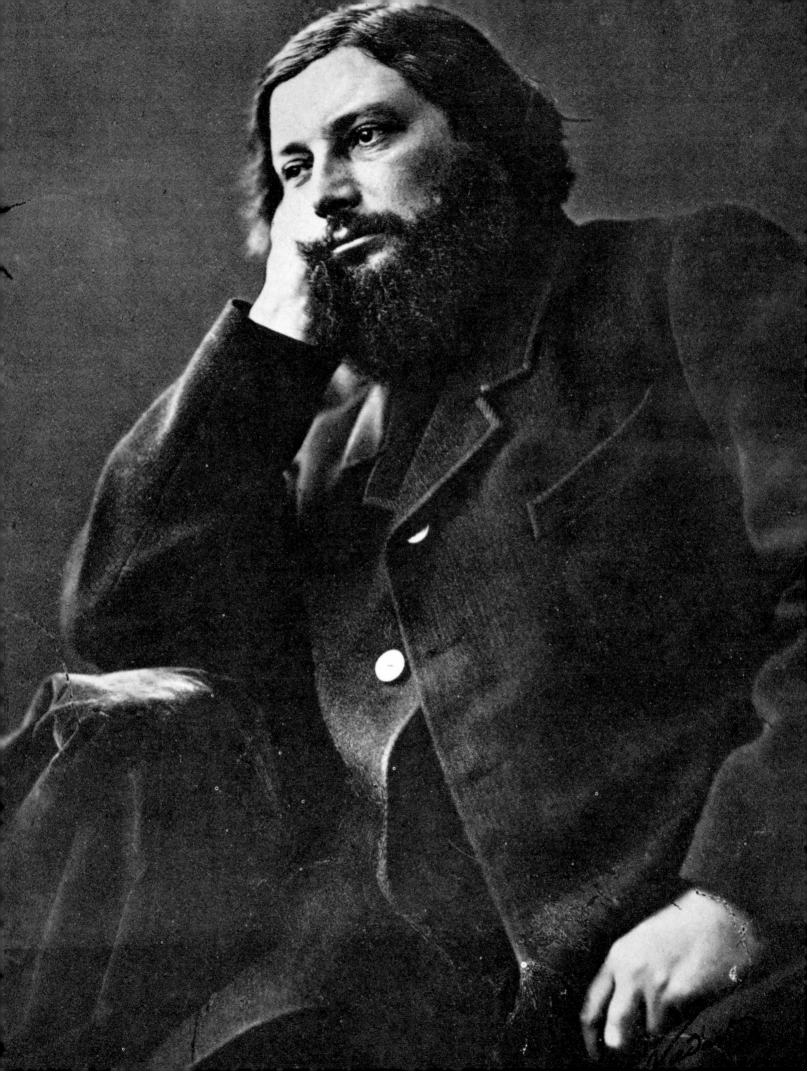

The Trout, 1872
(Zuricher Gesellschaft, Zurich)

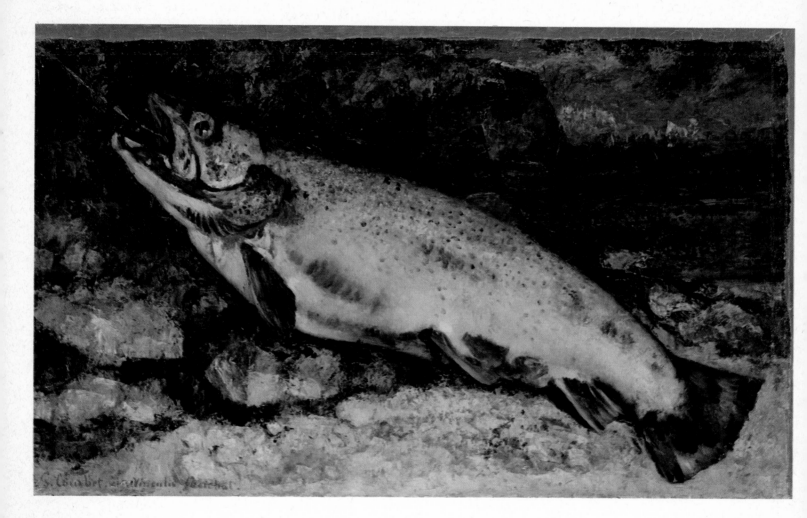

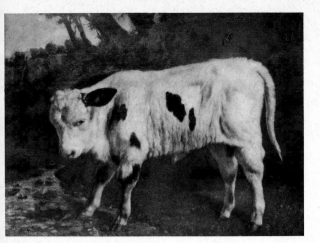

The Calf, 1872
(Private Collection)

"And yet I never wished to destroy it [the Vendôme Column]. My only desire in respect of this hollow phantom was to deprive it of its moral influence, by rendering it a dead letter to history. I wished to render it a museum piece, like the army pensioners who put it up, an object of art in keeping with the idea that produced it. I wished to render unto Caesar that which was Caesar's, to place it in the domain allocated by the capital to war and its institutions and memories. In a word, I wished to have everything in its place, classified by order, and to provide modern civilization with free ways, without detours.

"The idea of destruction is far from me. I am an artist and creator, just as men of war are destroyers. Nothing hampers, nothing influences my free thought. I draw from things the indications useful to my ideas and my life. I am an anti-iconoclast because the contrary would humiliate the pride of my individuality. Unlike the Versailles Government, I fight my enemies without destroying them, and after victory, far from massacring them, I would protect them and encourage them to find out whether I was right; for I distrust the rightness of the man who talks alone or who would destroy the museums to make people believe in his art."

In August he was brought before the Council of War with eighteen other members of the Commune. He was found guilty of criminal intent, incitement and levying troops, usurpation of official functions, and complicity in the destruction of a monument. He ceaselessly reaffirmed his position and the exclusively moral nature of his actions, without ever disavowing the great dream in which he had believed.

It was an aged, sick man with white hair who appeared before the tribunal. Neither the press nor the caricaturists spared him, and they ridiculed the leather cushion that he always kept with him because of his terribly painful hemorrhoids.

Despite the testimony of one of those accused with him, Paschal Grousset, who took full blame for the material destruction of the column, Courbet was condemned to six months' imprisonment, a fine of five hundred francs and the costs of the trial. Some people thought this a mild sentence. Other members of the Commune were sentenced to death or "transportation" (forced labor). But the Third Republic continued to harass Courbet unmercifully, rendering any normal life impossible, cynically hounding him to death.

His state of health had made it necessary to send him to the Versailles military hospital. He wrote to his sister: "I was very happy to be transferred to this hospital. I have entirely recovered from my sufferings in solitary confinement. Solitude weakens the brain. It is three weeks gained from misfortune. I am as thin as on the day of my first communion."

No sooner had he recovered than he was interned at Sainte-Pélagie, a prison that has since disappeared but which then stood near the Jardin des Plantes, between the rue Monge and the rue du Puits de l'Ermite, that is to say roughly on the site of the present Paris Mosque. He remained there until the end of December 1871. With difficulty he obtained both permission to paint and the necessary materials. But he was not allowed to receive models. From these three months date a number of delightful still-lifes, full of vigor and breathing with life, and the famous *Self-Portrait at Sainte-Pélagie;* with a pipe and a Basque beret, Courbet is seen seated at the window of his cell looking out over the prison yard. He is very thin, with a weary face and dreamy eyes, and bears only a faint resemblance to the powerful, self-confident, pugnacious painter of *The Meeting* or *The Atelier.* This is the man who wrote to his friend Lydie Jolicler: "I have been pillaged, ruined, defamed, dragged through the streets of Paris and Versailles, anguished by stupidities and insults. I have rotted in solitary confinement that destroys one's reason and physical strength; I have slept on the ground, crowded together with riff-raff among the vermin; I have been transported and re-transported

Self-Portrait at Sainte-Pélagie, 1871
(Musée d'Ornans, Ornans)

from prison to prison, in hospitals with people dying all around me, in police vans, in cells too small for the body to enter, with a gun or a revolver at my throat for four months.

"But alas, I am not alone, There are two hundred thousand of us more dead than alive. Ladies, women of the people, children of all ages, at the breast even, without counting the abandoned children roaming Paris with neither father nor mother, imprisoned by the thousands every day.

"Since the world has existed, the earth has never seen anything like it; in no people, in no history, at no time has there been such a massacre, such a vengeance."

The ultimate ignominy heaped on Courbet came from Alexandre Dumas *fils*: "From what fantastic copulation of a slug with a peacock, from what genetic antitheses, from what sebaceous seepage can this thing called Monsieur Gustave Courbet have been generated? Under what rock, nurtured by what dung, as the result of what mixture of wine, of beer, of corrosive mucus and flatulent edema, could this sonorous and hairy gourd with its esthetic belly have grown, the incarnation of the imbecile and impotent Ego?"

After a brief improvement, Courbet's condition worsened again and he obtained permission to enter Dr. Duval's nursing home at Neuilly, as a prisoner on parole. There his hemorrhoids were operated on by Dr. Nelaton, Napoleon III's doctor and one of the most famous practitioners of his day. There he was visited by Boudin, Claude Monet, and Amand Gautier. Courbet remained at Neuilly until March 2, 1872, the date of his discharge, but in order to be freed from prison he had to pay 6,850 francs, the costs of the trial.

After Courbet's release the art dealer Durand-Ruel — who during the war had gone to London, where he met Monet, Daubigny, and Pissarro in front of Turner's sunsets — put on an exhibition of thirty of Courbet's paintings in his shop in the rue Le Pelletier.

Courbet, encouraged by signs of sympathy from the

Impressionists, wished to return to public life. He submitted to the 1872 Salon two works that ought not to have created any problems: *The Lady of Munich* and a still life with apples. But the members of the Institut had not given up pursuing him with their hatred and the selection committee, presided over by Meissonnier, rejected both pictures. Puvis de Chavannes, foreseeing the result, withdrew before the discussion. Fromentin alone had the courage to defend Courbet.

The Courbet who returned to Ornans in spring 1872 bore little resemblance to the triumphant giant of 1869. He was a sick man, attacked from all sides, partially robbed of his property and his works. He gradually began to paint again. Brushes in hand, he became himself again, regaining his optimism and self-confidence. His subjects? The trout of the Loue, landscapes, a calf. In November, while staying with the Joliclers at Pontarlier, he recaptured his verve as a landscape painter in *The Blue Spring*. Was he going to be able to continue working in peace and calm?

He had fallen in love with a young lady of Ornans named Léontine and had made up his mind to marry her, or to live with her if she preferred. In speaking of her to his friend Cornuel he recovered some of his vanity. "She will surely be the most envied woman in France, and she could be born again three times over without ever coming upon a position like this one, since I could choose a woman from the whole of French society without fear of refusal.

"Mlle Léontine will be absolutely free with me; she can leave me whenever she pleases; as for me, money costs me nothing; she will never regret having been with me. My dear Cornuel, just think that in two days of work I can provide her with a dowry such as no woman in the village has. In a word, I can say that if she comes with me she will be the happiest woman in Europe. Let her consult on this subject not villagers, but people of intelligence." (October 6, 1872)

His love for Mademoiselle Léontine came to nothing, but as in most of his affairs of the heart, he was rapidly consoled.

And shortly afterwards, in March, he had regained all his boastfulness when he wrote to Castagnary: "Abroad especially I have supporting me the whole of democracy, all women of all categories, all the painters, the Swiss, the Germans.... At Ornans I already have so many commissions I shall never be able to complete them. I shall absolutely have to take on pupils to cope with them. It is unpleasant to say this, but I am reaping the whole benefit of the Commune, apart from my coreligionists. At the moment I have commissions for more than fifty pictures; and on all sides my paintings are selling like hot cakes.

"If I had joined the Commune expressly for this purpose I could not have been more successful. I am utterly delighted."

In fact three friends or pupils had come to join him: Armand Cornu, Marcel Ordinaire, and Cherubino Pata. He sent twenty pictures to Vienna. Durand-Ruel wished to send some to the United States.

But he was not to escape the vengeance of all those to whom his very existence was an outrage.

On May 24, 1873 the Bonapartists allied with the Legitimists overthrew the government of Thiers and replaced him by Marshal MacMahon. Immediately a law was passed calling for the rebuilding of the Vendôme Column. It was at once evident that Courbet was going to be made to "pay." On June 23, the new Finance Minister, Magne, without waiting for the verdict of a new trial, ordered the seizure of the painter's property up to a value of 500,000 francs. Since the studio had already been emptied, the seizure was carried out at Durand-Ruel's shop, at the Banque de France, at the Compagnie Lyon-Méditerranée (during his period of prosperity Courbet had acquired some railroad shares), and so on. (In 1874, 323,091 francs were claimed from him, a sum confirmed on appeal in 1875.

In 1876 another 286,549 francs 78 were demanded from him, and on November 26, 1877 his property was put up for sale.)

A whole life's works, even by such a famous painter, would not have sufficed to pay such reparations. Courbet realized that this sentence was merely a pretext to imprison him for debt. He decided to go into exile and before leaving, to save what could still be saved. He bequeathed to his sisters the inheritance from his mother, mortgaged his lands and houses to his friends, and asked Alexis Chopart to get some of his pictures to London, Brussels, Vienna, and La Chaux-de-Fonds.

On July 20, 1873 he wrote to his friend Lydie Jolicler: "The thing now is to slip neatly out of France, since according to the sentence it is five years of prison or thirty of exile if I do not pay. In this event, M.O. [Marcel Ordinaire] and I will leave for Laverine and we shall be there on Wednesday at 5 in the afternoon. We are counting on you to come and meet us, either Joliclerc, or the doctor, or M. Pillod, with a closed carriage, and to carry us in one stroke to Les Verrières, where we shall dine.

"In all this, there must be absolute secrecy; consequently we count on one of you without any need for a reply. There is no time to lose, the trial is on Thursday." (Sunday, July 20, 1873)

Chapter 9

EXILE AND ILLNESS
1873-1877

And now, my dear Castagnary, I take leave of you as I express in my name and in the name of a few friends, outlaws like myself, the wish that our unhappy country shall soon emerge from the terrible crisis it is passing through. One would blush to be French if one did not have the ardent conviction that the last word will lie with Right and Justice!

Gustave Courbet (to Castagnary, from La Tour de Peilz, December 12, 1877)

From July 23, 1873, the date when he crossed into Switzerland, until his death on December 31, 1877, Courbet's life was confused, sedentary, and tormented. He proved arrogant and wretched, intemperate and ailing. One might have imagined that after the years of war, revolution, prison, and illness he would have been filled with the desire for calm, anxious to find a haven, keen to work in peace. This was not so, for two reasons.

Firstly, on the banks of Lake Geneva, Courbet felt only half safe; he knew that he was physically protected, but his property was threatened. Everything he had painted, the pictures to which he was most attached, everything he had acquired, furniture, objects, even those of little value, was slipping away from him as the result of confiscations, theft, and neglect. He feared the pilfering of his sister Zoé Reverdy [1] and the vandalism of the Ornans peasants as much as the procedures of the Treasury. He was attached to everything, including the most insignificant things, with that peasant outlook which never left him, and from far away he felt helpless. He expended his energy, he exhausted himself in correspondence with his friends and with his enemies, with his solicitors and his advocates, and with the deputies of the new Chambers, to whom he sent an open letter. He lived in a constant state of anxiety from which he escaped only through conversations with his visitors or neighbors, or by drinking.

The other reason for that feverish passion which precipitated his end and prevented him from escaping from his destiny was that, even when ill, Courbet remained Courbet — vain, intemperate in everything, especially in drinking. The wine of the canton of Vaud, the delight of tourists, broke down his resistance. Witnesses said that he drank as much as twelve liters a day.

Throughout this account I have refrained from stress-

[1] After the painter's death, Zoé even tried to misappropriate the inheritance by producing a fake will. Courbet had made Juliette his general legatee.

ing Courbet's heavy drinking, since mention of it would have led to countless anecdotal digressions and halted the logical development of the story. But to explain his illness and his death we must quote one of many similar stories — those recollections of Courbet's trip to Germany reported by Gros-Kost. The scene is Munich; Courbet is speaking:

"The first question I was asked was: 'Have you brought some pictures?'

I replied: 'I've brought a great thirst. Let's go and have a drink.'

We found ourselves in a smoky room where a crowd of natives were paying their respects to the flowing bowl.

They said to me: 'You wanted a drink. Go ahead. Our tankards aren't like your little glasses. They're nothing but women's thimbles, from which you can sip one drop of liquid with great difficulty. Our bock is equal to a barrel.'

I drank a tankard, two tankards, three tankards — as the others rose to leave I held them back.

'It's not late,' I told them. 'We've got time for another tankard.'

'Oh, oh,' they cried, 'we see you've taken a liking to our beer. As you wish. We'll drink another tankard.'

I drank a tankard, two tankards, three tankards. My companions started talking about painting and suggested I should go with them to see a famous painter whose name I've forgotten. They told me I would see some admirable, astonishing landscapes in his studio.

'I don't want to see astonishing, admirable landscapes,' I replied. 'I paint them myself. I'd rather have another tankard.'

'Oh, oh,' yelled my Bavarians, 'you're challenging us. No doubt you're a good drinker, but you'll get drunk.'

'Let's bet I don't get drunk!'

'Let's bet you roll under the table!'

'Gretchen, beer all round!'

We drank during most of the night. Every quarter of an hour a Bavarian would fall to the floor. He was carried out face down into the yard, where the

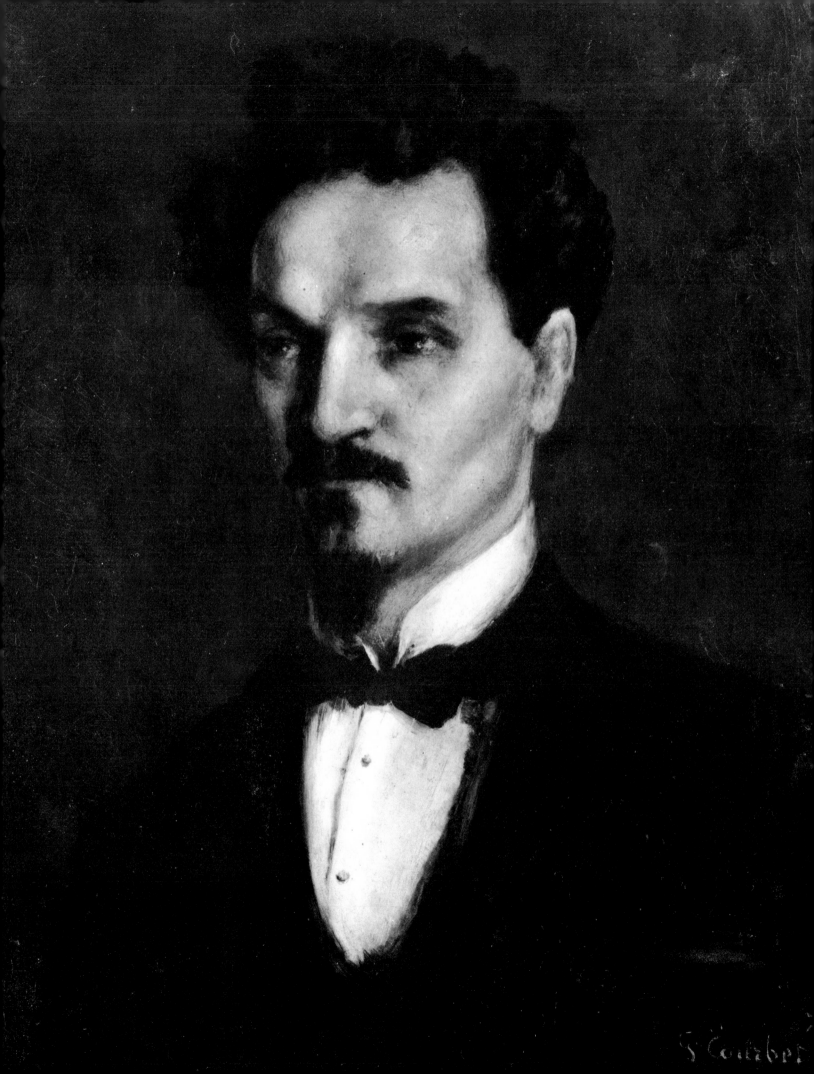

municipality, learning of this great battle, had hastily set up a medical post. After the painters who had brought me to the tavern, it was the turn of the amateurs.

At one o'clock I rose.

I looked in vain in the room, out in the square, in the streets, in the houses, in the catacombs, everywhere, for someone who was still capable of drinking with me, for the stirrup-cup. No one.

The women had fled with the children.

The men were lying on the battlefield.

I went back to my hotel. As I was thirsty, I emptied one of the bottles of Salins wine I had had the forethought to put in my suitcase for fear there might be no taverns in Munich."

In 1865 Champfleury was already writing to Max Buchon: "Courbet continued his night-life which, incidentally, I had never shared, and I came to realize this: gifted with considerable qualities as a painter, he had allowed them to be lulled to sleep in beer.... Courbet has too rich a stomach."

These performances, then still limited by lack of money, had started at the Brasserie Andler around 1840. They were scarcely interrupted; they went on continually, and they were always up to the level of the painter's reputation. This explains the sad years when painting became at times merely a diversion for Courbet or more often a means of earning money to pay his debts.

On his arrival in Switzerland, after a quick tour, Courbet decided to settle on the shores of Lake Léman (Lake Geneva) and picked Vevey, already a cosmopolitan town. No doubt as the result of intervention by the French police, he met some objections. He then stopped some kilometers further on, at La Tour de Peilz, a village of fishermen and above all of winegrowers. He stayed with the pastor, then with Monsieur Budry, a former butcher who ran the Café du Centre. This became the painter's favorite haunt after he had finally moved into the "Bon Port."

The "Bon Port" — of which there are numerous descriptions — was a former inn, very modest but situated on the shores of the lake, with a terrace furnished with tables and chairs bearing witness to its former use. There were three rooms: the bedroom, the living room and the studio, plus the kitchen. In one wing Courbet arranged a museum of his own work with the pictures he had brought and those which he painted there. To this he invited his notable visitors and possible clients, Henri Rochefort, the Duchess Colonna, and the Marquise Olga de Talleray. A family of Marseilles workers, exiled for their views during the Commune, occupied an outbuilding and looked after the house. One of his pupils, a native of Ticino, soon came to join him and turned himself into a secretary, an assistant, and an odd-job man. Cherubino Pata carried his cooperation so far that he finished a number of canvases, and it is often difficult to distinguish the work of the master from that of his pupil.

During the day, Courbet led a healthy life. He bathed, fished, and worked, adding to his productions a view of the nearby *Château de Chillon, The Winegrower's Wife of Montreux,* portraits of his father and of Henri Rochefort, and numerous landscapes — views of the lake in every kind of weather, chalets, snow effects, waterfalls; all were painted with the thick impasto and with the strong lights typical of his style.

In the evening Courbet had his table at Budry's Café du Centre, where he spent every evening, drinking a great deal and very late, surrounded by people, until they all went out into the square, where songs shouted at the tops of their lungs often woke the inhabitants. But Courbet had charmed the people of La Tour de Peilz and their affection for him was unshakable.

From time to time Courbet would disappear for several days; it worried those around him because he went off without luggage. When he returned, all smiles, he used to recount his adventures and the places he had discovered.

Among the many visitors he received, he most enjoyed Lydie Jolicler. She served as the model for a medallion, *The Woman with a Gull,* and for a bust, *Helvetia,*

symbolizing liberty. He presented this to the commune and the mayor thanked him in these terms: "You have found on the soil of Switzerland an asylum from the storms of revolution and, in memory of the hospitality you received, you have presented us with a bust to be placed as an ornament on the town's main fountain.... We appreciate the sentiment, pleasant and agreeable to us, which dictated this step, namely the sense that on the banks of Lake Léman you enjoyed peace, you learned to know our liberal institutions and lived undisturbed beneath the flag of that liberty which inspired you."

The only noteworthy incidents of his life at this time are recorded in the correspondence which he maintained with Paris and, above all, with Castagnary, who took steps (he went to see Gambetta and Jules Grévy) to come to an arrangement about Courbet's fine with the Minister of Finance. He succeeded, and Courbet accepted a solution according to which he was to pay 10,000 francs per year in two parts, until his debt of 323,000 francs had been discharged. The first payment fell due on January 1, 1878. He never paid it.

In order to cover the costs of the trial, he worked hard in collaboration with his friend Pata. Canvases piled up in the studio and many went abroad, to Germany, Britain, Belgium.

As the result of overwork and excessive drinking his health declined sharply during the summer of 1877. His obesity assumed an alarming character and his legs swelled. Courbet was suffering from cirrhosis of the liver, edema, and abdominal dropsy. At the beginning of October he left for treatment by a quack named Guerrieri at La Chaux de Fonds. The treatment by steam baths weakened him terribly. He lost a tremendous amount of weight without any diminution of his obesity. Those who went to see him became worried. On hearing the news, Castagnary begged him to return to France for treatment by competent doctors. Since the final trial was over, he ran no further risk of imprisonment. Moreover, would the authorities dare to pursue him into a nursing home?

But Courbet was still exasperated by the scandal of the public sale of his confiscated works at the Hôtel Drouot on November 26.[2] He refused to listen and returned to La Tour de Peilz on December 1. The story goes that a special railroad coach had to be chartered because his waist by then measured about one meter fifty! (59 inches)

Dr. Blondon of Besançon and a local doctor, Dr. Farvagnie, did their best to bring about an improvement, but in vain. It was then that Courbet confided to Marius Vachon: "I have saved Thiers more than a million, and the State more than ten million, and now I can no longer work. One has to have a mind at rest in order to produce anything."

Vachon adds: "It was a heartrending spectacle. He breathed with difficulty, painfully raised his arms to eat, and the slightest movement was rendered painful by the frightful inflammation of his abdomen and chest. His beard and his hair were white; there was nothing left of the handsome and powerful Courbet whom I had known, except that remarkable Assyrian profile which I was seeing for the last time and which stood out against the snow of the Alps as I sat on a bench beside him."

After being called on December 18, Dr. Collin arrived from Paris on the 24th. He found the patient in a desperate condition and the description which he left goes so far beyond a mere diagnosis as to become profoundly moving. After the failure of the steam baths at La Chaux de Fonds, Courbet agreed to undergo a puncture of the peritoneum: twenty pounds of water! But there was a quick return of his frightening obesity, which he measured with anguish in centimeters: 145! (57 inches)

He had one obsession: to bathe in the lake. He firmly believed that if he could go for a swim he would derive great relief and an immediate improvement from it.

"Courbet, it is incontestable, had aggravated his

[2] The highest price was fetched by *Proudhon and his Family*, 1,500 francs. All the works went at prices far below those Courbet was in the habit of charging.

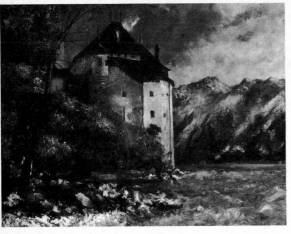

Château de Chillon, 1875
(Collection André Held, Ecublens,
Switzerland)

Château de Chillon, ca. 1873
(Private Collection)

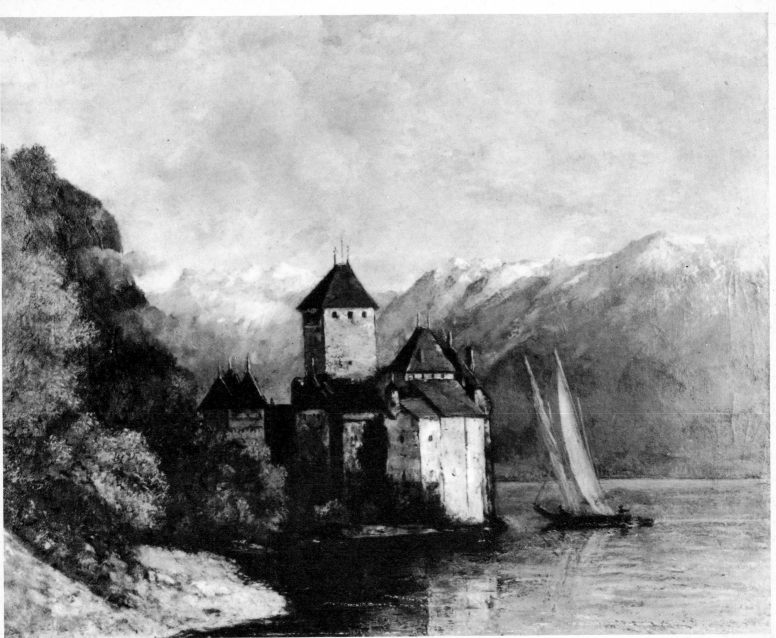

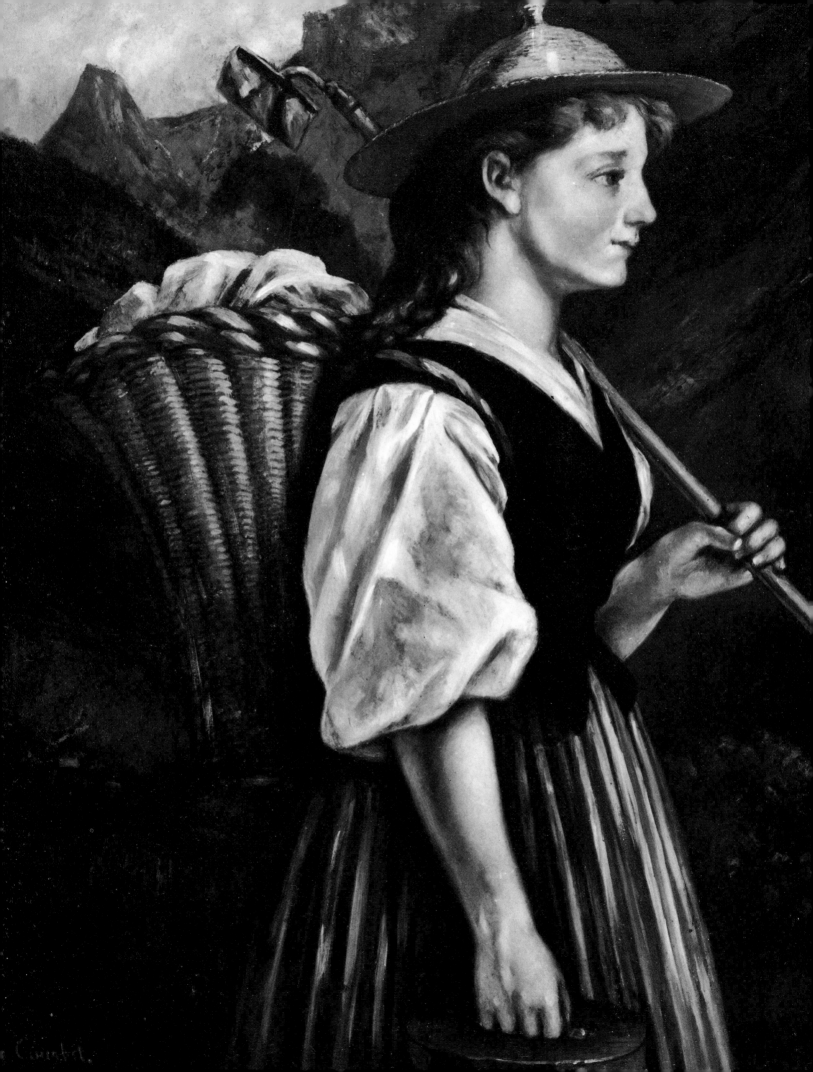

illness by unbridled drinking. In the end he was still drinking about two liters of liquid per day and only secreting half a liter in his urine (an oak-red color clearly indicating the true illness). But prior to this he had been drinking up to twelve liters a day. Unfortunately it was that wine which has made so many widows in the region."

On December 28 he was seized with the hiccups. Dr. Collin informed his family. His father Régis Courbet arrived after crossing the Jura Mountains in the snow at the age of eighty-two.

These are his last moments during the night of the 30th and the 31st as recorded by Dr. Collin:

"He made this comment, unfortunately all too true: 'I don't think I shall live through the night.'
And he repeated this remark to the male nurse who watched over him.
I applied poultices containing laudanum, but this was not sufficient to calm him. He begged me to give him a subcutaneous injection in the painful area.
At this moment his eyes were cavernous, his mouth dry and sooty. The hiccups continued. About half an hour after the morphine injection he fell asleep.
It was then about 8 in the evening.
Courbet woke around 10 o'clock and remained for a while in a somnolent state. He spoke a few words, then he lost consciousness. The death agony began towards 5 in the morning and lasted for a little more than one hour.
Courbet died at 6:30."

He was then fifty-eight.
The death mask was made by Louis Niquet, which led the old father to comment: "It's not worth the trouble; there are enough portraits at home."

In accordance with his wishes Courbet was buried with a purely civil ceremony, at La Tour de Peilz, since he would not agree to the return of the body to France at a time when so many refugees remained in exile. An unaccustomed crowd gathered in this little Swiss town and many speeches paid tribute to the "communard," to the artist, and to Swiss hospitality. It was not until June 10, 1919, the one hundredth anniversary of his birth, that his remains were transferred to the little cemetery of Ornans, where all Courbet's admirers periodically gather.

From the moment of his death all those who had known and loved him worked for his reinstatement. In May 1882 a great exhibition in the very Ecole des Beaux-Arts that he had detested paid homage to him; in 1906 there was the Salon d'Automne exhibition. In 1920 a subscription placed *The Atelier* in the Louvre. One hundred and fifty years after his birth the painter is no longer the subject of argument, but his social and political views, which have preserved all their virulence, remain burningly topical.

1819 On June 10 Jean Désiré Gustave Courbet born at Ornans (Doubs). Son of Eléonor Régis and Sylvie Oudot.

1831 The little seminary at Ornans. Studies drawing with le Père Baud, a former disciple of Baron Gros.

1837 Boarder in the department of philosophy at the Collège Royal de Besançon.

1838 Takes a room in the town, at Arthaud's, 140 rue du Rondot Saint-Quentin. Atelier des Beaux-Arts of Flajoulot, a former pupil of David.

1840 Paris. Lives in the rue Pierre-Sarrazin, then at 28 rue de Buci. Law studies. Académie du Père Suisse. Atelier du Père Lapin (Desprez).

1843 89 rue de la Harpe. Series of self-portraits.

1844 Accepted at the Salon with *Self-Portrait with the Black Dog.*

1845 Accepted at the Salon with *The Guitarrero.*

1846 Accepted at the Salon.

1847 Rejected at the Salon. Travels to Holland on the invitation of Van Wisselingh. Moves to 32 rue Hautefeuille, near the Brasserie Andler.

1848 Meeting with Charles Baudelaire. *Salon libre,* without selection committee.

1849 Invited to Louveciennes for the summer by the Weys. Salon reorganized (at the Tuileries). *After Dinner at Ornans* bought for 1,500 francs by the State. Courbet awarded a gold medal. *The Burial at Ornans.*

1850-51 Salon (*The Peasants of Flagey, The Burial, The Apostle Jean Journet*).

1852 *The Young Ladies from the Village, Les Baigneuses.* Exhibits at Frankfurt. The Duc de Morny buys *The Young Ladies from the Village.* Journey to Dieppe. Birth of a son.

1853 Meeting with Alfred Bruyas. Stays at Montpellier with Bruyas. Trip to Palavas.

1854	Salon cancelled. *The Atelier*. Reply to the conditions of the commission offered by Nieuwerkerke, Napoleon III's Superintendent of Fine Arts.
1855	Universal Exhibition. Pavilion of Realism at the Carré Marigny.
1856	Visits Belgium and Germany.
1857	Meeting with Castagnary. Second stay with Bruyas.
1858-59	Frankfurt-am-Main. Series of hunt scenes.
1859	Honfleur: meeting with Boudin.
1861	Second gold medal at the Salon. Antwerp Congress. Creates a studio for his pupils at 83 rue Notre-Dame des Champs.
1862	The studio closes down. Travels in Saintonge with Castagnary. Idyl with Madame Boreau. Paints alongside Corot. Exhibition at Saintes (43 pictures). *The Return from the Conference.*
1863	Salon (*The Huntsman's Horse* and *The Lady with the Black Hat*). Travels in England and Belgium.
1864	*The Awakening* or *The Two Friends* rejected by the Salon for immorality. Stays at Salins with Max Buchon and at Pontarlier with the Joliclers.
1865	January 21, death of his friend P. J. Proudhon. *Portrait of P. J. Proudhon and his Family.* Summer at Trouville.
1866	Summer at Deauville. Friendship with Whistler. *Portrait of Jo. (La Belle Irlandaise).*
1867	Universal Exhibition on the Champ de Mars. Individual pavilion at the Rond-Point de l'Alma. More than 100 pictures. Death of Baudelaire and Ingres.
1868	Salon (*The Hunted Roebuck Listening, Giving Alms to a Beggar at Ornans*). Exhibition at Ghent.
1869	At Etretat with Eugène Diaz. The King of Bavaria decorates him with the St. Michael's Cross first class order of merit and gives him the title of Baron. Munich. Return via Switzerland. At Pontarlier with the Joliclers.

1870	Announcement in the *Journal Officiel* of Courbet's nomination to the rank of Chevalier of the Legion of Honor (June 22). June 23 open letter of refusal to the Minister.
1870	September 6. Elected president of the commission of artists set up to safeguard works of art. September 14. Petition to the government for the removal of the Vendôme Column. September 24. Elected to the Commission of Archives charged with investigating the activities of previous officials of the Beaux-Arts. October 29. *Open Letters to the German Army and the German Artists* proposing a monument to Peace to replace the column.
1871	April 12. The Commune votes a decree ordering the demolition of the Vendôme Column. April 16. Elected to represent the VIth arrondissement. April 17. Elected President of the Federation of Artists. April 23. Elected to the Commune, delegate to the Beaux-Arts, and member of the Education Commission. May 16. Demolition of the Vendôme Column.
1871	June 7. Courbet is arrested. Interned in the Château de Versailles. In August, brought before the Council of War, found guilty of *attentat*, incitement and levying troops, usurpation of official functions, and complicity in the destruction of a monument. Condemned to six months in prison, 500 francs fine and the costs of the trial. Versailles military hospital. Imprisoned at Sainte-Pélagie. Nursing home of Dr. Duval, Neuilly, until March 2, 1872.
1872	Rejected at the Salon. Ornans. Proposal of marriage to a young lady named Léontine at Ornans. No result.
1873	Law passed ordering the rebuilding of the Vendôme Column. Courbet's property seized. July 23, Courbet crosses into Switzerland. Settles at La Tour de Peilz, near Vevey.
1874	New trial: Courbet is sentenced to pay more than 300,000 francs for the rebuilding of the column.
1877	Courbet suffers from cirrhosis of the liver, edema, and abdominal dropsy. Treated with steam baths by a quack at La Chaux-de-Fonds. Public sale of his confiscated works at the Hôtel Drouot on November 26. Treated by Dr. Blondon of Besançon and a local doctor. Dr. Collin arrives from Paris on December 24. Courbet dies on December 31 at 6:30 in the morning.

1824-30	Charles X, King of France. Extreme rightists gain ascendancy.
1830	July 26. Repressive "July Ordinances" precipitate revolution. Republican insurgents take control of Paris. Louis-Philippe, Duke of Orléans, accepted as constitutional monarch.
1830-48	Louis-Philippe, King of the French. Disappointed in conservatism of the new monarchy, radicals continue activity. Revolts in Paris and Lyons in 1834, severely put down. Repressive laws enacted. A period of industrial expansion, giving rise to intense discussion of social problems.
1846-47	Widespread unemployment and unrest.
1848	February 22. Paris in revolt; workers take control of the city by the 24th. Louis-Philippe abdicates; the Second Republic proclaimed. Left wing of government led by Louis Blanc and Ledru-Rollin, who begin radical social and economic reforms, such as the national workshops, a work-relief scheme. April elections give moderates control of the assembly. Workers organize protests, culminating in June 23-26. Insurrection. Bloody street fighting. General Cavaignac intervenes and puts down the revolt with great severity. Reaction sets in. December. Prince Louis-Napoleon, nephew of Bonaparte, elected President.
1849-51	Louis-Napoleon works towards a return to monarchy.
1851	December 2. Coup d'état. Barred from re-election, Louis-Napoleon dissolves the assembly. A plebiscite arranged to confirm his dictatorship.
1852	December 2. The Empire re-established.
1852-70	Napoleon III, Emperor. Period of technological and economic progress; advances in social and public works. (Under Baron Haussmann, prefect of the Seine, the great boulevards of Paris are created.)
1854	France joins against Russia in the Crimean War.
1860	Napoleon liberalizes his regime somewhat.
1867-69	Emperor discredited by failures in foreign ventures (Maximilien in Mexico; intervention in Italian war of independence; growing troubles with Prussia). Radical opposition forces concessions.
1870	July 19. France declares war on Prussia. September 2. Napoleon III capitulates to the Prussians at Sedan. September 4. Third Republic proclaimed. September 19. Germans besiege Paris, which falls on January 28.

1871 February 17. Thiers becomes head of government.
May 10. Treaty of Frankfurt; harsh terms imposed on France.
March-May. The Paris Commune.
Social discontent, intensified by the hardships of the siege, the humiliation of the German victory, and the frustration arising from the conservatism of the new government, leads to revolution.
March 1-3. The radicals seize Paris and on March 26 elect the Commune to govern it.
April-May. Troops of the national government at Versailles fight back, enter Paris May 21; bloody fighting ending in defeat of the Communards, May 28. Executions and harsh reprisals follow.

1871-73 Period of economic recovery. The Republic consolidated.

1873 May 24. Thiers resigns, succeeded as President of the Republic by Marshal MacMahon.

Bibliography

Baudelaire, Charles	*Exposition universelle de 1855.* Paris: Calmann-Lévy.
Silvestre, Théophile	*Les artistes français, études d'après nature.* Paris: Blanchard, 1856.
Buchon, Max	*Recueil de dissertations sur le Réalisme.* Neuchâtel, 1856.
Champfleury	"Sur M. Courbet," in *Le Réalisme.* Paris: Michel-Lévy, 1857.
About, Edmond	*Nos artistes au Salon de 1857.* Paris: Hachette, 1858.
Champfleury	*Grandes figures d'hier et d'aujourd'hui.* Paris: Poulet-Malassis, 1861.
Castagnary, J. A.	"Courbet: son atelier; ses théories," in *Les libres propos.* Paris: Lacroix, 1864.
Proudhon, Pierre Joseph	*Du principe de l'art et de sa destination sociale.* Paris: Garnier, 1865.
Zola, Emile	*Mes haines.* Paris: Charpentier, 1866.
Duret, Théodore	"M. Courbet," in *Les peintres français en 1867.* Paris: Dentu, 1867.
Ideville, Henri d'	*G. Courbet. Notes et documents sur sa vie et son oeuvre.* Paris: Heymann et Pérois, 1878.
Gros-Kost, Emile	*Courbet. Souvenirs intimes.* Paris: Derveaux, 1880.
Castagnary, J. A.	*Catalogue des Oeuvres de Gustave Courbet.* Paris, 1881.
Castagnary, J. A.	*Exposition des Oeuvres de G. Courbet à l'Ecole des Beaux-Arts, catalogue.* Paris: Martinet, 1882.
Castagnary, J. A.	*Courbet et la Colonne Vendôme. Plaidoyer pour un Ami mort.* Paris: Dentu, 1883.
Meier-Graefe, Julius	*Corot und Courbet. Ein Beitrag zur Entwicklung der modernen Malerei.* Leipzig: Im. Insel-Verlag, 1905.
Riat, Georges	*Les maîtres de l'Art: Gustave Courbet, peintre.* Paris: Floury, 1906.
Geffroy, Gustave	"Gustave Courbet," *L'art et les artistes,* October, 1906.
Duret, Théodore	"Courbet graveur et illustrateur," *Gazette des Beaux-Arts,* May 1, 1908.
Léger, Charles	*Au pays de Gustave Courbet.* Meudon: chez l'auteur, 1910.

Castagnary, J. A.	"Fragments d'un livre sur Courbet," *Gazette des Beaux-Arts*. 1911 vol. I, 1912 vol. II.
Duret, Théodore	*Courbet.* Paris: Bernheim-Jeune, 1918.
Lecomte, Georges	*Le centenaire de Gustave Courbet.* Paris.
Léger, Charles	*Courbet, selon les caricatures et les images.* Paris, 1920.
Meier-Graefe, Julius	*Courbet.* Munich: R. Piper, 1921.
Courbet, Gustave	*Lettres et documents manuscrits.* Archives du Doubs.
Léger, Charles	*Courbet.* Paris: Nilsson, 1925.
Chirico, G. de	*Courbet.* Rome: Valori Plastici, 1925.
Kahn, Gustave	*Courbet.* Paris: Floury, 1931.
Léger, Charles	*Courbet.* Paris: Crès, 1929.
Courthion, Pierre	*Courbet.* Paris: Floury, 1931.
Léger, Charles	*Courbet.* Paris: Braun, 1934.
Huyghe, René; Bazin, Germain; and Adhémar, Mme. Jean	*Courbet, l'atelier du peintre.* Edit. des Musées nationaux. Paris: Plon, 1944.
Léger, Charles	*Courbet et son temps.* Paris: Editions Universelles, 1948.
	Courbet raconté par lui-même et par ses amis. Geneva: Pierre Cailler, 1948-50.
Zahar, Marcel	*Gustave Courbet.* Paris: Flammarion, 1950.
MacOrlan, Pierre	*Courbet.* Paris: Editions du Dimanche, 1951.
Borel, Pierre	*Lettres de Gustave Courbet à Alfred Bruyas.* Geneva: Pierre Cailler, 1951.
Aragon, Louis	*L'exemple de Courbet.* Paris: Cercle d'Art, 1952.
Zahar, Marcel	*Courbet.* Geneva: Pierre Cailler, 1952.
Chamson, André	*Gustave Courbet.* Paris: Flammarion, 1955.
	Bulletin des Amis de Gustave Courbet. Paris-Ornans, 1947-69.